$4495

D1020027

# Ernst Barlach's Literary and Visual Art

## The Issue of Multiple Talent

# Studies in the Fine Arts:
# Art Theory, No. 15

## Donald B. Kuspit, Series Editor

Professor of Art History
State University of New York at Stony Brook

## Other Titles in This Series

# Ernst Barlach's
# Literary and Visual Art
## The Issue of Multiple Talent

by
Kent W. Hooper

U·M·I Research Press

Ann Arbor / London

Copyright © 1987,
Kent William Hooper
All rights reserved

Produced and distributed by
UMI Research Press
an imprint of
University Microfilms, Inc.
Ann Arbor, Michigan 48106

Library of Congress Cataloging in Publication Data

**Hooper, Kent W. (Kent William), 1958-**
Ernst Barlach's literary and visual art.

(Studies in fine arts. Art theory ; no. 15)
Bibliography: p.
Includes index.
1. Barlach, Ernst, 1870-1938—Criticism and
interpretation.   2. Arts, Modern—20th century—
Germany.   I. Title.   II. Series: Studies in the
fine arts. Art theory ; no. 15.
NX550.Z9B3743   1987        700'.92'4              87-19130
ISBN 0-8357-1830-1 (alk. paper)

British library CIP data is available.

*Dedicated to*
*Rainer Rumold*

# Contents

# Figures

# Preface

Expressionism in literature and the visual arts has been the subject of increased interest this past decade. Major exhibitions in both Europe and the United States have featured the works of many individual artists including Kandinsky, Kokoschka, Barlach, Heckel, Beckmann, Marc, and Klee. Both individual retrospectives and exhibitions focusing on broader issues—expressionist sculptors, primitivism in modern art, or the art scenes in Berlin, Munich, and Vienna, for example—have proven extremely popular with the general public. Such popularity has been paralleled by, and perhaps has even fueled, a dramatic increase in the prices collectors are willing to pay at auction for works by expressionists. Granvil and Marcia Specks and Bert van Borck, collectors of expressionist prints and drawings, estimate that, in general, prices have almost tripled in the last five or six years alone—even more for exceptionally fine prints.

Literary expressionists and their works have also enjoyed a renaissance in the last few years. While interest in well-known figures, such as Kafka and Trakl, continues to remain strong, scholars are now re-evaluating the significance of works by lesser known writers—Carl Einstein, for one—and reviewing the status of less familiar sources, such as short-lived periodicals.

Artistic multiple talents, such as those possessed by such expressionist artists as Kandinsky, Kokoschka, Klee, and Kubin, require special consideration and provide a different kind of scholarly challenge. Despite the growing interest in research on expressionist topics, interdisciplinary relations between and among the various arts of a single individual have not yet been substantially considered. A study of the works of another expressionist, Ernst Barlach—gifted in both visual and literary arts—presents an opportunity to study the interartistic relations between diverse means of expression. By identifying signs that serve as formal features in the works of Barlach, by tracing a system of signification rules that allows these signs to acquire meaning, and by interpreting these elements as part of a personal yet coherent philosophy of expression, Barlach's gifts as a multiply-talented artist can be more effectively understood. This approach could also supply a methodology for a more general exploration of artistic multiple talent.

The year 1988 will mark the fiftieth anniversary of Barlach's death and hopefully also the beginning of an era of Barlach scholarship characterized by an interdisciplinary approach to the artist's works.

In this study, the translations, unless otherwise noted, are my own.

I would like to express gratitude to my professors in the Department of German at Northwestern University, to the University of Puget Sound, and to the German Academic Exchange Service (DAAD). I also want to thank Russell Maylone at the Northwestern University Library; the Ernst-Barlach-Haus, Stiftung Hermann F. Reemtsma; Heinz-Peter Cordes, for graciously providing most of the photographs used in this book; and Ernst und Hans Barlach GBR, Linzenverwaltung Ratzeburg.

I would furthermore like to thank Aileen, Ian, George, Grace, Eric, and Nancy.

# Abbreviations

| | |
|---|---|
| *Schult I* | Barlach, Ernst. *Das plastische Werk*. Ed. Friedrich Schult and Die deutsche Akademie der Künste zu Berlin (DDR). In *Werkverzeichnis: Band I*. Hamburg: Ernst Hauswedell, 1960. |
| *Schult II* | Barlach, Ernst. *Das graphische Werk*. Ed. Friedrich Schult and Die deutsche Akademie der Künste zu Berlin (DDR). In *Werkverzeichnis: Band II*. Hamburg: Ernst Hauswedell, 1958. |
| *Schult III* | Barlach, Ernst. *Werkkatalog der Zeichnungen*. Ed. Friedrich Schult and Die deutsche Akademie der Künste zu Berlin (DDR). In *Werkverzeichnis: Band III*. Hamburg: Ernst Hauswedell, 1971. |
| *Dramen* | Barlach, Ernst. *Die Dramen*. Ed. Friedrich Dross. In *Das dichterische Werk: In drei Bänden*. Munich: R. Piper, 1956. |
| *Prosa I* | Barlach, Ernst. *Die Prosa I*. Ed. Friedrich Dross. In *Das dichterische Werk: In drei Bänden*. Munich: R. Piper, 1958. |
| *Prosa II* | Barlach, Ernst. *Die Prosa II*. Ed. Friedrich Dross. In *Das dichterische Werk: In drei Bänden*. Munich: R. Piper, 1959. |

Page numbers only will be listed if quoted passage is obviously from *Der gestohlene Mond* in *Prosa II* (cf. especially chap. 4).

| | |
|---|---|
| *Briefe I* | Barlach, Ernst. *Die Briefe I: 1888–1924*. Ed. Friedrich Dross. In *Die Briefe 1888–1938: In zwei Bänden*. Munich: R. Piper, 1968. |
| *Briefe II* | Barlach, Ernst. *Die Briefe II: 1925–1938*. Ed. Friedrich Dross. In *Die Briefe 1888–1938: In zwei Bänden*. Munich: R. Piper, 1969. |

When passages from Barlach's letters are cited, the dates the letters were written will also be provided.

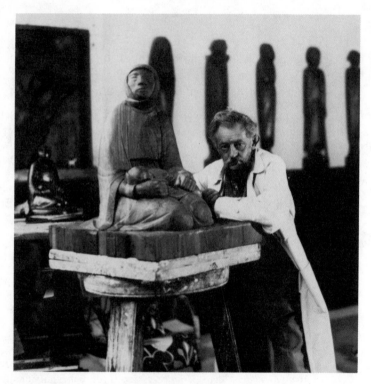

Ernst Barlach in His Atelier, 1935
*(Photograph by B. Kegebein)*

# 1

## Literature and the Other Arts:
## The Issue of Artistic Multiple Talents

Artistic multiple talents, or *Doppelbegabungen*, are frequently alluded to by historians of both literature and the visual arts. The significance of prominent figures who demonstrate mastery of two or more art forms is acknowledged by most scholars: Michelangelo and William Blake are but two names among many that frequently recur in this context. A survey of artistic multiple talents would include a host of less prominent, less productive, and perhaps less talented figures, though they are in no way less interesting, especially to a study that is methodologically oriented. Nonetheless, multiple talent in artists, as an issue of scholarly debate, is continually relegated to the fringes of the interart field, now often referred to as "literature and the other arts."

Herbert Günther, in his *Künstlerische Doppelbegabungen*, first published in 1938, attempts a comprehensive listing of German-speaking artists from the sixteenth century through the first half of the twentieth century active in more than one medium. Günther explains that his primary objective is to compile a complete listing of multiple talents, not to provide a complete catalog of their works (1960: 8).

In 1960, Günther published *Künstlerische Doppelbegabungen* in a substantially revised format and expanded it by 47 entries. In the foreword to the revised edition, Günther notes continued public interest in the general phenomenon of multitalented artists:

> The Heidelberg exhibition of 1931 . . . was titled "German Poets as Painters and Draftsmen."
> . . . This exhibition was followed by similar ones in Vienna (1931–2) . . . , Osnabrück (1932), Dresden (1938) . . . , Lübeck (1939) . . . , Berlin (1939) . . . , and St. Gallen (1957). The latter two exhibitions featured not only poets who were painters but also painters who were writers. . . . All of these exhibitions and also the publications devoted to individual artistic multiple talents demonstrate the degree to which the public is interested in the issue of *Doppelbegabung*. (1960: 12)

Nonetheless, Günther remarks, "There has been no attempt to supersede my own [1938 version of *Künstlerische Doppelbegabungen*]" (1960: 12), and this points to the need for continued critical efforts.

The exhibitions to which Günther refers were limited in scope to poet-painters and painter-poets; that is, they documented a specific relation between literature and the visual arts. Günther, on the other hand, broadens the focus. He treats "all possible combinations of talents that arise out of the connections among literature, painting, sculpture, architecture, music, and theater" (1960: 12). Unfortunately, Günther does not mention specific criteria for selection; and he does not produce any sort of methodology in his prefaces. Furthermore, the years covered in the 1960 version remain the same as in the 1938 edition. *Künstlerische Doppelbegabungen* (1960) is a chronological listing of artistic multiple talents, an improvement over the alphabetical arrangement of 1938, and contains brief biographical outlines, occasional reproductions from the oeuvres, and short bibliographical listings of varying merit.

In a study that is related in kind to Günther's, Kurt Böttcher and Johannes Mittenzwei focus on poets known also to have been painters.[1] In *Dichter als Maler* (1980), Böttcher and Mittenzwei make the following claim:

> [We] offer biographical, literary, cultural, and art historical information —information that concerns the relationship between art and society. [We] provide insights into the problems of artistic creation for dually or multiply talented writers, into their achievements, and into the historical and psychic conditions underlying their productivity. [We] draw attention to an area that has been ignored by presenting a variety of documentation, some of which has been largely forgotten, some of which has been previously either unavailable or inaccessible. Material from the middle ages up to the present should prompt observations and assessments concerning the relationships . . . among the arts that are more exacting and better founded than has been previously possible. (26)

The attempts by the editors to relate several areas they mention to the topic of poets as painters will prove to be highly problematic. As will be conclusively shown later in this chapter, the subjects of "artistic creativity" and "the psychic conditions underlying artistic productivity" force the focus of research away from the art works themselves. And the question of the relation between art and society cannot be adequately addressed until the relation between a literary work and an art work is more fully understood.

Just as multiple talent in artists is frequently alluded to, so too are German expressionist literature and art the subjects of an almost incalculable number of scholarly treatises. And yet, the various interartistic relations are discussed in only a handful of publications. More specifically, the problem of artistic multiple talents remains virtually ignored. Scholars may frequently allude to prominent expressionists who were productive in more than one medium, including Oskar Kokoschka, Wassily Kandinsky, Paul Klee and Alfred Kubin, but seldom ex-

plore the relations among their works in the varying media.[2] Furthermore, a comprehensive survey of expressionist multitalents would include a host of artists less frequently referred to, some of whom prove to be extremely valuable, Ernst Barlach for example, for a study that is methodologically oriented.

Barlach and the phenomenon of multiple talent exhibited by a number of expressionist artists must be placed in historical context. Beginning with the turn of this century, conventional boundaries separating the various media disintegrated: literature incorporated line and form, generally associated with the visual arts; and the visual arts appropriated language, generally associated with literature (Faust, 1977: 7). Numerous scholars, including Wolfgang Max Faust (1977), Wendy Steiner (1982), and Willard Bohl (1986), offer complementary studies of this early-twentieth-century trend, this *Verfransungstendenz* or *Verfransungsprozeß* (Adorno, 1967: 159). At the same time, the scholarly controversy regarding the relation between literary history and art history intensified. Are literature and the visual arts separate media that demand separate modes of criticism? Or can there be a successful reciprocative association of interpretive methods?

It becomes increasingly clear that critical interpretation of the trend of reciprocal influencing of literature and the visual arts, "eine wechselseitige Durchdringung" (Faust, 1977: 7 and 29), must employ a methodology that can account for both the literary elements and the visual elements exhibited by a particular work of art. This methodology must be able to address the question of "the intersection, within the same medium, of representation by resemblence and of representation by signs" (Foucault, 1983: 33–34), that is, of "plastic representation" and "linguistic reference" (Foucault, 1983: 32).

Wendy Steiner, in *The Colors of Rhetoric*, comments on the scholarly debate about the relation between literary history and art history and claims the following:

> At the beginning of this century, the *ut pictura poesis* controversy stood as a mere historical curiosity. Irving Babbitt's denial of interartistic similarity in *The New Laokoön* of 1910, for example, received wide critical approbation. (1982: 19)

Babbitt reiterates Gotthold Ephraim Lessing's distinction between literature and the visual arts, which is based on the identification of two separate categories of aesthetic expression: succession and simultaneity.[3] Jeoraldean McClain correctly remarks: "Lessing meant that the visual arts are essentially spatial and simultaneous whereas literature is temporal and successive."[4] (It followed that artists and writers should stay within the limits of their proper domains)" (1985: 41). Lessing pronounces attempts to blur the distinction between literature and the visual arts products of false taste, "falscher Geschmack," and unfounded judgments, "unbegründete Urteile." In the preface to *Laocoön: An Essay on the*

*Limits of Painting and Poetry* (1962; 1984), originally published in 1766 as a fragment, he thus lashes out at the mania for description in poetry, speaking pictures, and the mania for allegory in painting, silent poems, because such trends confuse or ignore the means or signs particular to the respective art medium.[5]

Admittedly, the main tenets of Lessing's argument were accepted by Babbitt. And yet, even a cursory reading of Jost Hermand's *Literaturwissenschaft und Kunstwissenschaft. Methodische Wechselbeziehungen seit 1900* (1965) reveals the inaccuracy of Wendy Steiner's contention. Hermand reports that the modern-day discussion in Germany concerning relations between literature and the other arts can be traced back to at least the turn of the century. He explains what occasioned this renewal of interest in interart relations at the *Jahrhundertwende*:

> It is best if one begins around the [turn of the century]. . . . A neoidealistic reorientation takes place in the humanities and arts then, and the relationship between literary criticism and art criticism is viewed in entirely new terms. It is during these years, when both disciplines struggle to force their way out of the biographical amorphism of the positivistic era, that they suddenly become conscious of their common grounds. (1965: v)

Hermand, whose work functions primarily as an annotated bibliography written in prose fashion, documents this early twentieth-century trend towards a general striving for syntheses, "where one is no longer concerned with the individual arts but with art itself," that is, with "die Kunst an sich" (1965: 5–6). He relates that during the earlier years of this century, this neoidealistic reorientation evolves into three separate, and yet not always mutually exclusive, approaches which are designated "The Systematization of Culture" (6–8), "Nationalistic and Neoromantic Histories of Literature" (8–11) and "Analyses of Form and Style" (11–16). Within each of these headings, Hermand discusses numerous important interart studies, including Rüttenauer's *Maler-Poeten* (1899), Hamann's *Der Impressionismus in Leben und Kunst* (1907), Worringer's *Formprobleme der Gotik* (1911), Riegl's *Stilfragen* (1893) and Waetzoldt's *Deutsche Wortkunst und deutsche Bildkunst* (1916), all published before Oskar Walzel's seminal tract, *Wechselseitige Erhellung der Künste. Ein Beitrag zur Würdigung kunstgeschichtlicher Begriffe* (1917), generally credited with having generated the field of "literature and the other arts."

During the early decades of this century, Babbitt's work receives no mention in German secondary literature discussing the relation between literature and the other arts. Clearly, many works that maintain positions affirming interart relations appeared during the era in which Babbit wrote. Thus Steiner's assertion that the critical position denying interartistic similarity received "wide critical approbation" (Steiner never mentions the sources on which her assumptions are

based) is disproved. Certainly by 1917, with Walzel's *Wechselseitige Erhellung der Künste*, exactly the opposite position enjoyed more critical acclaim.

Hermand then documents the evolution of general trends in German interart criticism between the turn of the century and the mid-fifties. His work is useful because it provides a general indication of whether a particular trend might treat the issue of the multitalented artist.

The majority of trends Hermand explores, "The Systematization of Culture," "Nationalistic and Neoromantic Histories of Literature," "Style and Concepts of Worldview," "Periodic Systems," "Spiritual Universalism," "The Embodiment of the German Essence" and "Racial Unity of Thought," to mention but a few, are clearly only peripherally related to a study of the topic of artistic multiple talents for various reasons which need not be discussed here in detail. To cite one example, books under "Periodic Systems" are devoted to the periodization of "the entire world history of literature and art" (24), in the fashion of Oswald Spengler's *Untergang des Abendlandes*, written 1918–22. One does not, therefore, expect to find there anything on so specific an issue as multiple talent in artists. Other trends, in contrast, "Analyses of Form and Style," "The Mutual Illumination of the Arts," and "Back to the Facts," for example, prove more relevant. Indeed, Hermand specifically mentions that several studies in the context of these approaches, those by Waetzoldt, Wellek and Bebermeyer, for example, do examine the phenomenon of the artistic multiple talent. The theories advanced by these critics will be discussed in detail in the course of this chapter.

Because Hermand limits himself to interart criticism written in German (with the exception of studies done by René Wellek and Austin Warren) and because a large number of important interart studies have been written since 1965, one can only view Hermand's publication as a practical source with which to begin one's study of the issue of *Doppelbegabung*.

Critical positions regarding this issue must be scrutinized and any confusion they engender or misconceptions they perpetuate must be dispelled in the hope that multiple talent in artists will ultimately be included among the legitimate topics of research within "Literature and the Other Arts." And yet, Breon Mitchell's comments warn one to approach the interart field cautiously and to be wary of those who would claim to have an unequivocal understanding of the issues involved: "The 'interarts' borderland might . . . be characterized as an intellectual no-man's-land, since it is an intrepid traveller indeed who feels completely secure in venturing into it" (1978: 5).

Approaches to the issue of *Doppelbegabung* often serve to distinguish between two opposing views regarding the relationship between literature and the visual arts. The one viewpoint, that which advocates a reciprocal illumination of the arts, holds that the multitalented artist is the instance where "the different arts merge in the personality of one person" (Wais, 1936: 17), and thus underscore the necessity of reciprocal interpretive methods. Mario Praz subscribes to this

view in *Mnemosyne*: "[If] an artist is at the same time a writer, we should be likely to find in his work the surest test of the theory of a parallel between the arts" (1970: 40). The opposing viewpoint, that which maintains that art history and literary history are "independent disciplines, [and] each explores its own subjects and develops its own methodology" (Waetzoldt, 1916: 3), contends that even when the same person creates works in two or more media, differing interpretive methods are necessary. René Wellek defends this position in his publications, for example, in "The Parallelism between Literature and the Arts" (1942) and his *Theory of Literature*, third edition (chap. 11, 1963):

> Theories and conscious intention mean something very different in the various arts and say little or nothing about the concrete results of an artist's activity. . . . How indecisive for specific exegesis the approach through the author's intention may be, can best be observed in the rare cases when artist and poet are identical. (1963: 128)

Wellek's skepticism is based on the following contention: "The 'medium' of a work of art . . . is not merely a technical obstacle to be overcome by the artist . . . , but a factor pre-formed by tradition and having a powerful determining character which shapes and modifies the approach and expression of the individual artist" (1963: 129). In fact, however, one must agree with Ulrich Weisstein's assertion that extreme positions regarding the issue of multitalents have little pragmatic value: "Wellek's view is just as one-sided as that which, at the other end of the spectrum, claims that all creative activities of an artist working in several media are perfectly aligned and hence aesthetically compatible" (1982: 261). This latter claim has been voiced by numerous scholars, including Mario Praz: "[There] is either a latent or a manifest unity in the productions of the same artist in whatever field he tries his hand" (1970: 54). In fact, there are artists whose works in two media bear no resemblence to one another, such as Kafka, whose handful of "hastily drawn sketches" (Böttcher/Mittenzwei, 1980: 248), can hardly be compared in form or content to his carefully executed literary texts, and there are also artists, like Barlach, whose works in more than one medium are clearly related, as will be shown in the course of this study.

A more conciliatory stance than either that expressed by Wellek or Praz is taken by critics who view the *Doppelbegabung* as a *Grenzgebiet*, or borderline issue, whose study is exclusive neither to literary criticism nor to art criticism. Most scholars are not quite as extreme as Wellek in their separation of literary history and art history: they generally acknowledge a certain number of issues, including that of multiple talent in artists, which are best dealt with by some sort of cooperative interpretive effort. The fact that such matters are even considered indicates that scholars have moved away from Lessing's earlier distinction between literature and the visual arts and his corresponding separation of aesthetic

expression into the categories of succession and simultaneity. In 1916, one year earlier than Oskar Walzel's *Wechselseitige Erhellung der Künste*, Wilhelm Waetzoldt discusses this question of borderline issues: "Art history and literary history are indeed separate disciplines. And yet, this does not alter the fact that there are a number of issues that can be satisfactorily explained only if both disciplines work together" (1916: 3–4).

Waetzoldt recommends that the following issues be approached by a joint effort of the sciences of literature and art: "The History of Motifs," "*Doppelbegabung*," "The History of Style," and "The History of Illustration." Ten years later, Gustav Bebermeyer arrives at essentially this same position:

> Art history and literary history are independent disciplines. Each cultivates its own areas of research based on its own methodology. And yet, these areas do coincide in many instances and thus raise numerous borderline issues. These issues cannot be understood from the bias of only one discipline; they are best approached through the sensible cooperation and collaboration of both disciplines. (1925–31, vol. 2: 160)

Multiple talent in artists is also among those *Grenzgebiete* Bebermeyer proposes. His comments and listing appear in the *Reallexikon* in an entry entitled "Art and Literature (and their Interrelations)" and represent the established consensus that *Doppelbegabungen* be included among a growing number (when compared to earlier opinions) of *Grenzgebiete*. Bebermeyer's entry, in slightly revised form, appears again in the *Reallexikon* published in 1958 (82–103); his position regarding the multiply-talented artist, however, remains unchanged. By this time, an area of focus has evolved requiring comparatist strategies, in essence an interart discipline devoted to the consideration of many *Grenzfragen*. And yet, *Doppelbegabung* will also be considered a *Grenzfrage* to even this discipline, as remarks by Ulrich Weisstein and others will indicate.

A review of modern scholarship discussing the relation between literature and the other arts leads me to concur with James D. Merriman's remark that "the success or usefulness in [interart studies] seems to occur in inverse relation to the largeness of goals" (1972: 153). This view is held by most recent interart scholars ranging from Jean Seznec ("[one] can only gain from such studies, limited in their object and rigourous in their form" [1972: 574]) to Ulrich Weisstein ("[the] choice of topics ought to be gauged as precisely and narrowly as possible" [1981: 26]). The realization has evolved that "the time of brilliant generalizations seems to be passing" (Seznec, 1972: 574).

One way to avoid gross generalizations is to limit the object of study to the art works themselves; for this reason the objective of my study is limited but not "narrowed down" to the study of Barlach as an artistic multiple talent. As a matter of course, one will then be required to "proceed from the particular to the general" (Weisstein, 1981: 26). Ulrich Weisstein, in his article "Comparing

Literature and Art: Current Trends and Prospects in Critical Theory and Methodology" (1981) lists eight types of interart subjects and approaches that one might consequently investigate:

1. Works of art which depict and interpret a story, rather than merely illustrating a text;
2. Literary works describing specific works of art (ekphrases, and *Bild-*, as distinguished from *Ding-*, *gedichte*);
3. Literary works constituting or literally re-creating works of art (technopaignia, including pattern poems and much of the so-called Concrete Poetry);
4. Literary works emulating pictorial styles;
5. Literary works using artistic techniques . . . ;
6. Literary works concerned with art and artists or presupposing specialized art-historical knowledge . . . ;
7. Synoptic genres (emblem);
8. Literary works sharing a theme, or themes with works of art. (1981: 23)

Addressed then are the questions "how fruitfully [these areas] have been studied in the past and how much attention should be paid to them in the future" (Weisstein, 1981: 22–23). This study is not the place to contest Weisstein's critical assessments of each area nor to show how his choices differ from the interart *Grenzgebiete* of, for instance, Bebermeyer.

Weisstein's omission of multiple talent in artists from the listing, however, raises certain questions. Weisstein explains below his theories concerning *Doppelbegabung*:

> When we turn from the preoccupation with works—the center of gravity for the interart comparison—to the scholarly concern with their makers and to the creative process itself, we face the intriguing phenomenon of *Doppelbegabung* and, by extension, that of writers who double as art critics. . . . Certainly, the study of multiple talents has its place in the domain of "Literature and the Other Arts"; but unfortunately, too many such investigations in the past have clung to a handful of towering geniuses—a Michelangelo or William Blake—and there has been a great deal of redundancy. Let scholars, therefore, search through the pages of Herbert Günther's dictionary of *Künstlerische Doppelbegabungen* to identify viable candidates among the figures of lesser eminence and less universal appeal, whose cases may be just as enlightening and methodologically rewarding! (1981: 25)

I agree with the call for a conscious concentration on manageable case studies that are "methodologically rewarding." And yet, one needs formal criteria for the evaluation of multiply talented artists. To begin with, while Michelangelo as well as William Blake are acknowledged masters in one particular medium, can the same be said of them in other media? The decision to call writers who double as art critics *doppelbegabt* is equally problematic. A *Künstler* creates art works, whereas an art critic produces expository prose, that is, he writes about art works. My overriding question, however, is whether a discussion of the issue of artistic multiple talents should turn from the preoccupation

with the works to the concern with their makers or to the creative process itself. I, for one, cannot find anything fruitful in Weisstein's position that the heart of the issue is the creative person rather than the created works, and is therefore best left to the psychologist (1981: 25). I am concerned, rather, with the methodological confrontation with works of art in the different media.[6]

Certainly any cult of the psychology of *Doppelbegabung*-geniuses must be debunked if multiple talent in artists is to be included as a legitimate area of study within "Literature and the Other Arts." The perpetuation of the towering-genius myth is indicative of a greater problem that besets many a study addressing the issue of multiple talents: the indiscriminate substitution of the term "*Doppelbegabung*," which refers to artists who achieved equal mastery of two or more different art forms, for mere "*Doppelbetätigungen*," which refers to artists who achieved mastery in only one of the art forms in which they were active. Kurt Böttcher and Johannes Mittenzwei, in the introduction to their *Dichter als Maler*, help to clarify this distinction:

> When someone is active in more than one medium, he is frequently and perhaps too rashly rated a true multiple talent. Of course, an artist's creative works are often not limited to but one "field." And yet, closer inspection will generally reveal that in most cases, one cannot speak of an equal mastery of more than one artistic medium but rather of the occasional tendency of a creative personality to work outside of his preferred artistic discipline. (1980: 8)

Often, claims by interart scholars that artists manifest equal abilities in more than one artistic medium can simply not be substantiated. Böttcher and Mittenzwei note that this is generally the case with respect to poet-painters: "One may not charge art historians with neglect for not having taken notice of those writers active in the visual arts. . . . For, even had they abandoned their writing, these figures would probably not have become significant in the history of art" (1980: 8).

It follows that studies of a multiple talent should be concerned with artistic works, not with the creative process. One proceeds on the assumption that there is a relation between the works of art in varying media if produced by the same person. And yet, to validate this assumption, it is most productive to begin not with a worst-case scenario, that is, a *Doppelbetätigung*, or someone who is not equally gifted in more than one medium, but with an obvious *Doppelbegabung*, an artist whose talents are doubted by neither literary historians nor art historians.

One should also not venture an all-inclusive definition of *Doppelbegabung*. The extreme positions advocated by Wellek and Praz have already proven problematic. Indeed, one should in this respect heed the following remarks by Herbert Günther: "Can there be a definition of multiple talent in an artist? I do not believe so. Such a topic defies attempts at schematization. As soon as one scholar proclaims to have found a rule, another discovers the exceptions to it" (1960: 35).

The conventional choice of artists regarded as true multiple talents must be scrutinized and by extension revised, if the issue of multiple talent in artists is to be better understood. The key is not so much to "expand the scope of inquiry," as Weisstein would have it (1981: 25), but to refine methodological procedures, to increase awareness of the process of comparing works of art and literature (Steiner, 1982: 2).

Although scholars are devising more workable prospects for interart study, "Literature and the Other Arts" has not always projected itself as a well-defined discipline. It has taken scholarship the better part of the past 15 years to exploit fully and, at the same time, extricate itself from the evident confusion of interart studies written between 1900 and 1975. Only now is one witnessing a "new phase" of scholarship (a representative work is Wendy Steiner's *The Colors of Rhetoric*) that looks not to dwell on the mistakes made by earlier theorists but to explore new avenues of critical inquiry. And yet, *Doppelbegabung* remains a topic slighted by even those in the vanguard of interart scholarship.

Theorists past and present, when considering the issue of artistic multiple talents, tend to concentrate on the artist and not on his works. Perhaps for this reason, *Doppelbegabung* continues to be considered merely a *Grenzgebiet*. Most scholars write about the issue of multiple talent in artists as one related to the psychology of creativity. This is found in Waetzoldt ("the psychologically important question of the multiple talent" [1916: 4]), in Bebermeyer ("the psychologically and artistically significant appearance of the multiple talent" [1925: 160]), in Wais ("the most important original bond among the arts appears to lie on the psychological plane" [1936: 15]), in Günther, Wellek, Schneider, Böttcher/Mittenzwei, and is ultimately perpetuated by Ulrich Weisstein in comments made in 1976 ("multiple talent [*Doppelbegabung*] . . . where two or several arts are psychologically . . . joined" [6]), 1978 ("throughout the ages, the arts have sought to reunite . . . : psychologically through *Doppelbegabung* . . . fusing the channels of the creative process" [7]) and in 1981 and 1982, as has already been discussed.

Attempts by Waetzoldt, Walzel, Bebermeyer and others to pinpoint similarities of the emotions evoked by works of art (which evolve out of efforts to conceptualize artistic intent) are related to this issue of psychology. Once again, the focus of inquiry shifts to the responses to art objects and away from assertions about them. Most scholars now avoid this whole issue, with good reason, considering the psychologist better "equipped to deal with moods [*Stimmungen*] and emotional responses" (Weisstein, 1981: 25).

The consistent inability or unwillingness to separate *Doppelbetätigung* from *Doppelbegabung* facilitates the perpetuation of these trends, which must necessarily lead to dead ends. One encounters many a listing of so-called multiple talents; most are of little use, as they merely amount to extremely abbreviated indexes similar to the more detailed ones provided by both Günther and

Böttcher/Mittenzwei. Specific works are very seldom mentioned in such abbreviated indexes. Furthermore, conclusions are rarely drawn, mainly because too many disparate artists are lumped together under one inadequately outlined concept. It is thus hardly surprising that theorists can only deal in gross and misleading generalizations when confronting the problem of the artistic multiple talents: what can one objectively state that will apply equally to, for example, Barlach, Geßner, Keller, Goethe and Runge? A focus of any kind is nearly nonexistent.

Another issue that often confuses matters is the notion of "spontaneity," according to which multitalents are viewed as "a group of visual artists through whose veins coursed the urge to write poetry so to speak and who thus sought close connections with poets" (Waetzoldt, 1916: 15). Likewise, Wais characterizes matters as contingent upon "the spontaneous camaraderie of artists among themselves" (1936: 18). Schneider, writing more recently (1963) even asserts: "The lively exchanges among the ever more closely related arts, provided conditions that were extremely favorable to the development of artistic multiple talents" (1963: 234). By "lively exchanges" is meant an "active exchange of artistic ideas" among, in this case, expressionist writers and painters. Perhaps one should ask whether "economic or social or ethnic backgrounds of artists are regularly associated with specific features in their work, no matter in what art," as Merriman suggests (1972: 158). All these observations, of course, have their relative value. For the strictly formalist study that I propose, however, there exists no suitable technique as yet to determine whether this "climate" had definitively identifiable results.

In sum, the issue of multiple talent in artists continues to be skirted. Attention is not focused on the resultant artistic works of the so-called multiple talent, where research should be concentrated, but on the artists themselves. This focus can only reinforce the notion of *Doppelbegabung* as a *Grenzgebiet* of "Literature and the Other Arts." Discussions which center on the psychology of creativity usually necessitate follow-up analyses of similarities among the emotional responses to art works. There is no consistency among artists named as multiple talents, and most are minor figures in both literary and art history. Even when a major figure like Goethe is mentioned, the relation between literary and artistic production is too tenuous to form the basis for a cogent argument stressing relations among the works. Hence many scholars still feel compelled to explore the aforementioned issues related to psychology, which have little or nothing to do with literary criticism, art history, or "Literature and the Other Arts" as we know them today.

Nonetheless, a number of the studies discussed so far possess the following positive feature: they assert that the stylistic similarity among works created by multiple talents, regardless of medium, appears significant. Or as it is stated in slightly modified form by Kurt Wais: "If one wishes to speak of an identity of

style in the various arts, the first thing to do is to investigate where those arts merge in the personality of a multiple talent" (1936: 17). An analysis of passages where this stylistic similarity is outlined, however, reveals a problem that is common to many interart studies. James D. Merriman formulates what many contemporary scholars have also identified: "[One] obvious error in the search for parallels is to be found in the metaphorical nature of many of the terms used in characterizations of art objects" (1972: 154). In support of his observation, Merriman dissects a passage from a section of Mario Praz's *Mnemosyne* addressing the issue of artistic multiple talents:

> [Praz] finds a parallel between "roughly hewn portions" of some of Michelangelo's sculptures and the "harsh and jagged style" of Michelangelo's sonnets. Roughness is, of course, a feature which can be literally present in sculpture, but "jagged" as applied to poetry is only the vehicle of a rather nebulous metaphor, since poetry literally speaking has no surfaces, whether rough or smooth, jagged or straight, despite our tendency to speak loosely of "texture" in literature. (1972: 154)

The citation of tendencies that can occur literally in one medium and yet only metaphorically in another is criticized by Merriman, Weisstein, Steiner and others. I wish therefore to cite only one further example of metaphoric transfer of terminology. Waetzoldt writes: "Wilhelm Busch's drawings demonstrate just as much wit in line and form ["Witz der Linie und der Form"], as his verses do in word and thought" (1916: 15). "Witz der Linie und der Form" is the "nebulous" metaphor that breaks down under scrutiny. We witness vague contentions that rely on a metaphoric transfer of terms in almost all early interart writings that analyze stylistic similarities. And while its use proves problematic, if not misleading, it is in many ways related to the much more fruitful structural and semiotic methods of comparison.

The increasingly frequent tendency of one art medium to borrow elements traditionally associated with another during the early decades of this century accompanied or necessitated the development of interpretive methods that could account for both the literary and the visual elements exhibited by a particular work of art. And yet, it does not necessarily follow that such methodologies, even if ideal, are applicable to a comparison of two separate works in differing media and where there is no evident borrowing of artistic elements from other media, otherwise referred to by Adorno as "Verfransung der Mediengrenzen" (Adorno, 1967: 159). What interpretive framework can be posited that will be legitimate for discussions concerning interart relations?

It has long been suspected that the issue of artistic multiple talents might hold a clue to the understanding of this problem of comparison; and yet, paradoxically, even in current scholarship this issue is skirted. In this chapter, approaches to multiple talents by Günther, Weisstein, Praz, Waetzoldt, Bebermeyer, Wais and others have been outlined. Analysis of these approaches

has revealed many a methodological inadequacy. The skepticism which mention of *Doppelbegabung* generally engenders appears, to a great extent, well founded. Admittedly, valid findings are occasionally arrived at in the aforementioned studies, as when Waetzoldt recognizes a relation between Wilhelm Busch's use of line and his use of language, as has been mentioned (1916: 15), or when Kurt Wais espies a similarity in Goethe's treatment of subject matter in both his drawings and writings: "One finds the basic features, although naturally not the actual significance of Goethe's poetic transformations confirmed in his sketches: from the fantastic rough sketches of the 70s, he went on to classicistic contours and precise, geologically physiognomic landscape sketches (1936: 29)." And yet, one may only attribute such findings to a critic's keen sense of perception and not to any methodological precision.

Regardless of the many methodological flaws inherent in these studies, the proposition that there often exist correspondences among works by artists with *Doppelbegabungen* is seldom challenged. Similarities may reveal themselves quickly to most viewers, but defining the manner in which they may be discussed remains a most difficult task.

There is something "intuitively" common to Wassily Kandinsky's stage composition, *The Yellow Sound*, and many of his pre-World War I oil paintings such as *Composition IV* (1911), *Composition V* (1911), *Small Pleasures* (1913) or *The Picture with the White Border* (1913). Similarly, one "recognizes" that Ernst Barlach's literary works bear a resemblance to his plastic and graphic efforts. Such resemblances will have to be pinpointed and then discussed in a fashion not subject to the usual criticisms aimed at studies of multitalents.

One framework within which studies of multitalents may be legitimated is developed by Umberto Eco, who views works of art regardless of the medium as complex systems of signs. When one considers the following "simple" example provided by Eco and follows his comments as they relate to the endeavors of a general semiotics, one begins to realize the important role Eco's theories can play in providing a solid theoretical basis for many an interart approach, including attempts to detail the similarities among works created by the same artist in more than one medium:

> [There] is something "intuitively" common to the red light of a traffic signal and the verbal order /stop/. One does not need to have a semiotic mind to understand this. The semiotic problem is not so much to recognize that both physical vehicles convey more or less the same command; it begins when one wonders about the cultural or cognitive mechanisms that allow any trained addressee to react to both sign-vehicles in the same way. . . . Now the basic problem of a semiotic inquiry on different kinds of signs is exactly this one: why does one understand something *intuitively*?
>
> [One] (if not the most important) of the semiotic endeavors is to explain why something looks intuitive, in order to discover under the felicity of the so-called intuition a complex cognitive process. . . . To look for . . . a deeper common structure, for the cognitive and cultural laws that rule both phenomena—such is the endeavor of a general semiotics. (1984: 9)

To recognize that both the red light and the verbal order /stop/ convey the same command may not be a problem. To relate a drama to a sculpture, however, would involve infinitely more complex and varied interpretive possibilities before one could hope to exact a common "message" or determine which signs engender which responses. We must take a closer look at those processes which allow one to think in terms of relations.

Relational thinking lies at the heart of attempts to outline stylistic similarities among works of differing media. That is, identity of stylistic features is proposed as that "deeper common structure" that governs more than one phenomenon. But the metaphoric nature of terms employed in comparisons of so-called like features has proven problematic (cf., for example, Wilhelm Waetzoldt's remarks describing Wilhelm Busch's "wit in line and form" or Mario Praz's use of the phrase "harsh and jagged" to characterize the style of Michelangelo's sonnets). And yet, will the continued unveiling of the shortcomings of metaphoric expressions employed by earlier critics ultimately lead to a breakthrough in the process of comparing art works? Will one eventually be able to discern true stylistic "identities" or "equivalences" among works in differing media?

Merriman concludes that the use of terms such as "corresponding" or "equivalent" to characterize like formal features is "both illegitimate and seriously misleading" (1973: 314). For him, if a given X and a given Y are equivalent, they, though differing in form, must be equal in "value, measure, force, effect, meaning, significance, position or function" (1973: 315). Merriman then proceeds to demonstrate the irrelevance or inapplicability of each of these possible denotations of "equivalence" to interart comparisons.

To avoid metaphoric transfer of terminology and the notion of equivalent forms, Merriman derives a set of "general formal principles" which include, for example, contrast, comparison, balance, repetition, etc. Clearly, and Weisstein notes this too (1982: 267), such principles do not even fulfill Merriman's own criteria of workability as outlined below:

> In the study of the interrelations of the arts, the problem of the selection of features for comparison is of the greatest importance. . . . Clearly, the feature must at least be a possible feature of all the objects to be compared. . . . At the same time, . . . it should be a feature possible only to the arts, or at least of clearly special significance to the arts. . . . Third, the feature must be capable of literal presence in all the objects to be compared. . . . The test of whether features seen in two different objects are identical rather than merely joined under the same label is to determine whether in both cases the same units of measurement or the same descriptors apply. . . . A feature must be objective, that is, it must be clearly and unambiguously definable in such a way that all observers can agree on. . . . Features . . . ought to be simple or elementary rather than complex. Finally, for many features degree of presence may be of great importance. (1972: 160)

Merriman does not attempt to demonstrate that the categories he names are indigenous only to the arts; such a task would prove impossible. Balance, for example, could just as easily be used to describe the make-up of a football team's offensive capabilities. As Merriman notes, one does not react to the abstract notions of, e.g., balance or contrast, but rather to "concrete instances . . . of the principle" (1973: 315). But, as Weisstein astutely comments, "how often does an identical feature inhere in two works belonging to two different spheres of art?" (1982: 268). Here the question of measurement becomes more than a mere methodological stumbling block—it becomes a nightmare. A totally unacceptable conclusion results:

> This will require the development of sophisticated methods and scales of measurement in order to arrive at methods of weighting such specific measurement to arrive at a composite scoring for each innate form in a given art work, and finally development of a theory of correlations between such scores for art works drawn from two or more arts. (1973: 318)

The problem of measurement is not just an enormous problem to be solved, as Merriman views it, it is a problem that defies solution.

Merriman's forms are neither "simple" nor "elementary" and it is doubtful that they can be defined "in a way that all observers can agree on." One is not concerned with defining the abstract notion as a "kind of relationship" (1973: 315) but with those "concrete instances" that are medium-determined and which defy efforts of quantification. Merriman strives for the positivistically identifiable and quantifiable and yet fails to arrive at a workable method for discussing interart relations.

So-called equivalences of formal features dissolve into metaphoric transfer; similarly, the derivation of features that are "indigenous" to the arts proves problematic. Perhaps the notion that there cannot be "real" relations between art works if no "identical" formal features or "innate" principles can be derived needs to be reexamined.

Merriman's dismissal of Praz's metaphoric terminology, referred to earlier, for example, does not invalidate the proposition that a relation exists between Michelangelo's sonnets and sculpture. It merely indicates the problematic nature of the manner in which Praz discusses the relation. To validate or legitimate Praz's original proposition, or any interart comparison, requires an understanding of the process that allows one to think in terms of relations when confronted with sign systems.

Is the use of metaphor in relational thinking really so problematic that only by avoiding it will one arrive at some enlightened understanding of the comparative process, as Merriman suggests? Or does metaphor prove to be an indispensable tool when it comes to revealing "unexpected truth" in comparative analyses, as Wendy Steiner intimates?

Few concepts have undergone as much philosophic debunking in recent years as the notion of similarity or resemblance . . . . And yet, probably no mechanisms are as essential to the progress of . . . literary criticism as metaphors, analogies and models. . . . These iconic tools of thought are unique in their capacity to reveal "unexpected truth." (1982: 1)

In support of this latter position, one may turn to various writings of Umberto Eco, where a framework is posited within which the concept of metaphor occupies a central position, the importance of models is affirmed and interart comparisons can be legitimated.

Eco demonstrates the limited role of identical relations in a process of drawing conclusions:

If signs were rooted in mere equivalence, then understanding would represent a simple case of *modus ponens* . . . . This is in fact the absolutely deductive process we implement when dealing with substitutional tables, as it happens with the dots and dashes of the Morse alphabet. But it does not seem that we do the same with all the other signs, that is, when we are not invited to recognize the two different semiotic systems, but when we have to decide what content should be correlated to a given expression. (1984: 39)

By logical extension, identical relations do not figure prominently in the cognitive process of comparing signs belonging to different semiotic systems. I accept the notion of "sign" as formulated by Charles Sanders Peirce (1839–1914), the American philosopher and mathematician: "A sign, or *representamen*, is something which stands to somebody for something in some respect or capacity" (Peirce, 2.228). This formulation has been taken up by Umberto Eco, as his own definition of "sign" reveals: "I propose to define as a sign *everything* that, on the grounds of a previously established social convention, can be taken as *something standing for something else*" (1976: 16). In the first chapter of *Semiotics and the Philosophy of Language*, Eco points out that understanding even the most basic sign concept involves more than a mere spontaneous assumption of equivalence, more than an identity: "The semiosic process of interpretation is present at the very core of the concept of sign. . . . A sign is an x standing for a y which is absent, and the process which leads the interpreter from x to y is of an inferential nature" (1984: 1, 2).

The act of interpretation often involves abductions, inferential processes that differ from the two traditionally recognized types, induction and deduction.[7] Peirce was one of the first to recognize the significance of abductive reasoning to the inferential nature of interpretation, and the critical importance of his writings to the modern-day discussion of sign theory has been duly noted by semioticians such as Umberto Eco, René Thom, Thomas Sebeok, and Charles Morris. Although the difference between deduction and induction is clear to most readers, the distinction between induction and abduction, especially as Peirce details it, may not be. K.T. Fann provides an adequate summary of this basic distinction Peirce draws:

[In] induction we generalize from a number of cases of which something is true and infer that the same thing is probably true of a whole class [(Peirce, 2.624)]. But in abduction we pass from the observation of certain facts [results] to the supposition of a general principle [rule] to account for the facts. Thus induction may be said to be an inference from a sample to a whole, or from particulars to a general law; abduction is an inference from a body of data to an explaining hypothesis. . . . [Induction] classifies, [abduction] explains [(Peirce, 2.636)]. (1970: 9–10)

Thus, one reasons abductively when one finds a curious body of data and then posits or hypothesizes a rule so that the data are no longer strange.

As an especially clear example of abductive reasoning, Eco relates the following:

Kepler notices that the orbit of Mars passes through points x and y . . . ; this was the Result, but the Rule of which this was a Case was not yet known . . . . Points x and y could have been points of, among other possible geometrical figures, an ellipse. Kepler hypothesized the Rule . . . : they are the points of an ellipse. Therefore, if the orbit of Mars were in point of fact elliptical, then its passing through x and y (Result) would have been a case of the Rule. The abduction, of course, had to be verified. In light of the hypothesized rule, x and y were "signs" of the further passage of Mars through the points z and k. It was obviously necessary to wait for Mars at the spot where the first "sign" had led one to expect its appearance. Once the hypothesis was verified, the abduction [was] widened (and [again] verified): the behavior of Mars . . . became a sign for the general behavior of planets. (1984: 40–41)

Eco, in conjunction with Peirce, understands abduction as "the tentative and hazardous tracing of a system of signification rules which allow the sign to acquire its meaning" (1984: 40). For both Peirce and Eco there exist several types of abduction. For analysis, when dealing with metaphors, symbols, and poetic texts, Eco isolates what he refers to as "creative abduction"—where "the rule acting as an explanation has to be invented *ex novo*" (1984: 42).[8]

To clarify what is meant by creative abduction, Eco furnishes the following analysis of Copernicus's intuition of heliocentrism in *De revolutionibus orbium coelestium*:

Copernicus felt that the Ptolemaic system was inelegant, without harmony. . . . Then he decided that the sun *ought to be* at the center of the universe because only in this way the created world would have displayed an admirable symmetry. He figured out a possible world whose guarantee was its being well structured, "gestaltically" elegant. As in every case of creative abduction, this way of reasoning required a sort of metaabduction, which consisted in deciding whether the possible universe . . . outlined by the creative abduction was the same as the "real" universe. . . . In [other types of abductions] one uses explanations that already held for different results. In creative abductions one is not sure that the explanation one has selected is a "reasonable" one. (1984: 42–43)

To arrive at a consensus that an explanation is reasonable or can be "legitimated" requires an understanding of what is meant by "certitude." Eco correctly distinguishes "semiotic certitude" from "scientific certitude":

> The hiatus between [scientific certitude and semiotic certitude] constitutes the difference
> between scientific hypotheses and laws, on the one hand, and semiotic codes, on the other. The
> necessity of scientific evidence has little in common with the necessity of semiotic evidence.
> Scientifically, the whale is a mammal, but in many people's competency it is a fish. . . .
> Therefore, at the semiotic level, *the conditions of sign are socially determined.* . . . In this
> way, an event can be a sure sign, even though scientifically it is not so. (1984: 38)

Thus semiotics differs essentially from a science. When semiotics posits such
concepts as "sign," "metaphor," or "symbol," it does not, as Eco relates, act like
a science; rather, "it acts like a philosophy when it posits such abstractions as
subject, good and evil, truth or revelation" (1984: 10). This point must be
underscored as one that is virtually ignored by those critics, such as Merriman,
who strive for positivistically verifiable stylistic identities. It is obvious that these
critics begin with the false premise that semiotic codes are subject to empirical
verification or the criteria of scientific certitude:

> [A] philosophy is not a science, because its assertions cannot be empirically tested. . . .
> [P]hilosophical concepts are not "emic" definitions of previously recognizable "etic" data that
> display even minimal resemblence in shape or function. Philosophical entities exist only
> insofar as they have been philosophically posited. Outside their philosophical framework the
> empirical data that a philosophy organizes lose every possible unity and cohesion. . . .
>     A philosophy is true insofar as it satisfies a need to provide a coherent form to the world, so
> as to allow its followers to deal coherently with it. (Eco, 1984: 10, 11)

The understanding of signs and therefore of relations is not a mere matter of
recognition, of a stable equivalence; it is a matter of interpretation (1984: 43).
This is the thesis or premise which must underlie any attempts to relate the works
created in more than one medium by the same artist. If it is adhered to, one will
avoid the major problems of metaphorical transfer of terms (prevalent in Praz's
works) and the search for so-called innate formal principles (featured in
Merriman's works).

Thus my tasks here are to identify signs in the works of Ernst Barlach, in his
sculpture and in his prose, to trace a system of signification rules which allow
these signs to acquire meaning, and to interpret these signs and signification rules
as symbols that belong to a personal and yet coherent "philosophy" of
expression.

# 2

# Ernst Barlach as a Multiply-Talented Artist: The State of Research

Ernst Barlach should be considered a true artistic multiple talent. Furthermore, his art works should be referred to by those scholars who write about the relation between literature and the visual arts. And yet, only a few interart critics, such as Gustav Bebermeyer, Herbert Günther, Karl Ludwig Schneider, Richard Brinkmann, Kurt Böttcher and Johannes Mittenzwei, and Ulrich Weisstein, do call attention to Barlach. Bebermeyer merely cites Barlach's name in a list of many artists he considers to have achieved equal mastery of two or more different art forms (1925–31, vol. 2: 168). Günther (1960) and Böttcher/Mittenzwei (1980) include Barlach in their encyclopedic surveys of multiple talents but fail to provide detailed critical assessments of his works. In this sense, one might be misled to consider Paul Gurk and Ernst Barlach to have been multiple talents of equal abilities. Schneider accords Barlach special status among expressionist artist-writers and comments: "Ernst Barlach is the most important of the visual artists also active in the field of literature" (1963: 234). This admitedly keen observation, however, is not pursued or supported in any way. Brinkmann, in a remark that shows a sensitivity to the issue of *Doppelbegabung,* considers Barlach to have been one of the two most gifted expressionist multiple talents: "Kokoschka and Barlach are expressionist artists . . . who actually produced significant works in the visual arts as well as in literature" (1980: 19). Unfortunately though, Brinkmann elects to sidestep what could have constituted one of the more significant chapters of his *Forschungsbericht,* his report on the state of research in the field of expressionism: "The important chapter 'Barlach' cannot be discussed here because a separate study by a specialist has been planned for the near future" (1980: 19). Who this specialist is or when his study is scheduled to appear is not mentioned, and this "study by a specialist" has to my knowledge yet to be published. Weisstein goes one step further than either Schneider or Brinkmann by including Barlach among those very few men in the history of the arts he esteems to have produced enduring works in more than one medium: "There are instances (Michelangelo, Dante Gabriel Rossetti, Ernst Barlach, and

so on) where enduring works were created in two media" (1982: 261). Nevertheless, as was documented in the previous chapter of this study, Weisstein attends to the psyches of such multiple talents and not their works.

Even though Barlach and his works are mentioned only inconsistently in studies that examine the relation between literature and the visual arts (indeed, there are no figures that are mentioned consistently), very few scholars today would argue against including Barlach among a listing of true multiple talents. And yet, there were times, during the early years of this century when he was just beginning to emerge as a mature artist for example, when more than a few critics questioned Barlach's abilities in one or more of the media in which he was active. Karl Scheffler, for example, writes in an article published in 1901/1902 that despite his abilities in other media, Barlach is basically a sculptor: "As a sculptor he is actually a painter, as a painter actually a draftsman, as a draftsman actually an ornamentalist. He also makes an impression as a writer, as is the case with all mixed talents ["Mischtalente"]. And yet, in the end he is really just a sculptor" (79).

Barlach's plastic and graphic works were the first of his artistic contributions to gain both public and critical acclaim. Barlach's endeavors in these media were conservative, relative to the innovations wrought by the abstract expressionists and modernists for example. Such artists' works, for a good segment of the general public and for many critics and scholars, represented a scourge to be resisted at any cost. In contrast, Barlach's dramas, apparently less accessible than his works in other media, received only mixed reviews.[1] Such scathing criticism of Barlach's dramas as that leveled by Alfred Döblin in 1923, was rarely directed by critics at Barlach's sculpture, for example:

> I left after the fourth act of the five act play (*Der tote Tag*) performed in the Neues Volkstheater. I patiently sat through to the end of the twelve scene play (*Der arme Vetter*) staged in the Staatstheater. A farmer speaks slowly. I thought to myself in the Staatstheater: perhaps the main point will occur to Barlach yet. My staying power was not rewarded.
>
> I can give only a poor account of *Armer Vetter* because I myself understood it so poorly. . . . Barlach suffers from a most difficult case of emotional constipation. . . . I recommend humor to him. (Quoted in Jansen, 1972: 290–92)

Nonetheless, whether Barlach would be more highly praised as a poet or visual artist was fast becoming a moot point well before the Nazi takeover of power in 1933. Articles that accorded Barlach a place of honor among contemporary German artists were being replaced by those denouncing him as a "cultural bolshevist" and his works as depicting a world of "the unheroic, the negative, the base, the ignoble, the depressing, the earthbound," (Lübeß: 1934). To their credit, Elmar Jansen in *Werk und Wirkung* (1972) and more recently, Ernst Piper in *Ernst Barlach und die nationalsozialistische Kunstpolitik. Eine dokumentarische Darstellung zur "entarteten Kunst"* (1983), reproduce a wealth

of material written about Barlach during the late twenties and early-to-mid-thirties, thus affording the reader some knowledge of the horrific circumstances with which Barlach was faced.

By and large though, Barlach's talents in both literature and the visual arts have always been duly noted by the general public. As will be detailed in the next chapter, Barlach has always enjoyed both popularity and critical acclaim when featured in either one-man retrospectives or group exhibitions. And, as will be shown in yet a later chapter, Barlach's dramas were frequently performed during his own lifetime, during the so-called Barlach renaissance in leading German theaters during the early and middle 1950s (Chick, 1967: 121), and during a similar resurgence of interest in Barlach's pieces during the middle 1960s.

As may be expected, Barlach's works have not only enjoyed popularity with the public but have constituted the focus of innumerable scholarly articles and books. In 1961, Richard Brinkmann claims that with regard to expressionist authors, "a wealth of literature is available on Ernst Barlach. It is exceeded in volume only by research on Trakl" (1961: 65). Such a rich tradition in scholarship continues, as Rosina-Helga Schöne van Dyck remarks in 1976: "Barlach's life and works are discussed in an almost incalculable number of works" (1976: 5). Furthermore, the quantity of analyses is about equal vis-à-vis Barlach's literature and his visual art. In sum, it cannot be decisively stated that Barlach is better known or more highly regarded as a sculptor, graphic artist, or literary figure. He must be viewed as a *Doppelbegabung* and his works must be studied in this context.

Despite the large number of studies that concentrate on Barlach and his works of art, some scholars still conclude that nothing can be gained from an analysis of the relationship between Barlach's works in different media. Klaus Günther Just admits that Barlach was a true *Doppelbegabung*: "Barlach is one of the very few multiple talents to have produced works of equal significance in two fields" (1975: 459). And yet, Just then contends that to write and to sculpt are two different and hence unrelated activities: "To produce sculptures and to write dramas are two different things" (1975: 460). Such a premise, he feels, necessarily leads to the following conclusion: "Here we are neither faced with *Gesamtkunstwerke* nor with cases where a mutual illumination of the arts can be of assistance" (1975: 461). Since Just intends from the outset to write only about Barlach's dramatic works and his essay appears in Benno von Wiese's book entitled *Deutsche Dichter der Moderne: Ihr Leben und Werk*, this conclusion, unsupported by further evidence or explanation, provides an excuse for ignoring Barlach's works in the visual arts. Edson Chick, who also writes only about Barlach's literary works, agrees with Just about the need for separate discussions of Barlach's works in literature and in the visual arts: "A discussion of [Barlach's] sculpture and graphic work . . . would only obscure the view of his plays and novels" (1967: 7). And yet, Chick's assertion, like Just's, is not

supported by example or detailed explanation and thus remains unfounded. One of the main tasks of this study will be to demonstrate the inadequacies of such claims that Barlach's works of literature bear no resemblance to his works in the visual arts.

Nonetheless, at least Chick and Just address the issue of interart relations. Most scholars of literature, unfortunately, almost totally ignore Barlach's efforts in the visual arts. Likewise, historians of the visual arts seldom include more than cursory remarks about Barlach's works of literature. Attempts to relate Barlach's works in various media are surprisingly rare. As van Dyck comments: "A review of publications reveals conspicuously few comparative and analytical discussions of Barlach's total oeuvre" (1976: 6). For example, one expects that a demonstrable relationship among Barlach's works in various media will be detailed, if only in general terms, in critical biographies, as such studies usually assess both the life and the accomplishments of a person. And yet, the issue of a relationship is usually skirted by Barlach's biographers. Exceptions to this generalization include anecdotal accounts, like Friedrich Schult's *Barlach im Gespräch* (1948), personal memoirs, like Karl Barlach's *Mein Vetter Ernst Barlach* (1960) or semifictional books, like Ilse Kleberger's *Der Wanderer im Wind—Ernst Barlach* (1984). And yet, such publications are of little value, as they tend to be poorly documented and as much imaginative as objective in their renderings of people and events and in their discussions of works of art.[2] More objective assessments of Barlach's life and works include a number of monographs that are profusely illustrated and yet are so basic as to appeal more to the general public than to the scholar, including those written by Carl Dietrich Carls (1931, 1950, 1969), Alfred Werner (1966), Günter Gloede (1966), Naomi Jackson-Groves (1972) and Franz Fühmann (1964, 1970). The authors of these sources often identify a relationship between Barlach's works in literature and his works in the visual arts and yet always fail to come to terms with it. Alfred Werner, for example, in *Ernst Barlach* (1966), writes that of all of the German expressionist visual artists that had literary talent, "none had so clear a . . . double gift as Barlach" (53). Werner further acknowledges that there are indeed relations between Barlach's works of literature and his works in the visual arts. He nonetheless explains that a discussion of these relations would be beyond the scope of his book:

> While the literary contributions of [most expressionist artist-writers] may be treated in a paragraph or two as the side lines of professional artists, a chapter is not enough to deal adequately with the thousands of pages Barlach [composed].
>
> However, we will dwell here only briefly on Barlach the poet, dramatist, writer of letters, essays and narrative prose. For one thing the chief task of this volume is to introduce Barlach's sculptures, drawings and prints to the American public. Moreover, only a fraction of his literary work is available in English. (1966: 53)

If Werner wishes to introduce only Barlach's works in the visual arts to the public, he should not dwell for one chapter on Barlach's works of literature. In fact, Werner's treatment of individual dramas is not that much more cursory than his treatment of individual sculptures or drawings. Furthermore, English translations of Barlach's writings have little to do with analyses of the originals. In sum, Werner claims relations between Barlach's works of literature and his works in the visual arts but does not elaborate on them.

Like Werner, Carl Dietrich Carls, in the various editions of his *Ernst Barlach: das plastische, graphische und dichterische Werk*, acknowledges similarities among works by Barlach in various media without going into specifics. Carls's remarks on the matter of similarities, which have been expressed since the first edition of his book appeared in 1931, are most succinctly formulated in the English translation of the eighth edition:

> For a long time Barlach vacillated between the visual arts and writing, undecided as to which offered him the better chance of self-expression, when he suddenly reached the most unexpected decision of doing both—sculpting and writing. Both sprang from the same source and contained the same elements, only in different forms. He did not mix the two art forms and did not seek to remove the line that divided them. He never lost sight of their individual laws. He did not let literary ideas infiltrate his sculptures, nor are his plays the recorded voices of his plastic figures, and, most important, he was not one of those theatrical versifiers who nursed some nebulous ideas about "total art." However, there is no denying that there exist connecting lines between his sculptures, drawings, and writings. Everything he did bears the mark of an unusually strong personality whose astonishing gifts were channeled to present the image of man and his world in one focal point, in an existential experience. (1969: 51)

(To confirm that there is no change in Carls's original point of view, compare Carls, 1931: 33–36 and Carls, 1950: 51–52 to this passage.) One can see that Carls theorizes only vaguely about the relation between Barlach's works of literature and his works in the visual arts and that there is thus a definite need for more specific commentary about certain claims that are made. For example, Carls writes that Barlach's sculpture and writings contain "the same elements, only in different forms." What are these elements, and what are these forms? Also, Carls mentions that a line separates the two art forms and that each art form has its individual laws. What is the nature of this line, and what are the specific laws particular to each art? Furthermore, Carls contends that Barlach was not "one of those theatrical versifiers who nursed some nebulous ideas about total art." What are these nebulous ideas, and how do they differ from Barlach's views about the relation between literature and the other arts? Carls does, however, astutely remark that there are lines that connect Barlach's sculptures, drawings and writings. And yet, why does he never state what these lines are? Carls concludes that Barlach's works "bear the mark of an unusually strong personality." Does this imply that the heart of the issue of *Doppelbegabung* lies

in the exploration of the creative artist and not in his created works? In sum, Carls never addresses the questions raised by many of his claims, and he thus does not satisfactorily address the issue of the relation between Barlach's literature and art he has identified.

Monographs that critically assess both Barlach's life and his complete body of works and that are more detailed and more thoroughly researched than the aforementioned general overviews include those written by Naomi Jackson (1950), Paul Fechter (1957), Willi Flemming (1958), Hans Franck (1960) and Catherine Krahmer (1984). These scholars agree that Barlach must be acknowledged both as an important visual artist and as an important literary figure. As such, each scholar devotes equal space to reviews of Barlach's achievements in the various media. And yet, none satisfactorily addresses the issue of relations between Barlach's works of literature and his works in the visual arts.

Franck, in *Ernst Barlach: Leben und Werk* (1961), draws no definite parallels between Barlach's works in one medium and those in other media. He is more concerned with sketching biographical and historical details than with discussing the formal or thematic details of the works themselves. Krahmer, in *Ernst Barlach: mit Selbstzeugnissen und Bilddokumenten* (1984), like Franck, tends to be concerned more with biographical and historical details than with the works themselves. She seems less interested in documenting similarities among Barlach's works in literature and those in the visual arts than with revealing differences. For example, she remarks: "In contrast to his literary production, Barlach's plastic endeavors do not know the unfinished; in fact it is ruled out" (49). In another passage, she notes: "In the literary works [one finds that] the urge to create, if not to complete . . . , is surely more pronounced than in the plastic works" (47). Clearly, however, there are more similarities among Barlach's works than there are differences (and I would dispute Krahmer's claims above at any rate), and one wishes that Krahmer would concentrate on them.

The first chapter of Paul Fechter's monograph, *Ernst Barlach* (1957), is promisingly entitled "The Problem of the Multiple Talent" ("Das Problem der Doppelbegabung"). In this chapter, however, Fechter spends too much time philosophizing in vague terms about the history of mankind and too little time discussing how Barlach and his works help to define better the issue of *Doppelbegabung*. Fechter traces through the centuries the trend away from unity towards specialization that he feels now pervades all aspects of modern man's existence. He writes about the history of art: "The original unity of . . . the magic that one calls art is now divided as are the worlds of thought, research, and knowledge" (7). On the apparent fate of the individual artist, he reflects: "The original unity of the artist disintigrated into . . . individual talents and individual fields" (8). And yet, Fechter argues, if one looks closely at the great artists of the past, one discovers that most were active in more than one artistic medium and

for the following reason: "simply because man is a whole and is not merely an agent of any single inner tendency" (10). Fechter mentions that although one cannot divide what in a person is indivisible, namely the spirit of creativity, or "das Kunstwollen," scholars nonetheless tend to make the various artistic abilities of *Doppelbegabungen* the objects of separate studies. A case in point, he feels, is the way in which E.T.A. Hoffmann is approached: "The specialized investigations of the nineteenth century led scholars to consider separately Hoffmann as writer, as draftsman, as musician" (11). What one should instead strive to fathom, if one is to better understand works of art, according to Fechter, is the unified nature of the creative psyche of an artist which underlies all his artistic efforts (12). Fechter thus proposes to detail Barlach's essence, unity, spirit, structure, core, his spiritual attitude toward the world, that is, his "Wesen," "Einheit," "Geist," "Struktur," "Kern," "seine geistige Haltung zur Welt" (14). In addition to revealing that Fechter uses terms that are, as Richard Brinkmann has already noted, "too long-winded and inexact, too uncontrollable" (1961: 67), it becomes clear that Fechter, in the first chapter of his book, is primarily concerned with unity as it relates to Barlach the man, and not with unity as it relates to his works. And yet, such a concern proves to be a methodological error, since, as I have shown, the study of a person's psyche is a task best left to the psychologist. Thus, although Fechter may advance the understanding of Barlach's life, he does not further the discussion concerning the relation between Barlach's works of literature and his works in the visual arts.

Flemming, in *Ernst Barlach: Wesen und Werk* (1958), like Fechter, shifts the focus of study away from the thematic and formal features of works of art to, as two chapters are entitled, the "Personality" and "World-View" of the artist, Barlach, who created the works:

> The creations of an artist do not stand isolated from and unrelated to each other. As his children, they have something in common. It is more than an outward similarity; a picture of a man shines through them all and is what connects them. They arise out of the profound experiences of their creator, out of his experiences and suffering, struggles and premonitions. Because after all . . . all art is a result of the self-reflections of a person and his interpretation of . . . the significance of his existence. Thus it is appropriate to arrive at an understanding of Barlach the man ["ein Menschenbild"] and then see how he is reflected in his [works]. (Flemming, 1958: 235)

Clearly, however, the critic of literature or art should be primarily concerned with art works, especially if he wishes to document relations between works in two different artistic media.

Studies whose primary purpose is to reflect upon relationships between Barlach's works of literature and in the visual arts are rare indeed. The best example of such an attempt remains Naomi Jackson's dissertation, *Ernst Barlach: The Development of a Versatile Genius* (1950). Although a wealth of

primary material has been published since her dissertation was completed, including the oeuvre catalogs, the unfinished drama *Der Graf von Ratzeburg* and two volumes of letters written by Barlach which give support to understanding Barlach as a multiple talent, Jackson nonetheless correctly concludes that one must view Barlach's works in one medium in relation to his works in other media. Furthermore, she recognizes that it is productive to consider Barlach's individual works in light of his total oeuvre:

> Only when Barlach's work is viewed in its entirety can the significance of the individual parts be fully appreciated. How infinitely richer the understanding of his sculpture becomes when studied in context with his dramatic work; how much broader the comprehension of his dramas, when elucidated by viewing his plastic and graphic productivity with which they are connected so intimately. (1950: 526–27)

In her dissertation, Jackson proceeds chronologically, in contrast to most other critics who, she asserts, tend to proceed as follows:

> [They] select certain works and arrange them according to a preconceived pattern, such as the violent versus the peaceful . . . , without observing any special chronological sequence, on the assumption that spiritual affinites between particular works of different years [are] more important than the accident of birth. (1950: 155–56)

By studying Barlach's works in the order in which they were created, Jackson hopes to trace their characteristic thematic and formal features. Jackson's assumption that one can trace patterns of development by proceeding with a chronological analysis of Barlach's art works will be supported by the findings of this present study. However, her decision to trace as many of the themes, forms and ideas as she can identify (1950: 156) in Barlach's works proves problematic, because she can not do justice to them all. Jackson's dissertation is filled with valuable insights regarding individual works, but it lacks a clearly stated thesis and thus a coherent and straightforward argument that would tie together the various chapters, excurses, and appendices.

Furthermore, although Jackson does trace, with varying degrees of proficiency, both thematic and formal developments within a particular medium, such as the appearance of the father-son theme in the dramas or the use of tall, severely columnar shapes in the sculpture, she mentions for the most part, and only in passing, only apparent thematic similarities among works in different media. Jackson writes, for example: "There are at least six sculptural works between the years 1909 and 1918 whose symbolism moves in the same orbit as that of [*Der arme Vetter*]" (1950: 231). And yet, what this symbolism proves to be is never discussed. She remarks in another passage: "[*Mutter und Kind* (1920), a relief,] in content and spirit finds a close parallel to the woodcuts and situations in *Der Findling*" (295). Jackson will often intuitively sense a general

relation among works in different media, based on an analysis of subject matter; rarely, however, will she identify the specific formal features or signs in the art works themselves that generate this sense of similarity. Thus Jackson does not propose a system of signification rules which allow signs to acquire meaning. In sum, most of Jackson's findings are due to her keen sense of observation and not to any kind of methodological precision.

Furthermore, as is generally recognized by scholars who write on trends and prospects in critical theory and methodology in the field of "Literature and the Other Arts," thematic or subject-matter-based similarities between works in different artistic media prove difficult to discuss in methodologically sound terms. Many interart critics, including James D. Merriman (1972: 161–63; 1973: 310–14) and Ulrich Weisstein (1981: 23; 1982: 260) note that while "the category of subject matter or content has often seemed to be the ideal feature on which to base claims of similarities between the arts" (Merriman, 1972: 161), it, that is, "interdisciplinary *Stoffgeschichte*," proves to be "a game of infinite variety, often indulged in for its own sake and likely to bring results that are out of keeping with the time and effort spent on its pursuit" (Weisstein, 1981: 23). What emerges in such studies that identify thematic similarities in works done in different media are, at best, merely "parallelisms" (Weisstein, 1982: 260; Merriman, 1972: 161). And indeed, Jackson's pursuit of thematic similarities among Barlach's works in various artistic media does primarily yield parallelisms, as can be seen by the above-cited examples. These parallelisms are furthermore rarely explored in depth. If there does prove to be a valid similarity between *Mutter und Kind* and *Der Findling*, for example, it will be because the formal characteristics of the two works bear a resemblance to one another.

Unfortunately, almost all studies that mention, however briefly, relations among Barlach's works in different media engage in the pursuit of what Weisstein refers to as "interdisciplinary *Stoffgeschichte*." The conclusions that are drawn in such studies (and they are rare in any event) are thus of little value because they lack a sound methodological foundation.

On the other hand, studies that have significant methodological value, and to which frequent reference will be made in the upcoming chapters, are those in which formal characteristics of Barlach's works are discussed, that is, those studies in which Barlach's use of language and of line and form are detailed. However, as such studies generally focus on formal characteristics that prevail in Barlach's works in one artistic medium and not in their relation to formal characteristics that prevail in works in other media, they will not be discussed at this point. One of my tasks, however, will be to relate those significant insights arrived at by scholars regarding formal characteristics pertinent to one medium with those pertinent to another medium.

In chapter 1 I concluded that the primary tasks of any study of a *Doppelbegabung* would be to identify signs in the works of the artist, to trace a system of

signification rules which allow these signs to acquire meaning and to interpret these signs and signification rules as symbols that belong to a personal and yet coherent philosophy of expression. In chapter 3 I will discuss the intermediary figure, one of Barlach's most frequently occurring motifs. Its formal development will be traced and its symbolic significance determined. The validity of the thesis that Barlach's works in one medium bear resemblence to his works in other media will be demonstrated according to an argument that is methodologically sound. Let us now turn to an examination of features, that is, signs, that characterize Barlach's graphic and plastic works.

# 3

# The Identification and Interpretation of Icons and Symbols: Barlach's Intermediary Figures in the Visual Arts

The majority of Barlach's most refined plastic achievements were executed during the decade preceding the Nazi ascent to power in 1933. Paul Fechter, one of the many critics who support this contention, remarks that the artist was then "in full possession of all of his artistic abilities, that is, master of both his ideas and the possibilities for realizing them [through art]" (Fechter, 1957: 166–67); and Fechter says of this period in Barlach's artistic career: "It was a time when Barlach both branched out beyond and yet also built upon the efforts of previous years" (1957: 170).[1] The public's awareness and acceptance of Barlach's endeavors, both plastic and literary, increased dramatically during the mid-to-late-twenties and early thirties. Concurring with Fechter, Elmar Jansen considers the period between 1924 and 1932 to have been the one during which "Barlach's work experienced the greatest public response before the outbreak of the Nazi-era" (1972: 31). In support of this finding, one notes, for example, that Barlach was featured in a number of major retrospectives. One-man exhibitions were arranged at the following galleries and institutions: Galerie Paul Cassirer, Berlin (1926); Preußische Akademie der Künste, Berlin (1930); Galerie Alfred Flechtheim, Berlin and Düsseldorf (1930); Folkwang-Museum Essen (1930); Kunsthalle Kiel (1930); Kunstverein Hamburg (1931); Kestner-Gesellschaft in Hannover (1931) and Kunsthalle Bern (1934). General exhibitions which featured prominent displays of Barlach's works were organized in such cities as Berlin, Dresden, Zurich, Lucerne, Venice, New York and Chicago.[2] Important public monuments Barlach was commissioned to execute in Güstrow (1927), Kiel (1928), Magdeburg (1929), Hamburg (1931) and other cities provide further evidence of Barlach's popularity and prestige. In addition, lucrative private commissions Barlach received also resulted in a number of major sculptures, most important among them *Der Fries der Lauschenden*. Moreover, as will be detailed in the next chapter, Barlach's plays were regularly performed by respected theatrical organizations in Germany and discussed in prominent newspapers and literary journals.

It would take only a few years, however, for the accolade Barlach and his works had enjoyed to be replaced by widespread public disclaim. The reader is referred to appendix A for a discussion of the consequences this disclaim had for Barlach, the sculptor. Barlach's artistic activity, while severely limited after Hitler's takeover of power in 1933, was not totally squelched, as is evidenced by the series of drawings entitled *Übungen der leichten Hand* (1935). Friedrich Schult concludes his introduction to the *Werkkatalog der Zeichnungen* (*Schult III*) with the following remarks concerning *Übungen der leichten Hand*: "As early as the summer of 1935, what Barlach the sculptor was no longer allowed to execute was entrusted to Barlach the draftsman. . . . The result was a cycle of figures of great significance and quality which surmounted the times during which they were created" (13).

Nonetheless, *Übungen der leichten Hand* demonstrates that Barlach, although still in possession of his sculpting talents, was compelled to concentrate on other, less overt, avenues of expression during the Nazi era. In this respect, one also finds that energy was expended by Barlach during these years on two literary endeavors: *Der Graf von Ratzeburg* and *Der gestohlene Mond*. Neither work was completed; both fragments were first published posthumously. These literary pieces will be considered in detail in the next chapter.

As mentioned, many of Barlach's most mature plastic endeavors were conceived between 1924 and 1932. A significant number of these mature works reveal solutions to problems of expression which occupied the sculptor through-out his long career. And yet, very few studies concentrate on the formal aspects of these mature works. Thematic statements of individual pieces are discussed, although, as I showed in chapter 2, there are few systematic attempts to relate themes conveyed by the body of sculpture to themes common to Barlach's dramas and prose. As van Dyck noted, "A review of publications reveals conspi-cuously few comparative and analytical discussions of Barlach's total oeuvre" (1976: 6). Thematic comparisons of works in differing media, at any rate, prove difficult to discuss in terms that are methodologically sound, as I also discussed in chapter 2. A more solid foundation for a comparison begins with an analysis of formal elements. In this chapter, certain significant formal attributes that char-acterize one of Barlach's most frequently occurring motifs, that of the intermedi-ary figure, will be traced and their symbolic significance identified.

The *Güstrower Ehrenmal*, an intermediary figure as will be shown, is one of Barlach's most famous and most innovative sculptures. It is also one of his few true bronzes. Isa Lohmann-Siems correctly asserts that the mature Barlach considered himself primarily a wood sculptor; basing her insights on analyses of documents, for example, statements made by Barlach and formal criteria, she concludes: "Very few of Barlach's artistic ideas were originally intended to be realized in bronze (for example, *Der singende Mann*, *Das Güstrower Ehrenmal* and *Der Geistkämpfer*)" (1975: 26). Lohmann-Siems justifiably cautions against

analyzing bronze versions of most other figures and maintains that they "hardly correspond to the artist's original plastic designs, generally conceived for execution in wood" (1975: 24). This finding is well supported by Lohmann-Siems's examination of formal features exhibited by the various versions of *Der Flötenbläser* (1936) and by the instructive illustrations that accompany her article:

> A comparison of model, plaster, bronze and wood yields striking information. Whereas in the soft plaster, [Barlach] achieves delicate, distinct, and persuasive effects— which are articulated without becoming their negatives when transferred to wood—in the bronze, such fundamental variations are produced that one misses the controlling eye of the artist. The glaze of the plaster depends on the differentiations in the treatment of surfaces. The varying smoothness and roughness of the surfaces of the face, the hands, and the clothing of the figure is, as it were, in accord with . . . Barlach's unique artistic exploitation of the organic quality of the wood. The plaster casts and the wood sculpture are therefore quite comparable. . . . Nevertheless, the bozetto may . . . be considered a preliminary stage for the wood version. This is not true for the bronze. Also, the simple fact that plaster casts of the model are truer to the artist's hand than bronze castings . . . requiring retouching by secondary finishers, illustrates in a particular manner the "status" of the plaster and bronze casts. Even if bronze, as a material, is more valuable and resiliant than plaster, it nonetheless has particular expressional qualities that must be placed in relation to the intentions of the artist. This material speaks so loudly and clearly that it eclipses all differentiation in the wood, already evident in the plaster. The delicate nuances of expression in the head, the smooth slurrings of the physiognomical features, which definitely belong to this subject, are engulfed and coarsened, for bronze distributes its reflections evenly over large areas and details. Strictly speaking, only the overall form remains. (1975: 28)

In a related matter, it should be noted that controversy currently surrounds the Barlach estate's recent decision to cast bronze sculptures using as molds copies of original plaster working models. I must agree with those scholars, including Eduard Beaucamp and Ursel Berger, who object to such a practice (cf. B[eaucamp], 26 April 1984; Beaucamp and Barlach, 22 May 1984; and Berger, 13 June 1984). Comments by these critics (Beaucamp writes for the *Frankfurter Allgemeine Zeitung* and Berger directs the Kolbe Museum in Berlin), the aforementioned article by Lohmann-Siems, and later remarks in this present study conclusively demonstrate that, generally speaking, little is to be gained by casting from working models. One almost always finds that Barlach makes significant conceptual alterations vis-à-vis a working model and the final sculpture. Barlach himself writes in a letter: "I consider an exact model to be a dangerous matter, for one would commit oneself to things for the final version which have only proved suitable for other conditions regarding size and materials. In wood, a work appears quite different than it does in plaster" (27 June 1912; *Briefe I:* 402). With few exceptions, the public is now being misled to think that the recent castings, done in significant numbers (Berger, 13 June 1984), truly reflect Barlach's artistic intentions. Berger capsulizes the attitude

held by most experts on Barlach's works: "There is no question that the work of Ernst Barlach will appear quite different—diluted, falsified, distorted—upon completion of the 'posthumous production'" (Berger, 13 June 1984).

In contrast to the controversy that surrounds the recent castings in bronze based on plaster working models, most scholars, including Isa Lohmann-Siems and Maike Bruhns (1978: title page), agree that the *Güstrower Ehrenmal* as a bronze remains true to the artist's original conceptions. The *Güstrower Ehrenmal* was placed in the memorial chapel of the Güstrow cathedral in 1927. The pastor in Güstrow at the time, Johannes Schwarzkopff, with whom Barlach was well acquainted, recalls in an entry written for Elmar Jansen's *Werk und Wirkung* (1972) that Barlach had rejected the idea of a monument to be placed in front of the cathedral, as suggested by members of the congregation (he felt it would have ruined the architectural integrity of the building) and also had been unable to conceive of a suitable subject for a relief, his own first choice (in: Jansen, 1972: 265–66).[3]

A brief description of the memorial and what it commemorates is provided by Friedrich Schult in a review written in 1928:

> A bronze angel . . . hangs here in memory of the faithful of the cathedral who were killed in action. . . . An old, long-abandoned wrought-iron railing, now graced with new meaning, encloses the space below. In the center, a flat, round stone bears only the dates, 1914–1918, in commemoration of those four endless, heroic, and anguishing years. The threatening figure floats, balanced stiffly and motionlessly, chained to the keystone of the vault; it rests, solemnly, peaceful in its enormity, eyes closed, hands crossed and drawn tightly to its breast, conjured from a higher world, suspended as a sign of mourning . . . above thousands of victims.[4]

Barlach thought highly of this description, calling it "extraordinarily sympathetic" and "articulate," and transcribed it almost verbatim in a letter to Karl von Seeger, a scholar who was writing a book on war memorials which was subsequently published as *Das Denkmal des Weltkrieges* (1930) and who had asked Barlach for commentary on his own various war memorials (6 February 1929; *Briefe II:* 150).

The above remarks by Schwarzkopff and Schult which describe the project in Güstrow are interesting from an historical standpoint. More concretely, and to return to the issue of formal features, however, the monument's origins can be traced to a sketch done on June 27, 1926, #1848, to drawings completed on October 22, 25 and 27, 1927, that is, #1849 through #1857, "Entwürfe zum Güstrower Mal" (although Schult mentions only those drawings from the 22nd and 27th of October [*Schult I:* 186]), and to the plaster and bronze *Vorentwürfe* and *Vormodelle*, #332 through #335, also executed in 1927. The relation of these versions of the floating figure to the final bronze will be investigated in the course of this chapter.

The aforementioned preliminary sketches, *Handzeichnungen,* to the *Güstrower Ehrenmal* from 1927 (#1848–57) merely signify the emergence of Barlach's preoccupation with the specific project in Güstrow. His interest in thematic, stylistic and formal elements prevalent in these plans, however, can be traced back many years. Indeed, the *Güstrower Ehrenmal* represents a summing up, a synthesis, an end product.

Stylistic and formal elements of the *Güstrower Ehrenmal* indicate solutions to or the coming to terms with certain problems of expression with which Barlach was concerned for many years. Thus, the bronze can be viewed in its relation to many previous plastic works. The consequences of the developmental process that culminates in the *Güstrower Ehrenmal* must be fleshed out so that a relation between Barlach's literature and art can be formulated.

The ensuing discussion will demonstrate that as Barlach perfects his conception of a floating figure, *eine schwebende Figur,* the formal features associated with the garment, *Gewand,* and the face or head evolve from signs that function primarily as icons to signs that function primarily as symbols, that is, from where there is a resemblance between signs and objects, a sharing of putative properties, to where there is signification without motivation, through conventions and rules particular to Barlach's "philosophy of expression," as Eco understands this phrase, there being no immediate or direct bond between signs as symbols and objects.

The *Güstrower Ehrenmal* is a floating figure, a figure suspended by chains which are anchored in the keystone of a Gothic vault. One locates a multitude of floating or ascending figures among Barlach's drawings.[5] Some of these drawings form the bases for later graphic or plastic works; others do not. In a similar manner, many of Barlach's plastic figures are airborne or appear to be so.[6] Barlach succeeds in synthesizing differing aspects of these related efforts (drawings, reliefs and sculpture) in the creation of the *Güstrower Ehrenmal.* Barlach's preoccupation with the motifs of "floating" and "the floating figure" indicates that they serve an important function, a symbolic function as will be demonstrated, in his "philosophy of expression."

Stated in conventionally interpretative terms, a floating figure often occupies a position between man or earth, and God or the heavens. Frequently, as an intermediary, the floating figure functions as a messenger (apparently able to travel from one realm to the other), or as an angel.[7] In such works, as is generally acknowledged, one perceives that Barlach attributes a dualistic nature to existence: earth/heaven, man/God, etc.: "It is significant that one always takes up pairs of opposites to represent the effects of Barlach's world" (Fechter, 1957: 149).

*Die gemarterte Menschheit* (1919) reveals the nature of man's position between the two extremes of heaven and earth, "the exposure of the human

situation between heaven and earth" (*Prosa I:* 55). Helmut Gross describes *Die gemarterte Menschheit* in a context pertinent to this discussion:

> [This situation] results from the opposing powers which pull at the figure, the powers which make man into the "creature goodbad" ["Wesen Gutböse"]: the downward force, towards earthliness, the upward force, towards a higher destiny. The force which pulls downward is represented by an iron ball in the relief. . . . The force that pulls upward, on the other hand, is not visible, as the rope leads out of the relief. This shows . . . that the forces of the earth function overtly in the world, while the forces of the heavens remain hidden. (1967: 76)

Communication between the two realms is at times made possible by an intermediary—information from the beyond can be made comprehensible through a revelation transmitted by the intermediary figure, for example. This is found to be true in the graphic and plastic works as well as in the poetic works.

Floating figures, or intermediary figures, can appear as allegories. One such allegorical piece, as will be shown, is the *Kieler Geistkämpfer*, a sculpture which defines itself in the realm of Christian mythology, specifically the St. George legend. By contrast, many an intermediary figure defines its own significance within its own structure. Eco's distinction between allegory and symbol can supply one with the theoretical understanding of Barlach's signification process:

> [One] difference between symbol and allegory stands in this: that the allegory is more insisted upon than the symbol and, furthermore, that the allegory . . . should immediately suggest its own key; it should point toward a portion of encyclopedia which already hosts the right frames for interpreting it . . . , whereas a symbol leaves the interpreter face to face with the uncoded. Thus a symbol cannot send back to a previously coded cultural competence; it is ideolectical because it holds only for the . . . environment where it appears. (1984: 161)

Art works, regardless of medium, are composed of formal features, of signs. As I briefly mentioned in chapter 1, although in connection with a different matter, the notion of "sign" is here to be understood as *aliquid stat pro aliquo*, or in C.S. Peirce's terms: "A sign, or *representamen*, is something which stands to some-body for something in some respect or capacity" (2.228). A sign in all cases, and thus in a work of art, is, as Peirce relates, "connected with three things[:] the ground, the object, and the interpretant" (2.229). These three concepts and the manner in which they are related is detailed by Peirce in the following passage:

> [A sign, or *representamen*] addresses somebody, that is, creates in the mind of that person an equivalent sign, or perhaps a more developed sign. That sign which it creates [is called] the *interpretant* of the first sign. The sign stands for something, its *object*. It stands for that object, not in all respects, but in reference to a sort of idea, which [is] sometimes called the *ground* of the representamen. "Idea" is here to be understood in a sort of Platonic sense." (2.227)

A sign is either an icon, an index or a symbol (Peirce, 2.304), depending on how it can be related via the interpretant to its object. Although Peirce explores

in great detail each of the three classes of sign, Robert Innis provides working definitions that will suffice for this study:

> *Indexes* . . . signify by existential or physical connection with their objects.
> *Symbols* signify without motivation, through conventions and rules, there being no immediate or direct bond between symbols and objects. . . .
> *Icons* . . . are based on "resemblance" between sign and object as well as on a putative sharing of "properties." (Innis, 1985: 2)

Peirce writes that "a low barometer with a moist air is an index of rain; that is we suppose that the forces of nature establish a probable connection between the low barometer with moist air and coming rain" (2.286). Peirce furnishes the following example of a symbol:

> We speak of writing or pronouncing the word "man"; but it is only a replica, or embodiment of the word, that is pronounced or written. The word itself has no existence although it has a real being, consisting in the fact that existents will conform to it. It is a general mode of succession of three sounds or representamens of sounds, which becomes a sign only in the fact that a habit, or acquired law, will cause replicas of it to be interpreted as meaning a man or men. The word and its meaning are both general rules; but the word alone of the two prescribes the qualities of its replicas in themselves. (Peirce, 2.292)

Furthermore, although it will not be necessary in this study to make such fine distinctions, Peirce argues for three varieties of icon: images, diagrams and metaphors (2.277), whose characteristics are summarized by Wendy Steiner:

> A sign which substantially replicates its object, e.g., a model of a house showing doors, windows, and other house properties, is called an image; a sign whose relations replicate those of its object, e.g., a blueprint of a house, is called a diagram; and a sign that represents . . . the representative character of another sign through a parallelism, e.g., "snail shell" used for "house" to stress the house's protective nature, is a metaphor. (Steiner, 1982: 20)

There are problems, however, with Peirce's general theory of iconism, indeed with any theory of iconism that supposes that signs are to some degree similar to, analogous to, or naturally linked with their object. As Eco points out in his chapter entitled "Critique of Iconism" (1976: 191–217), one finds that not only in symbols but also in icons "a correlational convention is in operation" (191). Thus when one speaks of a similarity between a sign and an object, one is actually referring to a relationship between the image and a previously culturalized content (Eco, 1976: 204). In his recent article "Resemblance, Signification, and Metaphor in the Visual Arts" (1985), James A.W. Heffernan writes that there are two opposing views regarding the relation between an icon and its object. On the one hand, scholars such as Peirce, E.H. Gombrich and Jonathan Culler claim that icons signify by natural resemblance. On the other hand, critics such as Eco, Nelson Goodman and Wendy Steiner contend that icons signify due to inculca-

tion and thus "depend at any time entirely upon what frame or mode [of representation] is then standard" (Goodman, 1976: 38). I accept the latter position, mainly due to Wendy Steiner's assessment of the situation:

> Considering the array of languages and other models of reality, and the changes in them throughout history, one could not argue for a fully iconic representation of reality through any sign system. All sign systems are conventional. But once a system is conventional, its artificiality is largely invisible, and the system is perceived as a model, a diagram of reality. A work of art that imitates a model of reality thus seems to be imitating reality itself. (1982: 30–31)

Nonetheless, as Heffernan astutely comments: "Whether or not resemblance itself is something we are taught to see cannot change the fact that we customarily *do* see it between certain kinds of pictures and what they represent" (1985: 173). There is no question that signs in certain of Barlach's works in the visual arts are iconic; that is, they resemble actual objects if not naturally then at least they conform to a model of reality readily accepted by most viewers. There is also no question that there are signs in certain of Barlach's works in the visual arts that are symbolic; that is they do not resemble actual objects or conform to a model of reality accepted by most viewers.

It is important to note, moreover, that Peirce did not consider these classes of signs—index, symbol and icon—mutually exclusive. On the contrary, all three aspects frequently or, he sometimes suggests, invariably, overlap and are co-present. As has been most recently noted by Umberto Eco, "[The] most skilled of Peirce's interpreters know . . . that never, in Peirce, does one meet a 'real' icon, a 'real' index or a 'real' symbol, but rather the result of a complex intertwining of processes of iconism, symbolization and indexicalization" (1985: 177). It is this awareness of overlapping or intertwining which will allow for particularly important remarks about Barlach's works of art. Clearly, one must now identify signs in Barlach's art works and attempt to understand how they function.

As is the case in *Die gemartete Menschheit*, Barlach often depicts those elements which constitute "the powers of earthliness," (die Kräfte des Erdhaften), by employing signs that a viewer can associate with elements he encounters in his everyday world, or as Eco might phrase it, these signs point toward a portion of a person's encyclopedia which already hosts the right frames for interpreting them. In consequence, such works or portions of works are interpreted with relative ease. Signs in this sense are essentially icons. Of more significance than Barlach's renderings of "die Kräfte des Erdhaften" are his interpretations of "the powers from above which only [operate] obscurely" (Gross, 1967: 76), of man's "clash with elementary, superhuman powers" (Bruhns, 1978: 23), including the *Güstrower Ehrenmal* and other intermediary figures. Such works contain signs that are symbols that most viewers can interpret only with difficulty. As Eco would phrase matters, these signs as symbols

leave most interpreters face to face with the uncoded. Here, in Peircean terms, there is no longer a resemblance between sign and object; rather, signs signify without motivation, according to conventions particular to Barlach's "philosophy" of expression. The sign as symbol is ideolectical because it holds only for the environment where it appears. As Eco exlains further:

> In the modern aesthetic perspective the artist is a detonator of a vision that he himself produces: an expression purposefully endowed with vague meanings and that cannot be anchored to a preestablished code (there is no fixed explanation). The poetic work remains *open.* . . . [Modernist] symbols are *private;* they do not need a *Physiologus* to explain their possible meaning. They acquire their full significance only within their poetic context. . . . [E]vents, gesture, things suddenly appear as strange, inexplicable, intrusive evidence within a context which is too weak to justify their presence. So they reveal that they are there to reveal something else; it is up to the reader to decide what else. (156)

Thus, a thorough exposition of the intermediary figure, that expression purposefully endowed with vague meanings and not anchored to a preestablished code, to which Eco refers, as it appears in Barlach's oeuvre is necessary, if its full symbolic significance within Barlach's "philosophy" of expression is to be explained.

The viewer should feel "uneasy" in the presence of floating figures in Barlach's oeuvre, primarily because they appear to have acquired so much importance. As Eco notes:

> The standard reaction to the instantiation of the symbolic mode should be a sort of uneasiness felt by the interpreter when witnessing an inexplicable move on the part of the text, the sentiment that a certain word, sentence, fact, or object should not have been introduced in the discourse or at least not have acquired such an importance. The interpreter feels a *surplus* of signification since he guesses that the maxims of relevance, manner, or quantity have not been violated by chance or by mistake. On the contrary, they are not only flouted, but—so to speak—flouted dramatically. (1984: 158)

As Barlach's conception of what a floating figure is to signify becomes more sophisticated, we see that such figures increasingly come to violate expressional maxims. Thus the viewer feels an increasing surplus of signification. And yet, he knows that signs as symbols relate to ideas that become evident, if the broader context in which the signs occur is more fully understood. Eco writes in this regard:

> In the modern aesthetic experience, the possible contents [of a symbol] are suggested by the co-text and by the intertextual tradition: the interpreter knows that he is not discovering an external truth but that, rather, he makes the encyclopedia [that is, one's universe of human culture conceived as structured like a labyrinth best imagined in the vegetable metaphor of a rhizome (Eco, 1984: 81–82),] work at its best. Modern poetic symbolism is a secularized symbolism where languages speak about their possibilities. (Eco, 1984: 163)

The full significance of intermediary figures can only be seen in their artistic context, that is, within Barlach's philosophy of expression. Nonetheless, even when one chooses not to realize the symbolic mode in interpreting floating figures, they remain endowed with sense on a literal or figurative level, as will be seen. This is also in accordance with Eco's views on the symbolic mode of expression: "The main characteristic of the symbolic mode is that the text, when this mode is not realized interpretively, remains endowed with sense—at its literal or figurative level" (1984: 163). Furthermore, this is one important way of differentiating symbols and allegories from metaphors. Eco writes:

> Symbols [and allegories] are different from metaphors. When facing a metaphor, the interpreter, in discovering that the metaphoric expression does not tell the truth, is obliged to interpret it metaphorically. . . . On the contrary, when meeting an allegory [or a symbol], the interpreter could also decide to interpret it in a literal sense. (1984: 161)

Thematic statements and formal features of Barlach's drawings are examined by Claus Virch in his dissertation entitled *Die Handzeichnungen Ernst Barlachs und ihre stilistische Entwicklung*, completed in 1951. Virch isolates two antithetical formal principles that occur "both simultaneously and in temporal succession" (215): a tendency toward the natural-organic ("das Organisch-natürliche") and a tendency toward the stylized ("das Künstlich-tektonische" or "das Starre, Gerade, Kantige"). The former propensity is characterized in drawings by "a smooth and flowing line" (215), presenting the subject "straightforwardly" and "objectively." In contrast, the latter tendency displays "straight, angular, or broken lines" (215), presenting the subject in a decidedly nonobjective manner and thus violating established representational maxims based on the principle of mimesis. Generally, however, the drawings reveal a synthesis of opposing tendencies, a "fusion of the tectonic with the organic, the blocklike of the intended form with the roundness of the human body" (215), which leads to an overcoming of Barlach's initial formal and thematic dualism. Icons and symbols are co-present in the same work of art.

Virch reasons that Barlach employs stylization ("das Künstliche-tektonische") and violates representational norms as a means of infusing the everyday occurrence, person, or thing with the qualities of spirituality or timelessness; "to elevate the natural to the spiritual, universal, and timeless" (215). Stylization is thus used to indicate the presence of either the allegorical or the symbolic mode of communication, as described by Eco and detailed earlier in this chapter. As support for his theories, Virch considers certain drawings detailing the conception of a monument commissioned by the city of Kiel in 1927 that resulted in the *Geistkämpfer* (1928): "The spiritual principle is to be easily discerned in the straight and clear touch, in the tectonically effective linearity of the champion of the spirit, while a smooth, rounded, and thus comparatively more organic play of lines serves to embody the natural, the arch-backed demon"

(215). Presented thematically by Barlach, as an allegory, is the motif of the fight between the forces of good and evil, of *Geist* and *Ungeist*. Actually, neither a fight nor a victory are actually depicted. Rather, the condition of eternal antagonism between two opposing forces is portrayed. In man, the forces of evil, the animalistic, and of good, the spiritual, are inextricably bound. The animal in the sculpture does not lie in defeat. Rather, his back is arched in defiance, in resistance. The angel, the force of goodness, of spirituality, however, stands poised for action, with raised sword.[8] Stylistically, stylization is associated with the angel, with *Geist*, and the iconic with the animal, with *Ungeist*.

Virch advances theories that need to be further developed, whose ramifications need to be more fully explored. His discussion of formal attributes inherent in the preliminary drawings for the *Geistkämpfer* substantiate his theories to a limited degree.

As yet another example relating to the iconic and the stylized, Virch mentions drawing #1005 (1912), which is listed by Schult as "Verdammte im Feuersturm," from the *Apokalyptische-Blätter* series and precursor to the lithograph entitled *Zwei Schwebende* (*Schult II: #97*, 1916).[9] Virch comments:

> The duality of formal possibilities is nowhere more directly or more clearly presented than in the drawing "Zwei Schwebende" [Schult listing: "Verdammte im Feuersturm"]. . . . The difference in presentation of the two figures has already been pointed out: while flowing parallel lines caressingly trace the soft, rounded forms of the woman's body, the man's body is enveloped by a stiff and angular garment which merely suggests his general bodily proportions, as in the narrowing of the hips. Even though the representation thus conforms to the organic, living appearance on the one hand, it creates an angular blocklike form on the other. (1951: 214)

It is debatable, however, whether "das Organisch-lebendige," that is, iconicity, is to be generally associated with women and stylization with man, as Virch surmises following the above passage. Nonetheless, two distinctly different styles do emerge, in concurrence with Virch's observations, one related to *Geist*, the other to *Ungeist*.

Virch's association of *Geist* with man and *Ungeist* with woman in Barlach's works is, to a degree, a valid one. Certainly, one does find negative portrayals of females, not balanced by negative portrayals of males, in a number of Barlach's relatively early works, most obviously in the drama *Der tote Tag* (1910) and the drawings and lithographs that are related to it, and in the sculpture *Sorgende Frau* (1910). For example, the mother in *Toter Tag*, as many critics have noted and as Karl Graucob writes, "exists only in the realm of the earthly. She neither considers nor recognizes spiritual striving, questions, or goals" (1969: 17). *Toter Tag* depicts the son's struggles to free himself from the earthly, the nonspiritual, that is, from the grasp of his mother, to achieve a sort of spiritual rebirth, a reunion with God, with his absent father. As Graucob summarizes:

The bond with the mother is physical and earthly. The reunion with God, here symbolized by the father-son relationship, is spiritual and is therefore the essential and the significant. It is only possible to approach the distant, unknown father (God) when the familiar has been left behind. . . . The inner struggle of the son . . . therefore becomes the inner struggle of mankind in general between the tendency towards spiritual rebirth and transformation on the one hand, and earthbound affiliation on the other. (1969: 21)

Barlach's male chauvinism is even more clearly revealed in his personal letters. He writes, for example: "Away from the maternal, the cajoling, the well-ordained, the mutually fulfilling, and on the whole . . . away from the eternally sexual" (22-28 April 1916; *Briefe I:* 480). Barlach does explain, however, that during the period he was working on *Toter Tag* and *Sorgende Frau*, there was at least one specific incident that fed his chauvinism, namely "my situation at the time as the father of an illegitimate child whose mother deceived and blackmailed me" (22-28 April 1916; *Briefe I:* 480). After a lengthy court battle, Barlach did win custody of the child. Barlach's negativism toward women in general might also have been further fueled by the fact that his own mother, towards whom he expressed ambivalent feelings, had come to live with him and remained until about 1920.

In any case, Barlach's unflattering portrayals of women are reminiscent of the ideas of Otto Weininger, in his pseudoscientific treatise *Geschlecht und Charakter: eine prinzipielle Untersuchung*, originally published in 1902. Like Barlach, as the aforementioned excerpt from one of his letters reveals, Weininger believed that women were primarily preoccupied with animalistic sexual instincts, in contrast to men, who were concerned with more spiritual matters: "The woman is devoted wholly to sexual matters, that is to say, to the spheres of begetting and of reproduction. Her relations to her husband and children complete her life, whereas the male is something more than sexual" (1911: 112; 1975: 88–89). Furthermore, a woman is supposedly incapable of thinking logically and does not possess an ego, in the Freudian sense, according to Weininger: "And so it appears that woman is without logic. . . . The absolute female has no ego" (1911: 191 and 240; 1975: 148 and 186). As in Barlach's *Toter Tag*, where the realm of the spiritual is associated with man and the nonspiritual with woman—"the sons of god are no children of mothers" and "it is only strange that man does not want to learn that his father is god" (*Dramen:* 19 and 95)—Weininger postulates the opposition between the man, a higher, spiritual essence, responsible (as geniuses) for all of the positive achievements in history, and the woman, a lower, animal essence, responsible for all that is negative (Schvey, 1982: 25–27, 35). Weininger himself writes:

Genius declares itself to be a kind of higher masculinity, and thus the female cannot be possessed of genius. . . . [G]enius is linked with manhood, that it represents an ideal masculinity in the highest form. Woman has no direct consciousness of it; she borrows a kind of

imperfect consciousness from man. Woman, in short, has an unconscious life, man a conscious life, and the genius the most conscious life. . . . [T]here is no female genius, and there never has been one . . . , and there never can be one. (1911: 142, 144, 242; 1975: 111, 113, 189)

The similarity between Barlach's views and Weininger's does not, however, imply a suggestion of definite influence by the Viennese psychologist. Nonetheless, as Barlach readily admits that he was aware of Freud's theories—"I am acquainted with the Freudian theory . . . , that is, I have read some short articles about it" (22-28 April 1916; *Briefe I:* 481)—it is not unlikely that Barlach was also familiar with the rudiments of Weininger's theories, which enjoyed incredible popularity, judging by the more than 25 printings of his *Geschlecht und Charakter* between the years of 1902 and 1930.

Certainly, Barlach's remarks on women must be viewed within the context of expressionism, where since the time of Strindberg and Munch there was a demonstrated fascination with the battle of the sexes, in, for example, Kokoschka's *Mörder, Hoffnung der Frauen* or *Sphinx und Strohmann*, in various articles by Karl Kraus, or in Schönberg's *Erwartung* or *Die glückliche Hand*, and where one encounters a deidealization of women, in, for example, Benn's poems "Mann" and "Englisches Café" or in his cycle of poems "Alaska." As Rainer Rumold notes:

At the turn of the century, a discussion which took many forms . . . ignited concerning the theme of woman which proved to have farreaching consequences for literature. Christian mythology had burdened the fine arts and literature with the ideal image of woman as the madonna, as the pure, saintly figure which corresponded to the view held during German classicism of the woman as the "ideal of humanity" (Iphegenia). This image of a woman, on the other hand, was flatly contradicted since Strindberg. (1982: 27)

*Toter Tag* and *Sorgende Frau* clearly are but two examples among many where expressionist writers and artists demonstrate a decidedly chauvinistic attitude toward women in society. And yet, Barlach, unlike Benn, for example, was to moderate, indeed to alter, his views on women, as will be demonstrated.

Floating figures that exhibit stylization, that exhibit signs that are symbols, can be located in numerous drawings.[10] Drawings #976–77 and 979 (1912), each entitled "Schwebender," depict floating figures whose long, flowing robes exhibit the stylization detailed in the discussion of drawing #1005 (1912), "Verdammte im Feuersturm." These drawings were clearly consulted by Barlach when he experimented with designs for *schwebende Figuren:* the drawings done in 1917 and, to an even greater extent, the preliminary models to the *Güstrower Ehrenmal* bear close resemblance to drawings #976–77, 979. The bronze *Güstrower Ehrenmal* (1928), however, exhibits significant innovation in the form of increased stylization. Differences will be discussed later. Many of the bronze's formal characteristics can be identified in a survey of those floating figures

exhibiting stylization. The *Güstrower Ehrenmal* represents the formal synthesis of the recurring *schwebende Figur* motif.

Drawings #976–77 and 979 (1912) are the earliest examples of stylization of formal elements applied to a floating figure. However, in drawings #878–79 from the same year, each called "Eingebung," where one earthbound figure and one floating figure is depicted, the opposition of stylistic tendencies is not yet introduced. The formal features of both figures, however, do not function symbolically. This iconicity of style characterizes most of Barlach's earlier plastic and graphic efforts.

After the year 1912, when #976–77, 979 ("Schwebender") and #1005 ("Verdammte im Feuersturm") were drawn, one identifies with increasing frequency that characteristic which Virch describes as "starr und kantig" associated with floating figures. Drawings #1204 (1917), "Armer Vetter und hoher Herr" and #1416 (1920), "Erschaffung Adams," exhibit the same dualistic tendencies Virch locates in drawing #1005. Drawing #1204 depicts one earthbound figure, drawn in a loose and fluid style with neither exaggerated nor distorted features, and one *schwebende Figur*, whose angular *Gewand* has been carefully executed. This figure's head, however, still appears in a quasinatural style as compared to the rigidity of the *Gewand*.

Similarly, drawing #1416 ("Erschaffung Adams") depicts God, wearing a stylized garment, in an awkward position that results in grossly foreshortened arms, breathing life into Adam, who manifests a decided absence of any tendency towards abstraction. Although hastily sketched, with a relative lack of development of secondary features, #1416 exhibits formal similarities to both #1005 ("Verdammte im Feuersturm") and #1204 ("Armer Vetter und hoher Herr"). God's head remains realistically portrayed, although it should be stylized, if the theory concerning the stylized depiction of representatives of *Geist* is correct. Barlach still limits stylization to the *Gewand* and, to a lesser extent, to torso configuration.

Floating figures in the following drawings exhibit this same stylization of garment eventually found refined and perfected in the *Güstrower Ehrenmal:*

| #1403 | (1920) | "Der erste Tag" (cf. also *Schult II*, #164) |
|---|---|---|
| #1404 | (1920) | "Die Dome" (cf. also *Schult II*, #165) |
| #1424 | (1920) | "Gestreckt liegende weibliche Gestalt" |
| #1446 | (1920/21) | "Der Flüchtling" |
| #1448 | (1921) | "Schmerzensmutter" (cf. also *Schult I*, #261) |
| #1722–23 | (1923/24) | "Grenzen der Menschheit" |
| #1848–57 | (1926) | "Entwürfe zum *Güstrower Ehrenmal*" |

A curious example of the opposition between the iconic mode of representation and the stylized is yielded by drawing #1417 (1920), "Bekenner und

Lästerer." The *Gewand* worn by the *Bekenner* is exactly as Virch describes the one worn by the man in drawing #1005 ("Verdammte im Feuersturm"): "The man's body is enveloped by a stiff and angular garment which merely suggests his general bodily proportions" (214). The triangularity, wider at the base of the garment and gradually tapering as the neck is approached, contributes to the pyramidal shape of the figure when viewed in its totality. The linearity of the facial features, pointed nose, sharply defined cheekbones, and straight-haired beard, are further examples of the angular stylization of formal features that characterize the *Bekenner*. The *Lästerer*, in contrast, resembles the woman appearing in drawing #1005. Whereas the *Bekenner* forms a pyramid, the *Lästerer* forms a sphere. The *Gewand* follows the portly contours of torso and limbs. Within the larger sphere formed by the *Lästerer* viewed as a totality, one identifies smaller spheres: the protruding belly, the round head (no hair, no beard), the balled fists, and even a round nose. Not one angular feature presents itself.

The religious ecstasy of the *Bekenner* is contrasted with the paganistic animalism of the *Lästerer;* the sublime is contrasted with the base, *Geist* with *Ungeist*. Certain formal features have become conveyors of thematic expression and indicate that Barlach's philosophy of expression is a coherent one. Since both figures are male in drawing #1417, Virch's association of *Geist* with man and *Ungeist* with woman is called into question. This theory may enjoy a degree of validity if applied to works created during the earlier years of Barlach's career, that is, from about 1906–19. And yet, any application of such standards certainly requires substantial modification to apply to Barlach's works of the mature period: female figures are positively portrayed in his later dramas and in *Fries der Lauschenden*, for example. The distinction between man and woman vis-à-vis *Geist* and *Ungeist* breaks down.

There is a third figure in "Bekenner und Lästerer": a crudely-sketched bearded man, outfitted with a flowing robe. Stance and facial features, as far as can be determined from the few lines that define the figure, indicate composure, as he appears to be watching the antics of the other two figures. Gross, in his analysis of the drawing, places an inordinate emphasis on this third figure and on the background, drawing conclusions that simply cannot be supported by what is actually depicted:

> It is a bearded old man, likewise clad in a long garment. He stands, hands joined in prayer, before a stone altar upon which an offering burns. He is perfectly still, in contrast to the two ecstatic figures in the foreground; he observes them, and his face is one of composure and kindness, knowledge and reverence. He is the essence of unobtrusiveness, as is clear from the stylistic treatment: he is not sketched succinctly like the other two, but rather inconspicuously, so inconspicuous that at first he is overlooked by the beholder.
>
> This praying man in the background is a believer in the true sense: not *beside* himself, as the two others, but *within* himself. And by being within himself he is within God. (1967: 37)

There is no indication that the third figure's hands are clasped in prayer, that the stone structure is an altar, or that there is a sacrificial victim. The third figure and the background are too crudely sketched (and I do not mean drawn) to support Gross's contentions. Furthermore, nothing in the drawing allows Gross to see the *Bekenner* as a "prattler," a "wheedler" as he does later (38). In a futile attempt to buttress an argument whose validity depends on the weak interpretation of the third figure, Gross introduces the following evidence:

> It can be seen that Barlach views the ecstatic exuberance of the confessor negatively, by contrasting it with a stylistically related portrayal: in the drawing, "Abraham und Isaak, zum Opfer bereit" [(1918), #1261]. In it, Abraham assumes a posture identical to that assumed by the confessor in "Bekenner und Lästerer": arms raised in prayer, face turned towards heaven. And yet, Abraham's posture is genuine and not ecstatically excessive. Although inwardly extremely agitated, he turns to God in devoutness and anxious fear. (1967: 37–38)

Abraham has little in common with the *Bekenner*—formally or otherwise. We cannot say that his "posture" is either "genuine" or "not ecstatically excessive." Again, no formal characteristics of the drawings support such exaggerated claims. And we have already documented that the formal features are primary elements of expression. Even without titles, one can interpret Barlach's message.

In any case, stylization, most clearly evident in the depiction of the garment, is associated with a decidedly symbolic mode of representation. Barlach's own remarks provide an excellent definition of his methodology, provide the reasons behind his decision to stylize formal features, to use signs as personal symbols:

> I [see] in man the damned, the bewitched so to speak, and yet also the primeval-essential, how am I supposed to portray that through common naturalism! I perceive something masklike in appearance and am tempted to look behind the mask. How am I supposed to keep to the details of the mask? But of course I am aware that the mask has evolved organically from the essential; and thus I am referred to the mask after all. I therefore had to find means of presenting what I felt and suspected, instead of that which I saw, and yet use what I saw as means nonetheless. (23 July 1911; *Briefe I:* 376)

This methodological statement is not, however, to be interpreted as a signal that Barlach embraced the formal techniques of stylization of, for instance, Wassily Kandinsky or Pablo Picasso. Barlach, who was presented a copy of *Über das Geistige in der Kunst*, originally published in 1912, by his close friend Reinhard Piper, writes the following about Kandinsky and his theories concerning nonobjectivity in art: "We could talk for a thousand years without agreement" (28 December 1911; *Briefe I:* 394). Kandinsky's innovative endeavors to reduce art to a universal system of signification is criticized by Barlach: "I cannot get mixed up with . . . an esperanto-art" (395). Barlach criticizes Picasso for similar reasons, referring to him as "an ornamental absolutist" (*Prosa II:* 374) and to his

art as "psychic geometry" (23 September 1915; *Briefe I:* 446 and *Prosa II:* 373). Barlach's own artistic language, his "artistic mother tongue," regardless of formal stylization, is rooted in the element of human experience:

> We must at all costs agree upon one language in order to understand anything at all. A person could say the most beautiful, glorious things in Chinese, but I would not even prick up my ears. If I am to relate to a spiritual experience, it must speak a language in which I can relive the deepest and most hidden things. My mother tongue is the most suitable for this, and my artistic mother tongue is the human form, or the milieu, the object, through which or in which man exists, suffers, is happy, feels, thinks. I cannot get past this. (28 December 1911; *Briefe I:* 395)

Thus Barlach expects others will find his art works accessible, because they are rooted in "the human form, or the milieu, the object, through which or in which man exists, suffers, is happy, feels, thinks." This accessibility of course often depends on a viewer's willingness to make his own "encyclopedia," that is, his universe of human culture, work at its best (Eco, 1984: 163), or it requires a viewer to associate with a sign a ground, or idea, that may not occur to him immediately.

Consequently, for Barlach, the more complex the symbolic nature of the subject matter, the more stylized the outward form. This is particularly true of the public monuments and of many of the sculptures done during the mid-to-late-twenties and early thirties. In this respect, Barlach searched for symbolic formal features that would help to determine the overall message conveyed by the *Güstrower Ehrenmal*.

Sculptures whose style tends primarily toward the iconic, or the "objective," will generally depict everyday persons or occurrences: *Schäfer im Sturm* (1908), *Sorgende Frau* (1910), *Der Einsame* (1911), *Der Spaziergänger* (1912), *Der Sammler* (1913). These sculptures are examples of nonsymbolic modes of expression. The "messages" these works convey can be easily exacted by a viewer because he is already familiar with the frames of reference. Nonetheless, if the signs that are present in these more objective, less symbolic sculptures are to acquire meaning, the viewer must trace a system of signification through an interpretive process that involves abductions. It is suggested that in arriving at an interpretation of a work whose style tends primarily toward the iconic, the viewer makes either overcoded abductions or undercoded abductions. Umberto Eco notes: "In over- and undercoded abductions . . . there are preexisting explanations of the same kind that have already proved to be plausible in other cases. In other words, in over- and undercoded abductions one uses explanations that already held for different results" (1984: 42–43). On the other hand, interpretive decisions involving symbols, and with most works containing intermediary figures this is what one has, necessitate creative abductions. Eco notes: "In creative abductions one is not sure that the explanation one has selected is a 'reasonable' one" (1984: 43).

Drawings displaying the motif of *schweben* (floating), however, have been admixtures of the iconic and the stylized, even when one would expect to find exclusively stylization (in "Erschaffung Adams," for example). Barlach does not appear to have been satisfied with these efforts, as one finds formal variations occuring even with respect to the same subject. Barlach will eventually embrace total stylization of *Gewand* and head; but what is meant by total stylization will have to be examined.

The design of a three-dimensional work—not to discount the significance of the drawings, in which the possibilities of the floating motif are explored—presented Barlach with a problem inherent to sculpture in general. Harald Seiler notes: "The floating-motif . . . is one motif within the sphere of the art of sculpture that is undoubtedly extremely difficult to formulate" (1961: 25). The relief, a *Zwischenstufe* combining elements of the strictly two-dimensional and sculpture-in-the-round, is one solution to the problem of giving plasticity to a floating figure. The relief seems to have functioned as the natural extension of the drawing for Barlach. Virch comments:

> Once Barlach has conceived his figures graphically by fixing their outlines in perspective as silhouettes in a plane, he [translates] this manner of seeing into three dimensions. . . . The medium of drawing is not, however, without its stylistic consequences: this creative process explains the relief-like appearance of all Barlach sculptures [that is the fact that they are best viewed from one specific angle ("Einansichtigkeit")]. (197–98)[11]

Drawings #976–77 and 979 (1912), each entitled "Schwebender," represent early stages in the evolution of the *Schwebende-Figur-Motif* which finds full development in the Güstrow memorial. Nonetheless, formal and stylistic features of these drawings and of drawing #1005 (1912), "Verdammte im Feuersturm," reveal the maturity of Barlach's graphic abilities vis-à-vis his plastic talents with relation to the portrayal of floating figures at this point, that is, around 1912. A comparison of these drawings with ones done earlier depicting the same motif reveals the tendency to eliminate distinguishing background or landscape, to stylize, in ever-increasing fashion, the garment and to experiment with body posture. In this respect, Barlach endeavors to minimalize those elements that are encompassed by the encyclopedic competence of most viewers.

*Die Vision* (1912), #120–23, a high relief, represents Barlach's first attempt to give three-dimensional form to a study centering on the motif of a floating figure. Thematically, *Die Vision* might be an outgrowth of the drawings done in the same year entitled "Eingebung" (#878–79), where a floating figure imparts information to a reclining figure. Stylistically, however, the floating figure of the relief, which is of interest here, is an attempt to give plastic form to drawing #797 (1911), "Zwei Schwebende," as Schult correctly perceives: "The upper figure is related to the group *Die Vision*" (*Schult III:* 107). As Barlach develops his conception of a floating figure, he makes formal adjustments. The

differences between drawing #797 and #976 (1912), "Schwebender" give indications of the refinements. *Die Vision*, it must be pointed out, is stylistically less advanced than drawings #976–77, 979. Formal innovations comparable to what is found in the drawings of this time are yet to come.

Paul Fechter in a detailed description of *Die Vision* (1957: 155–56) notes that the upper figure floats horizontally and that its body follows head and arms "like a cone, almost tapering off at the feet" (155). Side and front views of the floating figure, however, reveal the awkward attempt to give the illusion of a right arm and shoulder. The fully sculpted face is not directed straight ahead, but to the left, away from the background plane. If one stands in front of the relief *Die Vision*, one discerns the head which is not in profile, as the body's position would dictate, and the anatomically distorted right arm and shoulder configuration. Unlike the *Güstrower Ehrenmal*, *Die Vision* is a clumsy attempt to give three-dimensional form to a concept conceived and realized hitherto in but two dimensions. The formal logistics of depicting a floating figure have not been convincingly addressed. Barlach avoids the pure profile and develops both figures. And yet the dominating flat background prevents one from visualizing the floating figure in space. In this work, the depiction of *Schweben* largely depends on this background. The intermediate steps leading to the *Güstrower Ehrenmal* demonstrate why Barlach realized that a fully-sculpted floating figure would need to be freestanding. The implicit dualism (earthbound versus floating) of the *Güstrower Ehrenmal* is given explicit, that is, nonsymbolic, representation in *Die Vision*. The prose of *Die Vision* will later be elevated to the poetry of the *Güstrower Ehrenmal:* "The relief on the whole is [strongly] objectivistic; there is not only a figure but also a situation, a scene, the portrayal of a dramatic event" (Fechter, 1957: 160–61).

Other reliefs by Barlach that depict floating figures include *Auferstehung* (1917), *Der Übergang* (1917), *Grabmal Luise Barlach* (1921), *Kieler Ehrenmal* (1921), *Grabmal Reuss* (Engelrelief) (1931), *Grabmal Pauly* (1933), and *Grabmal Däubler* (1935).

*Grabmal Däubler* marks the reappearance of the floating figure of the *Vision;* the gravemarkers for Luise Barlach, Pauly and Reuss include reliefs of angels but are neither thematically nor stylistically related to the *Güstrower Mal*.

Thematically, *Auferstehung* and *Der Übergang*, with ascending figures, are only indirectly related to the *Güstrower Ehrenmal*. Stylistically, the ascending figures in each relief suffer from the same inadequacies suffered by the floating man of *Die Vision:* they remain trapped by or are bound to the background and are thus placed in a distracting situational context.

There are two interesting variations of the concept of *Schweben*. Formal elements of *Der Rächer* (1914, plaster; 1922, wood) and *Der Flüchtling* (1920) will later be incorporated in the design of the *Güstrower Mal*. Both of the former figures convey an illusion of motion which has been associated with floating

figures from the beginning. The stylization of the *Gewand* is the primary contributor to this effect, as Maike Bruhns notes with respect to *Der Rächer:* "The garment enhances the effect of blow, its sharp-edged creases which do not hang naturally intensify the movement ecstatically and emphasize the ferocity of the attack" (1978: 25).

The connection between the stylization of the garment and the effect of motion in Barlach's works was noted even before the conception of the Güstrow monument. Rheinhold von Walter, although writing later than 1927, echoes the remarks of these critics: "[It] is . . . striking that the more extreme [illusions of motion], as in the *Flüchtling* and, to an even greater degree, in the *Rächer*, tend to verge on the airborne. . . . The lineaments of the surfaces of the baggy garments arising from the violent movement are to be admired" (1929: 25).[12] Manfred Schneckenburger observes the explicit formal parallel between *Der Rächer* and *Das Güstrower Ehrenmal:* "The radial configuration of the cloak and the flying upper body [point toward] the *Güstrower Ehrenmal*" (1975: 92).

Significantly, formal attributes, not thematic aspects, of each sculpture account for the tendency of *Der Rächer* and *Der Flüchtling* to appear airborne and signal the presence of the symbolic mode of communication. These same formal qualities are then easily and appropriately applied to a figure that is supposed to be airborne: *Schwebender Gottvater* (1922), #276.

*Schwebender Gottvater* is a plastic version of drawing #1403 (1920), "Der erste Tag" and of the woodcut from the series *Die Wandlungen Gottes* (1920), entitled *Der erste Tag (Schult II: #164)*. Each figure in drawing and woodcut is shown "with open, outstretched light-emitting hands" (*Schult II:* 104), head slightly turned to the side. The sculpted figure, however, looks straight ahead and there is no attempt to portray the light emanating from the hands. Barlach has incorporated, in all three versions, the taut angular folds of the garment found in *Der Rächer* and *Der Flüchtling*. The torso configuration, however, is extracted from drawings #976–77 and 979 (1912), each of which depicts a *Schwebender*. That is, the line leading from the shoulders to the heels is not straight but rather forms a modified *V* which makes it less than aerodynamic.

The stylization of the *Gewand* contributes to the illusion of flight conveyed by *Schwebender Gottvater*, despite its overall V-shaped appearance. Furthermore, the situational context of, for example, *Die Vision* (1912) or *Auferstehung* (1917) has been avoided. As a single, freestanding, fully-sculpted figure, *Schwebender Gottvater* suffers from a different problem, however, which is identified by Maike Bruhns: "That which the woodcut [*Der erste Tag*, #164] effortlessly achieves, the illusionistic floating of a body in space, is [a problem] not convincingly addressed in the *Gottvater*, which is fixed onto a plinth. . . . The free floating . . . remains bound to the material" (1978: 32).

Placing the sculpture on a plinth, which is by no means a small one relative to the size of the sculpture, runs contrary to the subject matter the figure itself is

supposed to convey. God and intermediary figures distinguish themselves from everyday people—the motif of *Schweben* has become in Barlach's works an "expression of inner independence and a spiritual superiority" (Seiler, 1961: 25). Thus the formal aspect of support from above and not from below would reinforce the thematic aspects conveyed by this motif.

Barlach readdresses the issue of support in the design of the *Güstrower Ehrenmal* (1927). Here, the floating figure is suspended from the ceiling by chains—an approach that makes its initial appearance during the series of preliminary drawings to the Güstrow project (#1848–57). The above criticism leveled against *Schwebender Gottvater* by Maike Bruhns does not similarly apply to the Güstrow "angel." Barlach strives for unity of form and content or to find appropriate formal qualities to give expression to the inherent thematic basis. Käthe Kollwitz is most impressed by his ability to succeed at this task:

> If I ask myself what causes the strong impression which Barlach's works have always made on me, then I believe it is because, as he himself once formulated: "the outer is as the inner" ["es ist außen wie innen"]. His work is exterior as well as interior, form and content correspond precisely. Nowhere do they differ, nowhere is there filler. All that he produced out of himself, "all that is yours, the outermost, the innermost, gestures of piety and unruliness of rage," was one [Nirgends fällt etwas auseinander, nirgends ist Füllsel. Was er aus sich herausstellte, "alles Deinige, das Äußerste, das Innerste, Gebärde der Frömmigkeit und Ungebärde der Wut," war in sich eins]. Form and content coincided. This is the most convincing aspect of his work. (In Körtzinger, 1939: 35)

Barlach experiments with torso configurations and garment shape in the preliminary drawings to the *Güstrower Ehrenmal*. Sketch #1848 was completed on June 27, 1926, drawings #1849–57 from October 22, 1926 through October 27, 1926. Number 1848 differs significantly in shape and form from the other *Entwürfe* (although #1849, 1850, 1854 and 1855 are not shown in *Schult III*). Schult correctly identifies #1848 as: "Drawing to the contemporary plastic model [*Schult I:* #332]" (*Schult III:* 228). Number 1848 exhibits less stylization of body posture, facial expression (as far as can be determined), and *Gewand*. In all respects, #1848 is more iconic, as it has come to be understood in this study, than #1851, 1852, 1853, 1856 and 1857: the body posture retains the V-shape that characterizes, for example, *Schwebender Gottvater;* the shape of the garment is determined by body shape and posture; facial expression is nondescript. The formal features, in short, are not symbolic. Drawings #1851, 1852, 1853, 1856 and 1857 (those shown in *Schult III;* the other *Entwürfe*, part of the Barlach-*Nachlaß* in Güstrow, are not reproduced elsewhere) can be differentiated by the form taken by the *Gewand*. These drawings show the chain from which the bronze will later hang and the basic pose (unnatural—the body forms a modified projectile). Preliminary drawing #1853 most closely resembles the final bronze and has for this reason been displayed in numerous exhibitions of

Barlach's works (*Schult III:* 228).[13] Although this sketch shows the figure's arms positioned differently than in the bronze, the configuration of the torso and the design of the garment folds have been established as they will appear in final form.

The plaster rough copy (#332), a high relief, is described by Schult (and his description applies equally to preliminary drawing #1848): "deviating from the final model, the line of the back still [V-shaped] as in *Schwebender Gottvater;* legs slightly bent at the knees; arms stretched downward; hands folded across the body" (*Schult I:* 186). As has been mentioned earlier, the line leading from the shoulders to the heels of *Schwebender Gottvater* is not straight. The plaster rough copy of the *Güstrower Mal,* like *Schwebender Gottvater*, is not aerodynamically designed. Formal features of both figures too closely resemble the iconic style that is associated with the "earth-bound." More closely related to the Güstrow bronze than the above two figures in aerodynamic quality, as has been noted, is *Der Rächer.*

The cross formed by the intersection of the arms over the breast is thematically related to the message that is conveyed by the figure's formal attributes. Alteration of the initial arm position from extended, with hands clasped near the waist, and fully sculpted (cf. the rough plaster) further streamlines the figure; that is, the line of the garment leading from its bottom edge to the collar is not impeded. One observes extreme stylization of *Gewand;* its form is highly unnatural. Significantly, the garment becomes the carrier of expression, not the body. Walter Sokel's remarks, although not specifically directed at any particular sculpture by Barlach, apply perfectly to *Das Güstrower Ehrenmal:*

> [We] do not see a body gripped by tension but rather a tension that has become body. The expressive gesture of movement possesses the figure to such a degree that the figure becomes the carrier of the expression. . . . the expressive element swallows the representational; the aesthetic attribute becomes the aesthetic substance. . . . In Expressionist painting the aesthetic attribute color absorbs the represented objects. In Barlach's sculpture the aesthetic attribute—gesture, tension, facial expressiveness—usurps the human figure. (1959: 51–52)

Virch associates stylization with *Geist*, with elevation of subject matter. In addition to the stylization of *Gewand* in the *Güstrower Ehrenmal*, one finds stylization of facial features. There is a sense of tranquillity evoked by the countenance that offsets the illusion of motion projected by the *Gewand* and the projectile shape formed by the figure when viewed as a whole. This opposition of formal features gives rise to a tension or dynamic quality which characterizes many of Barlach's sculptures (Stubbe, 1959: 15–20). Often, however, such tension is a result of a predicament related to theme and hence is not an example of the symbolic mode of expression detailed thus far. *Panischer Schrecken* (1912), depicting figures recoiling from some unportrayed force which occupies their attention, is a clear example of man's "clash with elementary, superhuman

powers" (Bruhns, 1978: 23). The tension present in the Güstrow memorial, in contrast, is accomplished by pitting formal elements against each other; these aesthetic attributes in turn become the aesthetic substance, to use Sokel's terminology.

Drawings with floating figures do not reveal the significant facial stylization that one detects in the Güstrow bronze. The preliminary drawings to the *Güstrower Ehrenmal* (#1848–57), for example, make it difficult to determine to what degree the sculpted head will depart from the iconic style. This is partly because of the small scale of the drawings and partly because one encounters the figures only in profile. There is no evidence to suggest that the face of the *Güstrower Ehrenmal* might be drastically different than the faces of, say, the floating figures which are sketched in a natural-organic style in drawings #979 (1912), "Schwebender," or #1416 (1920), "Erschaffung Adams."

A transition from the iconic to the symbolic similar to that which one observes in the head and face of the *Güstrower Ehrenmal* occurs during the evolution of *Lehrender Christus* (1931). As Schult explains, drawing #1642 (1922), "Lehrender Christus," forms the basis for this figure (*Schult III:* 203). The essentials of this drawing, where the formal features of the head are nonsymbolic, are then captured by the plastic model, that is, #372. And yet, the head of the final extant plastic version of *Lehrender Christus* (#373) has been, stylistically, totally transformed. There is a pronounced difference in the degree of stylization of head and face between drawing #1642 (and thus the model, #372) and sculpture #373. A similar disparity between the prototype floating figures and the bronze memorial in Güstrow has already been noted. The head of *Lehrender Christus* undergoes intermediate stages of development beginning with the iconic and culminating with the fully stylized. A record of the alterations in design is provided by the plastic studies grouped in the series referred to as *Christusmasken*, executed in 1931, most of which are pictured in *Schult I:* 374–83. What one learns from these intermediate stages about the importance of stylization to Barlach can be applied to an analysis of the *Güstrower Ehrenmal*, where intermediate stages documenting the transition from the iconic preparatory drawings to the fully stylized face of the culminating figure do not exist. The developmental process occurred only in Barlach's mind. Nonetheless, the relation between the beginning product and the end product is the same.

The plaster model to *Lehrender Christus*, #372, which closely follows drawing #1642, is lifeless because the face, a focal point (especially so for Barlach, since the plain, loose-fitting garments worn by his figures do not always immediately distinquish themselves), is so blandly sculpted. Barlach does not take full advantage of the third dimension, depth; linear qualities are stressed at the expense of tactile values.

As Barlach, in the intermediate stages, alters the form of Christ's face, there is a noticeable shifting away from the nonsymbolic objectivity to the symbolic

rigidity and angularity inherent in the "Künstlich-tektonische." This decision serves to markedly accentuate or exaggerate facial features in the end result. *Christusmaske VI* is not merely drawing #1642 given plasticity: the original concept worked out in two dimensions has given rise to highly stylized form in three dimensions. Schult writes: "The final version is archaic in overall appearance, with enormous, angular, sunken eyes and troughlike brows, the face framed by a circle of falling strands of hair and beard" (*Schult I:* 209).

The position of Christ as an intermediary between God and man may account for the mixture of styles exhibited by *Lehrender Christus*, #373. The shape and posture of Christ's body determine the form of the garment he wears: it hangs naturally. In contrast, one finds the highly stylized head. Thus, tension is caused by the presence of opposing styles in the same work, mirroring the tension or instability of the position enjoyed by the intermediary figure.

Similarly, the tranquillity evoked by the countenance of the *Güstrower Ehrenmal* offsets the illusion of motion and the rigidity projected by other features.[14] While not referring specifically to the bronze in Güstrow, Wolf Stubbe identifies the general effect roundness of form has on appearance: "Whenever a figure is driven by fear or consumed by the fire of the spirit, the artist avoids the tranquillity of round forms, the absolute balance of the sphere and . . . [that which] tends towards the cylindrical" (1959: 17).

As this accentuated roundness of form is related to the "Künstlich-tektonische," it is not to be confused with the roundness that can be associated with the "Organisch-natürliche" (exemplified in drawing #1417, "Bekenner und Lästerer," of which mention has already been made). The latter roundness originates in and is most frequently to be observed in drawings by Barlach. In his sculpture, the linear or two-dimensional qualities are stressed at the expense of the tactile or three-dimensional qualities (cf. the discussion concerning the plaster model to *Lehrender Christus*).

Certain facial features of the *Güstrower Ehrenmal* dominate the human figure: especially evident are the disproportionately large eyes which are enveloped by the overstated concavity of the sockets. The effect of exaggeration is heightened by the lines formed to give the impression of eyebrows which have been extended to include parts of the cheekbones and the bridge of the nose.

The sharp definition of facial features engenders an angular roundness. Whereas the angularity of the garment folds is characterized by a rigidity based on straight lines and angles, the facial features are characterized by a curvature of line and roundness of form. Such roundness is tempered by the linearity of the strands of hair. The stylized facial features of the *Güstrower Ehrenmal*, in their departure from "objective" or iconic representation become aesthetic substance, symbols.

This *schwebende Figur* quits the realm of sensual perception: gaze is directed inward, arms embrace the self, lips are sealed. In modernist fashion,

Barlach's sculptures are often portrayals of persons in contemplative poses: *Fries der Lauschenden* (all figures completed by 1935), *Lesende Mönche I* (1921), *II* (1921) and *III* (1932), *Sitzendes Mädchen* (1908; 1937), *Mutter mit Kind* (1935), *Das Wiedersehen* (1926), *Der Asket* (*Der Beter*) (1925), *Der Wartende* (1924), the *Kieler Ehrenmal* (1921), *Moses* (1918), *Träumendes Weib* in *Die Vision* (1912), *Ruhender Wanderer* (1910), *Sorgende Frau* (1910), *Sterndeuter I* (1909) and *II* (1909), *Blinde Bettlerin mit Kind* (1907), and *Blinder Bettler* (1906) are only some of the more obvious examples.

Isa Lohman-Siems is able to briefly outline the evolution of the figure whose gaze is directed inward, or "der innerlich Schauende," as a subject of Barlach's sculpture by focusing on the eyes:

> The teak sculpture, *Mutter und Kind* is a document of Ernst Barlach's developmental path having come full circle. The motif of the sculpture . . . is an adaptation of the small sculpture, *Bettlerin mit Kind* . . . [1907]. All that differs is the facial expression. Whereas Ernst Barlach portrayed a "blind" woman in the realistic sense in 1907, he changed the extinguished eyes into seeing ones in the version produced 28 years later; yet the eyes of this woman are not fixed on any specific object or in a specific direction: these are eyes turned inwards, this is the look of the meditator. . . . From a realistic point of view, in which the symbol of a human situation is preserved in naturalistic detail, the transforming of the blindness symbol into the representation of the intended situation itself is accomplished: a blind person—for Barlach, the prototype of introspection,—has become the true seeing person. (1977: 38)[15]

On the formal level, further abnegation of the earthly is accomplished in the *Güstrower Ehrenmal* by raising the bronze above the ground. Appropriately, the figure is supported from above. In Barlach's poetic works, the weight of being all too human can be countered by support from above, in a figurative sense, as will be seen in the next chapter.

Helmut Gross perceives the cross as a symbol of unification of opposites and notes that the cross is

> [the only] form which makes such a unification possible. . . . For composed of an upright and a crossbeam, the cross is the merging of the antinomic: the vertical and the horizontal. It thus unites two incompatibilities in one form and is therefore symbol for the unification of the irreconcilable. (1967: 194)

The intersection of the arms of the *Güstrower Mal* at the chest forms a cross. The symbolic significance of the cross serves to underscore once again Barlach's preoccupation with the dialectic relation of thematic and formal opposites and their resultant syntheses.

We have seen the manner in which roundness of facial features engenders a sense of tranquillity and how the angularity characterizing the *Gewand* engenders an illusion of motion. Then there is the seeming incongruity of Barlach's choice of bronze, in its characteristic massivity, to express a motif associated with the

ethereal. The physical weight of the figure is countered by supports anchored above. The vertical dimension of the weight-versus-support tension is thrust into opposition with the horizontality of the figure's positioning relative to the ground. In a broader context, one must consider the horizontality of the cathedral floor vis-à-vis the verticality of the vaulted ceiling. Many of Barlach's plastic works, and I propose that the *Güstrower Ehrenmal* be considered representative of the mature efforts, derive a tension from the presence of antithetical and yet synthesized formal principles.

The evolution of formal attributes that characterize the *Güstrower Ehrenmal* indicates a gradual turning away from the iconic and an eventual embrace of the stylized. The former is an appropriate means of giving realistic nonsymbolic expression to the everyday person, occurrence or object. The latter appears, for Barlach, to be better suited to infuse the everyday with significance. The iconic, the aesthetic norm, thus requires little more than a spectator's basic sensual perception for disambiguation of Barlach's message. On the other hand, the stylized, which is integrally related to the symbolic mode of expression, requires a great deal of interpretation.

The *Güstrower Ehrenmal*, as a complex symbol, does not suggest its own key; it does not point toward a portion of the "encyclopedia" in the mind of Eco's reader or viewer which already hosts the right frames for interpreting it. The *Güstrower Ehrenmal* leaves the viewer face to face with the uncoded, if he is not familiar with Barlach's other plastic and graphic works.[16]

Having explored formal attributes inherent in a number of Barlach's plastic and graphic endeavors and having seen the symbolic significance of the intermediary figure, let us now turn our attention to the intermediary figures which appear in Barlach's poetic works.

# 4

# Icons versus Symbols:
# Intermediary Figures in the Poetic Works

Barlach conceived much of his mature sculpture between the mid-1920s and the early 1930s. As has been observed, however, the rise of fascism brought ever-increasing opposition to both the artist and his work. Barlach, at the apex of his career, was compelled to concentrate on other, less overt, avenues of expression. And yet, a series of drawings, *Übungen der leichten Hand* (1935), the unfinished drama *Graf von Ratzeburg* and the novel-fragment *Der gestohlene Mond* demonstrate that Barlach continued to work unabatedly, despite the Nazis having virtually forbidden him to work. Indeed, the confiscation of his artistic works and the banning of performances of his dramas in Altona amounted to the equivalent of an official *Werkverbot*, or order forbidding him to work. *Gestohlener Mond*, first published posthumously, reveals resolutions to various formal and thematic questions less convincingly addressed in earlier literary works, just as the *Güstrower Ehrenmal* comes to terms with sundry problems of expression which had occupied Barlach for years.

In the poetic works, as was the case in the plastic works, the focus of attention will be on intermediary figures—characters positioned between man, as nonreflective physicality, and God, as pure spirituality. These intermediary figures, which include, among others, the central protagonist in each drama and prose fragment, are of key importance to the understanding of Barlach's literary endeavors. Significantly, the developmental process of the intermediary figure culminates with Wau in *Gestohlener Mond*. Thus Wau will be studied to demonstrate a relation between the intermediary figures in Barlach's poetic endeavors and his plastic works. The characteristics inherent in intermediary figures in the poetic works will be discussed in relation to language that functions nonsymbolically and language that functions symbolically, just as the intermediary figures in the visual arts were discussed in relation to formal features that function either symbolically or nonsymbolically.

Stated in conventional interpretive terms, an intermediary figure is positioned between man and God and frequently serves as a messenger, able to communicate with both of the often mutually exclusive realms of "the heavenly" and "the earthly." Barlach, as was mentioned in the previous chapter, depicts the powers of the earthly, or "Kräfte des Erdhaften," by way of representation and mimesis, because they are easily understood. He can, however, only strive to clarify better those forces which prove ultimately inexplicable and uncontrollable. In this respect, Barlach believes that because man's intellectual and perceptual capacities are limited, certain concepts transcend his understanding. For example, he writes in a letter that "man will never be able to comprehend God" (4 February 1930; *Briefe II:* 205) because, as he later explains, "I am only too aware of the difference between the human capacity for feeling and understanding and the all-encompassing concept [God]" (3 December 1932; *Briefe II:* 337). Thus attempts to come to terms through the medium of language with a concept that transcends human understanding will prove futile. For this reason, Barlach at one point even resolves "to no longer use the word 'God'" (3 December 1932; *Briefe II:* 337). As Barlach despairingly notes, language simply cannot adequately convey the concept: "To talk about 'God' is to work with an unsuitable tool, language, which is bound to the realm of human understanding" (4 February 1930; *Briefe II:* 205).

The belief that God defies definition is often proclaimed in the Bible, of course. And yet, Barlach's preoccupation with this issue probably stems from his interest in mysticism. For example, the unknowability of God is a topic that is prominently featured in the writings of Meister Eckhart, Jakob Böhme, Dionysius and other mystics.[1] In her dissertation, Naomi Jackson presents evidence that Barlach had read certain works by Jakob Böhme: "On my visit to Güstrow in October 1949, I had the pleasant satisfaction of noting a well-used volume of Jakob Böhme's works among Barlach's books" (1950: 389). Unfortunately, as Jackson neglects to mention the title of the volume, one can only speculate on the exact nature of Böhme's influence on Barlach. Barlach never mentions any of the medieval mystics by name in either his fiction or correspondence, but he does confess a general affinity for mysticism. In one letter, he writes: "I am too much the mystic in every respect" (22-28 April 1916; *Briefe I:* 482). Similarly, in the *Güstrower Tagebuch*, Barlach says of himself: "[I] am more than a bit of a mystic" (*Prosa II:* 171).

And yet, paradoxically, man's search for God is not by definition absolutely hopeless, according to the mystics and to Barlach, as one may occasionally be subject to spontaneous dreams and visions that momentarily reveal the true nature of the divine essence, as will be discussed. In sum, certain aspects of Barlach's writings can be understood within the tradition of mysticism.

## The Apparent Inadequacies of Language in Relation to Existential Truths

At any rate, Ernst Barlach's distrust of language is not just an issue when he attempts to define abstract concepts, such as God. Rather, it takes on a broader dimension and results from an epistemological crisis, an *Erkenntniskrise*, understood in its most general sense. As Barlach writes:

> I believe . . . that the word is a miserable stopgap, an unworthy tool and that true knowledge is intuitive and must remain so. The word is given to man as small change for the financing of his needs and presumes again and again the order of absolute things, an earthly pot of temporality that would like to draw from the well of eternity. (3 December 1932; *Briefe II:* 338)

Such epistemological and linguistic crises are strikingly similar to those described by Hugo von Hofmannsthal in *Ein Brief*, the letter of Lord Chandos, which originally appeared in 1902. Just as Barlach senses that he is unable to define God and consequently feels compelled to avoid the use of the term "God," so too does Chandos realize that he is unable to fathom abstract concepts, whereby he shuns the use of certain words:

> At first I grew by degrees incapable of discussing a loftier or more general subject in terms of which everyone, fluently and without hesitation, is wont to avail himself. I experienced an inexplicable distaste for so much as uttering the words spirit, soul, or body . . . . [T]he abstract terms of which the tongue must avail itself as a matter of course in order to voice a judgment . . . crumbled in my mouth like mouldy fungi. (Hofmannsthal, 6: 11–12; 1952: 133–34)

Moreover, the crises, which at first had occurred only occasionally, gradually become more frequent and more overpowering. Chandos explains: "Gradually . . . these attacks of anguish spread like a corroding rust. Even in familiar and humdrum conversation all the opinions which are generally expressed with ease and sleep-walking assurance became so doubtful that I had to cease altogether taking part in such talk" (6: 12; 1952: 134). In short, Chandos feels that as the essence of any concept or thing is beyond his intellectual grasp, any efforts by him to speak about them will prove inadequate: "My case, in short, is this: I have lost completely the ability to think or to speak of anything coherently" (6: 11; 1952: 133). Language cannot express truths, "words desert me" (6: 14; 1952: 135), because man appears incapable of fathoming the truth. Hofmannsthal resolves the dilemma in which Chandos finds himself in a manner that is similar to the way Barlach resolves his own crisis of language, by means of dreams and visions, the consequences of which will be discussed.

Barlach's ideas on language remind one not only of Hofmannsthal's *Ein Brief* but also of Friedrich Nietzsche's posthumously appearing essay "Über

Wahrheit und Lüge im außermoralischen Sinne" (3: 309–22; 2: 171–92), drafted in 1873. In it, Nietzsche poses the following disconcerting question: "Is language the adequate expression of all realities?" (3: 311; 2: 177). Like Barlach and Hofmannsthal, Nietzsche, in response to his own question, asserts that he has lost faith in the ability of language to function as a conveyor of truths: "The 'Thing-in-itself' (it is just this which would be the pure ineffective truth) is also quite incomprehensible to the creator of language" (3: 312; 2: 178). Furthermore, he doubts that words bear any resemblance to or stand in any causal relationship to the ideas or objects they are supposed to represent. Nietzsche explains that all words are only metaphorically related to truths: "What is a word? A nerve-stimulus, first transformed into a percept! First metaphor! The percept again copied into a sound! Second metaphor! And each time [one] leaps completely out of one sphere right into the midst of an entirely different one" (3: 312; 2: 177–78). On the basis of this distinctly epistemological argument, Nietzsche concludes in the end, like Barlach and Hofmannsthal, that: "We believe we know something about the things themselves, and yet we only possess metaphors of the things, and these metaphors do not in the least correspond to the original essentials" (3: 312–13; 2: 178).

Nietzsche was, of course, not the first to theorize, in a nonreligious, philosophical context, about the inadequacies of language. One finds, for example, in the writings of Plato, especially in the dialogue entitled *Cratylus*, that Socrates too professes the powers of language to be limited: "No man of sense will like to put himself or the education of his mind in the power of [words]" (1961: 474). Words are of little help, he says, in finding the truth. Goodness and beauty, for example, exist and are permanent, but the words by which one tries to express them will never be adequate (473). "Reflect well," he bids Cratylus. "And when you have found the truth, come and tell me" (474).

The contention that words bear no natural resemblance to their objects likewise calls to mind passages in *Cratylus*. In fact, the dialogue begins as a result of Cratylus's insistence that names or words are "natural and not conventional—not a portion of the human voice which men agree to use—but that there is a truth or a correctness in them, which is the same for Hellenes as for barbarians" (422). Hermogenes disagrees with Cratylus and remarks:

> [I] cannot convince myself that there is any principle of correctness in names other than convention and agreement. Any name which you give . . . is the right one, and if you change that and give another, the new name is as correct as the old. . . . All is convention and habit of the users. (422)

It was, of course, primarily Nietzsche, along with Fritz Mauthner, author of a three-volume work entitled *Beiträge zu einer Kritik der Sprache*, which first appeared during the years 1901–2, who had the greatest direct influence on the "philosophies" of language, either explicit or implicit, of prominent expression-

ists and modernists, including Hofmannsthal, Rilke, Benn, Sternheim, Einstein, Ehrenstein, Sack, van Hoddis and Heym (see for example, Rainer Rumold, 1982: 36–40; 110–21; Elrud Kunne-Ibsch, 1972: 5–27). And yet, although one finds interesting parallels between Barlach's ideas concerning language and Nietzsche's, there is no evidence that would suggest that Barlach was influenced by Nietzsche, by Mauthner, or by other expressionists, for that matter. Rather, the sources for Barlach's conceptions of language and truth, if there can be said to have been any, are the writings of the German mystics of the Middle Ages. In his poetic works and letters, Barlach theorizes, clearly and knowledgeably albeit not systematically, about the nature of language and its relation to absolute truth. One of my tasks here will be to arrange Barlach's ideas into a coherent system or "philosophy" of expression.

For Barlach, as has been noted, the inability of language to express truths is directly related to the limits of man's perceptual and intellectual powers: "It is true that we can 'know'; and yet . . . 'true knowledge' is something for which the cerebrum and cerebellum prove inadequate" (20 May 1916; *Briefe I:* 485). Barlach echoes these sentiments elsewhere:

> Truths pass away, the Truth itself remains. . . . Truths are tangible and man-made inventions, the Truth is invisibility itself, the being of being, the unnamable for which the monosyllabic sound merely serves as proof that human imperfection is conscious of the perfection of the superhuman, which it names simply in order to label it as something existent: the emanation of the eternally unknown God, of that which is simply not man-like and which therefore is incomprehensible and unknown to man and remains so. (In "Dichterglaube"; *Prosa II:* 408)

And yet, despite these negative assertions, Barlach is more ambivalent than despairing in regard to the powers of language and man's efforts to strive in search of existential truths: "My struggle with my intuition of the unattainable will never cease" (13 August 1921; *Briefe I:* 635). Barlach maintains that even though man may never come to a full understanding of the truth, he should nonetheless take solace in the realization that his perceptual and intellectual powers can be "refined" and that thus the horizons of human experience and of the human mind may be expanded: "One thing remains positive: there is a deepening, a refinement, an ennoblement, a knowledge, that the 'self' is a dark wonder" (20 May 1916; *Briefe I:* 485). And it is through art that one may gain access to new worlds: "Our perceptual powers can be refined to an infinite degree. . . . Art sometimes enables us to sense which new worlds are yet to be discovered" (20 May 1916; *Briefe I:* 485). What one can come to understand, consequently, is not as limited as one might at first be led to believe:

> I mean namely that one, as a bounded personality within the realm of reality, can only comprehend oneself to a degree. And yet, the boundaries are further then one suspects, and there are guides in one's own as yet unexplored terrain—leaders, advisors, encouragers, providers of examples. (27 December 1927; *Briefe II:* 106)

One should strive for and look for guides toward this ultimately unattainable goal of absolute truth, because to do so is to somehow take part in the realm of God: "This drive within us is that of God—toiling, longing, struggling, hoping. . . . Why this—why not an eternally harmonious bliss? Because that is probably an impossibility" (20 May 1916; *Briefe I:* 485).

The best "images" or "guides in one's own as yet unexplored terrain," writes Barlach, are those which serve

> as intermediaries between the better self and the self that has lost its way or gone astray in the realm of temporality. . . . Thus one is made happy about one's unconscious self, as if something apocalyptic had been revealed. And yet, one has only become aware of one's own true self. (27 December 1927; *Briefe II:* 106)

It is thus the task of the artist, among others "who are driven or blessed," as Barlach explains, to expand horizons, to allow one to realize his fullest capacities. The artist has an obligation to make use of his "unique existence" or *Sonderexistenz:*

> The artist is no different than other mortals; and yet as an artist, like others who are driven or blessed to live life to the fullest, to speak out, without actually knowing why and to which end, out of the certainty of necessity, forming, composing, fantasizing—it is a unique existence. It is exactly because he is driven, because he experiences and endures his humanness so completely, often with such intensity, to be able to suffer more acutely, to have to live more severely, that the artist is what he is. (12 February 1933; *Briefe II:* 350)

And yet, remarks Barlach, to an artist this "unique existence" is "as often a curse as it is a blessing; the compulsion [to create] too often a whip" (12 February 1933; *Briefe II:* 350–51). It is a curse mainly because "the artist knows much more than he is able to say" (in "Dichterglaube"; *Prosa II:* 408). It is a curse because what he does know is that he knows so very little, an idea also voiced by Hofmannsthal's Chandos (6: 11–13).

Barlach's views on language seem contradictory. Despite his convictions concerning the inadequacies of language, Barlach is also convinced that words somehow allow one occasional glimpses of the realm of truth:

> You see, one wants "to know" and longs for the word. But the word is unsuitable, at best a crutch for those who are content with hobbling. And yet, there is something in the word that pentrates to the innermost, where it comes from the most pure, the absolute truth. . . . [One] may console oneself with the knowledge that . . . there is nothing better. (18 October 1932; *Briefe II:* 327)

More specifically, it is *Kunstsprache*, that is, poetic or symbolic language, that is able to reveal something of what is variously termed "the intuition of the unattainable," "one's own as yet unexplored terrain," and "the unconscious self":

[I am] convinced that the language and the means of representation accorded me are testimony—if a somewhat halting one—of something that is not at all touched by word, will, understanding and reason. Perhaps . . . there lies in the very nature of artistic language, inherent in it and communicated through it, the potential for suprarational qualities, such as beauty, greatness, majesty or shocking vividness, which emanates from beyond word mathematics and cannot be intended, learned, won or causally understood, but is instead pure grace. (In "Dichterglaube"; *Prosa II:* 409)

For these reasons, Barlach is extremely conscious of words and expressions, especially those he incorporates in his own poetic works. He writes, in a letter to his cousin Karl Barlach:

A story teller is victorious or defeated on the basis of the excellence or inferiority of his language. . . . He must chisel away, reverse, let lie and test with the ear and mouth; he must be such a fanatical artist that he can produce gold out of manure. . . . Something compels me and tyrannizes me, opposes me at almost every word. . . . I often struggle for days with but one word and experiment endlessly with sentences of three words. I must often give up, because I cannot find the right word; the word does not exist and yet it should. (26 December 1924; *Briefe I:* 744–45).

The notion that a word somehow relates to truth is, for Barlach, based on the following belief: "As is well known, in the beginning was the word, and its realm is as much this world as the other one. And yet, with words it is not a question of deciphering . . . but rather of a new formation out of the Spirit that existed in the beginning" (31 March 1937; *Briefe II:* 701). This belief is clearly modeled on a biblical passage, namely John 1:1–3: "In the beginning was the Word, and the Word was with God, and the word was God. The same was in the beginning with God. All things were made by Him and without Him was not anything made that was made." Thus man's act of creating, of his use of language, allows him to participate in a God-like activity, a notion which, interestingly enough, is also frequently expressed by numerous medieval mystics, including Jakob Böhme, in *De electione gratiae, oder Von der Gnaden-Wahl* (6.2: 7–11), for example.[2] Böhme was a major influence on German romanticism, and it is, of course, the romantic view of poetic language, the belief that a certain correspondence between the word and world can be achieved through the creative act of poetry, which informs the modern tradition.

Man must reevaluate his relationship to the truth and the function of his own creative powers. Thus Chandos feels that man can arrive at a meaningful relationship with the whole of existence if he learns to think with his heart: "We could enter into a new and hopeful relationship with the whole of existence if only we begin to think with the heart" (Hofmannsthal, 6: 17; 1952: 138). Similarly, Barlach writes that one needs to produce images that work on one's soul: "Yes, we need images we can follow with our souls, like telescopes whose mirrors collect the rays of the infinite" (in "Güstrower Tagebuch"; *Prosa I:* 327).

Thus the best words and images are symbols which act as mediators between the unknowable, the eternal, and the transitory, that is, the world of man. And one way the "unknowable" can be mediated for Barlach, for Hofmannsthal, and, as had been the case for numerous mystics, is through dreams and visions.[3] The mystical vision of the kind described by Dionysius, Meister Eckhart, and Jakob Böhme, in Barlach's works, although often of a more secularized nature, is the source of insight into the world more profound than any knowledge that might be gained through conventional means. In mystical thought and in Barlach's oeuvre, the two realms, the heavenly and the earthly, are bridged at times by the intermediary figure: visions he experiences help to make comprehensible certain aspects of "the intuition of the unattainable," that is, "das geahnte Unerreichbare" (13 August 1921; *Briefe I:* 635).

## Toward Metamorphosis:
## The Gradual Development of the Intermediary Figure

The reader can better understand the function of the intermediary in Barlach's dramatic works and prose fragments by determining how he differs from the aesthetic norm, the unitiated man of the milieu. What is it in one character that forces the reader to associate him with the realm of the milieu and what in another enables the reader to perceive him as a deviation from that norm?

In *Gestohlener Mond*, the relationship between Wau, an intermediary figure, and Wahl, a representative of the milieu, is depicted. The changes in the way this relationship is perceived by Wau reflect the difference between Wau when he lives according to the world of appearance, that is, when he interprets signs as icons, and Wau as he comes to focus on what ultimately proves essential to a meaningful existence, "das geahnte Unerreichbare." At that point, he views signs as symbols. Such a change in Wau is paralleled by a change in the way the reader reacts to Barlach's use of language.

There are indications already in the first chapter of *Der gestohlene Mond* that Wau will undergo a fundamental metamorphosis that will alter his entire manner of perception. Wau is initially cast in the sphere of the naturalistic milieu: he misinterprets his relationship with Wahl as one of friendship. "When one experiences something important, let us say, special, one easily tends to underestimate its significance" (435). He will only gradually arrive at the realization that they are actually archenemies (436). And yet those other characters in *Gestohlener Mond* who rely on the world of outward appearance to form their opinions, that is, the naturalistic milieu, will continue to perceive the two as friends: "Who would like to waste words on the fact that enmity can adorn itself with the most pleasant guise and colors of friendship?" (435). Very few characters in *Gestohlener Mond* will be able to discern the true nature of the relationship between Wau and Wahl: "Many cannot differentiate enmity such as existed between Wahl and Wau from true friendship" (436).

Analysis of Ernst Barlach's dramas and prose pieces reveals two antithetical formal principles which shall here be designated the iconic and the symbolic. The iconic is characterized by a certain resemblance to the commonplace, the everyday, which Barlach establishes as an aesthetic norm. This posited norm must be viewed as a semiotic device which functions as a contrast to the symbolic mode of expression. Thus, the symbolic is characterized by deviation from the norm.

Once the qualities of the iconic in the medium of prose, that is, in language, have been more exactingly established and concurrent manifestations located in the texts, evident deviations, the qualities that constitute the symbolic, can be traced. The following hypothesis stands to be legitimized: symbolism infuses the everyday occurrence, person or thing, that is, the aesthetic norm, with qualities not normally attributable to it.

The specific characteristics of icons and symbols, regardless of the medium in which they occur, are detailed in chapter 3. In Barlach's *Gestohlener Mond*, one senses that at times language is used iconically; that is, the meanings of words conform to models of reality readily identified and accepted by most readers. Most readers can interpret passages where language is used iconically because portions of the encyclopedia of human experience shared by the readers already host the right frames for interpretation. As Umberto Eco explains about discoursive competence: "There are a lot of phrases and indeed entire discourses that one [can easily] interpret or decode because one has already experienced them in analogous circumstances or contexts" (1976: 136). In other parts of *Gestohlener Mond*, however, language is used symbolically; that is, words are used whose meanings do not conform to models of reality that a reader can readily identify and accept. Symbolic language leaves most readers face to face with the uncoded. Words used as symbols signify according to conventions particular to Barlach's "philosophy" of expression. Symbolic words, expressions and episodes are ideolectical because their meanings hold only for the particular environment where they appear. Eco says about inventive use of language or symbols: "No previous convention exists to correlate the elements of the expression with the selected content, the sign producer must in some way posit this correlation so as to make it acceptable. In this sense inventions [or symbols] are radically different from [icons]" (1976: 245). As Eco explains modernist use of the symbolic mode of expression, in a passage already cited but which bears reiteration:

> In the modern aesthetic experience, the possible contents [of a symbol] are suggested by the co-text and by the intertextual tradition: the interpreter knows that he is not discovering an external truth but that, rather, he makes the encyclopedia work at its best. Modern poetic symbolism is a secularized symbolism where languages speak about their possibilities. (Eco, 1984: 163)

It is primarily in the dreams and visions experienced by Wau in *Gestohlener Mond* that the reader encounters the most radical examples of symbolic use of language, as will be seen.

Wau is introduced as an unassuming civil servant who is content with his lot as a *Bürger*, or member of the bourgeoisie. For example, in anticipation of an evening of merriment at the home of the mayor, Wau pulls on, "with pleasure," his overcoat which is "thickly lined" and "padded at the shoulders."[4] As he adjusts his tie ever so slightly while admiring himself in the mirror, Wau appears to voice approval of his fine overcoat: "Respectably bourgeois, to be sure, but it is warm, and I feel cozy in it" (436). The coat is more than a mere object to Wau and to the reader; indeed, it has become a sign by which one may identify an entire social class and its values. Literally, Wau protects himself against the cold reality of the evening; figuratively, as most readers will immediately recognize, Wau the *Bürger*, protects himself against the stark reality of existence:

> Then he walked out into the street, where he like a number of civil servants, teachers, and other dignitaries from the judiciary or post office or revenue service lived. The street was bare, normal, respectable, and it appeared to Wau in his bourgeois overcoat, that the bareness and normality made the cold of the evening feel spine-chilling. Therfore, he made himself properly comfortable in his overcoat, shook his arms, stuffed his hands in his pockets, and drew his shoulders upwards. (436)

On the way to the mayor's house, Wau bespies a cat stranded in a linden tree, having been chased there by neighborhood dogs. Wau surveys the situation "in his warm coat so well padded at the shoulders," but he arrives at no immediate solution to the cat's predicament. Unaffected, Wau trudges onward, "since the sociability of a pleasant . . . evening with the mayor awaits him" (437).

At the party hosted by the mayor, the guests are entertained by a story, concocted and read aloud by Assessor Bostelmann, about how the devil, in his infinite capacity to create mischief, deludes a group of narrow-minded and unsuspecting *Bürger* (including clergy) into believing the moon has disappeared. As this strange tale begins to unfold, though, Bostelmann pauses, painfully aware that his audience has become bored (441). The idea of a stolen moon, "ein gestohlener Mond," is dismissed as completely nonsensical, which deeply offends the assessor. The mayor and the other partygoers, with the exception of Wau, are unable to see past the simplistic and yet fantastic plot line, unaware that the significance of Bostelmann's tale lies on another level of interpretation. Bostelmann's soft-spoken and yet pointed remarks directed at the mayor support this view: "Yes, and yet doesn't exactly this sort of thing happen every single day? Think for a minute of how often one falls for . . . frauds and con tricks of every sort . . . . And if you had only realized what I really wanted to say with my . . . novella, Herr Mayor!" (441).

In an attempt to revive the atmosphere at the party, a toast is proposed; Bostelmann spoils it by choking, and he requires the assistance of Wau. An embarrassing silence again befalls the crowd which Wau tries to dispel by relating his encounter with the stranded cat. But, Wau only succeeds in gaining the distracted attention of one person:

> When [Wau] was finished, someone said: "and?" whereupon Wau, hurt at and annoyed with the indifference of the group, retorted: "Would you like to sit around up there in this cold? I have been thinking about the helpless animal the whole time, during every moment."—"Ach, the cat!" said the one addressed dismissively. (442)

The significance of Wau's story, too, does not lie on the literal level.

After the party, Wau ambles homeward, his thoughts consumed by the story of the "gestohlener Mond," by what it might have signified, and by the insensitivity of those at the gathering. Whereas on the way to the party Wau's coat was tightly buttoned to protect against the cold, one now finds that:

> Wau let the length of his overcoat wrap around his legs like two limp, hanging wings and offered his bodily self to the dank cold that streamed by. He surrendered to the cold around him as much of his warmth as the cold required. His head was hot—the many drinks had done him good and inflated the balloon of his soul. And thus he stood there, his buttons opened in both respects. (442)

As Heinz Schweizer correctly notes: "Thus [Wau's] inner self is unbuttoned as is his thickly lined bourgeois overcoat" (1959: 11), an indication to the reader of impending change.

Wau suddenly finds himself again underneath that same linden tree with the cat still stranded in the branches. He arrives just in time to witness it pushed off the branch by a long beanpole wielded by Kaufmann Paap, whose sleep has been disturbed by the screeching, an indication of the burghers' annoyance at having their complacency disturbed. Earlier, Wau had surveyed the cat's plight with disinterest: he had no intention of taking upon himself the responsibility of alleviating its suffering. During the evening, most likely prompted by the insensitivity of the partygoers toward Bostelmann, Wau reevaluates the consequences of his earlier actions: he regrets abandoning the cat. As Wau reencounters the cat, one finds that his attitude toward its fate has changed. Wau reacts with compassion as the cat lands on the ground near him: "This time Wau would have rushed to the aid of the delivered little animal, if it had had any need for his warm-heartedness" (443).

I concur with Schweizer's remarks that the innocent suffering of the cat parallels that which Frieda endures, pregnant by Wahl's father and abandoned to her fate, and that it furthermore represents "the existence of all suffering creatures" (1959: 130). In the context of this study, however, it is more pertinent

to document the alteration in Wau's perception of the cat and its situation. One witnesses a change from nonreaction based on a literal mode of perception to responsible action based on interpretation. Wau decides to interpret the cat's situation symbolically, as he has chosen to view Bostelmann's story symbolically (in contrast to the mayor, who can only grasp the literal sense of the story). These are but two examples of Wau's dawning awareness that the apparently meaningless may be reevaluated in such a manner that it becomes instrumental in the better understanding of oneself and the world. Wau searches for meaning by infusing the everyday object, occurrence or person with symbolic significance. And yet, the content of the symbols is extremely difficult for him to determine. Symbolic episodes such as the dreams and visions will be even more difficult to interpret, for both Wau and for the reader. In this respect, Umberto Eco writes:

> [An] episode is interpreted as symbolic exactly insofar as it cannot be definitely interpreted. The content of the symbol is a *nebula* of possible interpretations; open to a semiosic displacement from interpretant to interpretant, the symbol has no authorized interpretant. The symbol says that there is something that it could say, but this something cannot be definitely spelled out once and for all; otherwise the symbol would stop saying it. The symbol says clearly only that it is a semiotic machine devised to function according to the symbolic mode. (1984: 161)

The reader too should incorporate this manner of perception when attempting to understand *Gestohlener Mond*. One sign of Barlach's conscious implication of the reader is that Wau himself, merely a civil servant, has been infused by Barlach with a significance that has little to do with his iconic attributes, that is, with those traits by which one is generally gauged. Barlach indicates that Wau's case is worth reporting because his manner of perception changes, and not that the manner of perception changes because his is a special case to begin with. By pointing out Barlach's orientation towards the reader, I apply O'Neil's original finding, which follows below, in a broader sense:

> Wau has his vision of the divine shadow not as a gifted artist but as an ordinary human being caught up in a transcendental experience. Barlach indicates in a variety of ways that Wau's case is special and worthy of report because he has the vision, and not because his is a special case. He sees what all *might* be shown. (1966: 234)

Thus, Barlach demonstrates the importance of Wau's thought processes. Events, people and objects are introduced so that Wau can reveal both the relative insignificance of the naturalistic milieu and the superficiality of his own tendency occasionally to regard things solely at face value, that is, in their literal sense. Wau must strip away appearance and, through a process of interpretation, infuse everything with new meaning. Barlach's own remarks, which have already been quoted, provide an excellent definition of this methodology which relies on the use of signs as personal symbols:

I [see] in man the damned, the bewitched so to speak, and yet also the primeval-essential, how am I supposed to portray that through common naturalism! I perceive something masklike in appearance and am tempted to look behind the mask. How am I supposed to keep to the details of the mask? But of course I am aware that the mask has evolved organically from the essential; and thus I am referred to the mask after all. I therefore had to find means of presenting what I felt and suspected, instead of that which I saw, and yet use what I saw as means nonetheless. (23 July 1911; *Briefe I:* 376)

Immediately after the episode with the cat, Wau experiences a sensation which signals that his spiritual metamorphosis has begun in earnest:

Wau was pained by something like a hangover. He moreover sensed that . . . an impertinence of an indefinite nature all too surely resided in the rightful order of things. The stolen moon still had a hold on his . . . mind, the balloon of his soul had lost its billowy fullness and had contorted into the shape of ill humour. . . . In short, Wau was incensed by indeterminable impertinences and his heavy tread landed resounding blows on the now doubly pitiful normality of the street in which he lived. He was alone. (443)

This passage is one indication among others that Barlach's writings should be viewed as belonging within the modernist tradition, in spite of the unique valorization of the religious which marks his work as part of a genuinely German expressionism. Wau resembles Malte in Rilke's *Die Aufzeichnungen des Malte Laurids Brigge* (1910), Roquentin in Sartre's *La Nausée* (1938), Josef K. in Kafka's *Der Prozeß* (1914–15) and countless other protagonists who are preoccupied with the search for meaning in works one generally associates with the canon of modernist literature. Many protagonists, like Wau, are afflicted with "something like a hangover"—in the case of Roquentin, it is nausea—prompted by the unsettling realization that conventional modes of perception do not adequately explain existence. For some, many of Kafka's characters for example, this leads to terminal despair; for others, like Wau, there is a sense that one at least has to attempt to identify that which may ultimately prove incomprehensible.

The understanding of even very simple objects poses profound difficulties for the modern protagonist and indicates just how little a subject knows about himself and that which constitutes the world in which he lives. Barlach expresses this idea in *Gestohlener Mond* and also in a letter written during the same year he had been working on his novel: "Woe betide the person who forgets how infinitely pregnant with eternity the smallest things are; I often save myself exactly through the contemplation of this or that natural occurrence, no larger than that which fits in a box of matches" (24 November 1936; *Briefe II:* 672). Barlach, in this regard, echoes Hofmannstahl, as has been seen, and also Franz Kafka, if one considers his parable entitled *Der Kreisel*, originally written in 1920:

A certain philosopher used to hang about wherever children were at play. And whenever he saw a boy with a top, he would lie in wait. As soon as the top began to spin the philosopher went in pursuit and tried to catch it. . . . [S]o long as he could catch the top while it was still spinning, he was happy, but only for a moment; then he threw it to the ground and walked away. For he believed that the understanding of any detail, that of a spinning top, for instance, was sufficient for the understanding of all things. For this reason he did not busy himself with great problems, it seemed to him uneconomical. Once the smallest detail was understood, then everything was understood, which was why he busied himself only with the spinning top. And whenever preparations were being made for the spinning of the top, he hoped that this time it would succeed: as soon as the top began to spin and he was running breathlessly after it, the hope would turn to certainty, but when he held the silly piece of wood in his hand, he felt nauseated. The screaming of the children, which hitherto he had not heard and which now suddenly pierced his ears, chased him away, and he tottered like a top under a clumsy whip. (Kafka, 1961: 325; 1971: 444)

The inability of the subject to arrive at a stable view of reality are portrayed by many modernist poets and visual artists. In Barlach's works, one senses that this dilemma might ultimately find resolution. As long as the human experience is regarded as a dilemma, there is an affinity, also in terms of the whimsicality of expressing the existential, to Kafka's prose, which in contrast leaves one with an overriding sense of hopelessness.

Wau endeavors to derive a more enlightened conception of "die Kräfte des Höheren," whatever they may be. The reader, too, must identify apparently incidental details as symbols of the transcendent. Conventional plot and character exposés reveal little, Barlach maintains in modernist fashion: "The unimportance of the external or accidental aspects of Wau's life is made explicit" (O'Neil, 1966: 235). One finds in *Gestohlener Mond*, for example:

One would not be able to do Wau justice, if one were to think that it were a matter here of painting a portrait of his character, of his entirety, as if Wau were like a nice round sum formed of this, that, and the other rare or detectable characteristic that trickle together out of the rise and fall of events. . . . This is because the investigation of a character is not at all a task that is being proposed. . . . Nothing that has anything to do with what belongs to a bunch of good and proper novel chapters is being promised. (444–45)

In other words, the expressionist Barlach—like, foremost and programmatically in German literature, Döblin, Carl Einstein and Benn (Rumold, 1982: 29–35)—rejects the major vehicles of the realist-naturalist tradition: character and milieu. Barlach furnishes several examples of criteria by which a person is customarily gauged and indicates that they play an insignificant role in our understanding of Wau. Wau's "choice" of profession, for one, proves to have been almost accidental: "Wau chose—and 'chose' is really a misnomer—a career" (445). Wau merely opted for the most convenient route to a respectable and financially secure existence. Therefore, neither Wau nor the reader stands to gain anything by investigating this avenue of inquiry: "If . . . a career as a pirate

had been pushed as orderly, fairly practical, and at the same time respecatable . . . , Wau would certainly have chosen [it]" (445).

The institution of marriage has similarly failed to become a vehicle of existential revelation for Wau and as such will add nothing to our understanding of him. Significantly, Wau now rarely even sees Henny, his wife: "He was still married to be sure, but he was the husband of a woman always absent" (444). Wau has endured countless years of marriage, but their resultant impact on him has been negative: "He possessed the experiences of many years, experiences of a marriage rendered incurably shattered. . . . Wau suffered and experienced what was to be experienced through suffering; he had learned . . . to let pass what appeared bad" (444). In short, Wau's significance as the main protagonist of the novel has little to do with his past or what is conventionally considered his personality. Barlach writes in a letter about the relative unimportance of one's personality: "The curse of individualism is also on me, or as I usually say: 'The personality is not exactly the greatest joy of the children of the earth.' But this purgatory will no doubt have to be suffered by the world" (3 December 1932; *Briefe II:* 337). In a similar manner, the narrator in *Gestohlener Mond* remarks: "Since all of this can be regarded as . . . the distant past with respect to . . . Wau's present, it deserves to be forgotten entirely" (446). Thus what Barlach writes about himself in the following passage is equally applicable to the intermediary figures in his poetic works:

> What I feel regarding this personality as limitation and confinement, as determined by and laden with the curse of the transitory, does not belong here. It will surely suffice if [I mention that] I perceive my "self" as something other than my personality, in order to intimate that I seek my true essence in the dark, unconscious depths. (10 May 1926; *Briefe II:* 63)

In this context, however, O'Neil is only partly correct when he writes: "The narrator's remark about the unimportance of Wau's past [446] is essentially a statement of Barlach's attitude toward the past of all his characters" (1966: 235). A discussion of the past's "unimportance" is actually significant only to central protagonists in Barlach's poetic works and is hardly an issue that concerns "all his characters." Rather, as will be shown, the past, the apparently meaningless, that is, the everyday, can constitute an important element in the process of reevaluation a character such as Wau undergoes, if it is infused with significance.

Barlach the expressionist, when he rails against the *Bürger* and his notions concerning professionalism, marriage, and so on, is rejecting materialism at large. This emphatic rejection of materialism links him to a whole generation of artists—in particular, there is an affinity with the similar and yet more programmatic condemnation of the nightmare, "der Alpdruck," of materialism by Wassily Kandinsky, a multiple talent himself.

In *Über das Geistige in der Kunst: insbesondere in der Malerei*, completed in 1910 but not published until 1912, Kandinsky professes that the vast majority of his contemporaries continue to live essentially purposeless existences that are dominated by the evils of materialism: "The whole nightmare of the materialistic attitude, which has turned the life of the universe into an evil, purposeless game, is not yet over" (1912: 4; 1982: 128).[5] Kandinsky's pessimism regarding the nineteenth and early twentieth centuries is echoed in many of his theoretical treatises, including "Über die Formfrage," which appeared in the almanac *Der Blaue Reiter*, 1912, coedited by Kandinsky and Franz Marc: "There are whole periods in which the existence of the spirit is denied, since in general the eyes of men cannot see the spirit at such times. It was so in the nineteenth century and, by and large, it is still so today" (1979: 136; 1982: 235).

Kandinsky calls for the transcendence not only of the age of materialism but also of art which is based on the "external" and where "the cosmic element is completely lacking" (1979: 195; 1982: 260). Kandinsky, like many modernists, advocates a search for truth based on the "internal" (1979: 202; 1982: 263) and thus for art which is essentially nonmimetic or noniconic:

> When the external supports threaten to collapse, then man's gaze turns away from the external toward himself. Literature, music, and art are the first and most sensitive realms where this spiritual change becomes noticeable in real form. These spheres immediately reflect the murky present; they provide an intimation of that greatness which first becomes noticeable only to a few, as just a tiny point, and which for the masses does not exist at all. (1912: 26–27; 1982: 145–46)

Kandinsky furthermore calls on the artist, as an exalted, quintessential intermediary figure, the epitome of the "New Man" of expressionism, to advance civilization by educating the seemingly intransigent masses through art works: "Invisible, Moses comes down from the mountain, sees the dance around the golden calf. Yet he brings with him new wisdom for men. His voice, inaudible to the masses, is heard first by the artist" (1912: 16–17; 1982: 137).

Kandinsky contends that the artist as mediator must create works of art that are based on what he refers to as the principle of "innere Notwendigkeit" or "internal necessity" (1979: 206; 1982: 263). In "Über Bühnenkomposition," Kandinsky theorizes that a drama based on this principle would differ radically from those dramas of the nineteenth century which he terms "external" and which therefore have "no future" (1912: 5; 1982: 128).[6] He claims that his own "Ideendrama," *Der gelbe Klang: eine Bühnenkomposition*, which follows "Über Bühnenkomposition" in *Der Blaue Reiter Almanach* (1979: 209–29; 1982: 267–83), is a work based on "innere Notwendigkeit": "The following short stage composition [*Der gelbe Klang*] is an attempt to draw upon the source [of inward necessity]" (1979: 206; 1982: 264).

In *Der gelbe Klang*, Kandinsky rejects, for example, three of the most important tenets of nineteenth-century drama: character, plot and dialog. First, none of the "Participants," that is, "Five Giants," "Indistinct Beings," "Tenor (behind the stage)," "A Child," "A Man," "People in flowing garb," "People in tights," and "Chorus (behind the stage)" (1979: 210; 1982: 268), is viewed by Kandinsky as a conventional character (or group of characters) but rather as a material representation, which emerges necessarily ("out of inward necessity") from an idea. Secondly, there is nothing that resembles a conventional plot. One finds six "Bilder," or scenes, which are related primarily through a scheme of color symbolism that is consistently adhered to and which Kandinsky explains in detail in *Über das Geistige in der Kunst*. Furthermore, there is nothing that suggests conventional dialog. The lines of the chorus, for example, represent Kandinsky's use of language to give form to his preoccupation in theory with the principle of the juxtaposition of opposites or counterpoint. Numerous contradictory images are enjoined in the introduction, including: "stone-hard"/"dreams," "speaking"/"rocks," "melt[ing]"/"stones," "invisible"/"rampart," and "brilliant"/"shadows" (1979: 212–13; 1982: 269–70). These seemingly trivial pairs of opposites symbolize for Kandinsky the dualistic nature of existence: the material and the spiritual, superficial and profound, outer and inner, death and life, man and God.

Thus Kandinsky's rejection of materialist doctrine leads him to produce a stage composition that indicates a rejection of those tenets that characterize, in the more narrow sense, drama of the nineteenth century, and, in a more general sense, naturalistic and realistic works of art. In a similar fashion, albeit not nearly as radically realized, Barlach's rejection of materialism leads him to create works, in this instance *Der gestohlene Mond*, which depart from the conventions of naturalist-realist works.

## Wau versus Wahl:
## The Symbolic Consciousness versus the Iconic State of Mind

The names of Wau and Wahl immediately call to the mind of the reader those of Walt and Vult, the twins who are the central characters in Jean Paul's novel *Die Flegeljahre*, 1805. A brief comparison of the two works will prove useful for a "geistesgeschichtliche" sketch of Barlach's central dualistic strategy of the symbolic versus the iconic mode, that is, of Wau versus Wahl as an essentially romantic device, ultimately based on the romantic belief in the potential of poetic language as an expression of human imagination. In addition to the similarity between the two pairs of names, there are numerous other indications that *Die Flegeljahre* provided the impulse if not the model for *Der gestohlene Mond*. For example, plots exist in both only in skeletal form and revolve around the protagonists' relationships with women (whose names, incidentally also bear a

resemblance to one another). There is Wina in *Flegeljahre*, whom both Walt and Vult love, unbeknownst to each other, and Frieda in *Gestohlener Mond*, for whose fate Wau voluntarily accepts responsibility, after she becomes pregnant by Wahl's senile father and Wahl refuses to allow his father to admit his role. Significantly, the primary focus, albeit not the exclusive one, in both *Gestohlener Mond* and *Flegeljahre*, is on the presentation of the inner lives of the most important figures, Wau in the former work, Walt in the latter. In short, and as will be discussed in detail with respect to *Gestohlener Mond*, the spirituality of Wau and Walt is contrasted with the harsh rationalism of Wahl and Vult, except that Vult is not as critically, as negatively, portrayed. For Jean Paul, Vult is more the pragmatist of the sensual while Walt represents the faculty of imagination. Vult, in this respect, as Max Kommerell explains in remarks that are equally applicable to Wahl vis-à-vis Wau, "is definitely a foil for Walt" (1977: 358). Most noteworthy, it is often not so important what is presented but how it is presented—by means, more specifically, of dreams or visions. As Kommerell notes: "The purest form of the Jean-Paul-novel is the dream" (1977: 185). It is in this respect that one isolates the most significant similarity between Barlach's *Gestohlener Mond* and Jean Paul's *Flegeljahre*, one which is due to the influence exerted on both authors by the tradition of German mysticism.

Like the mystics before and like Barlach later, Jean Paul was clearly interested in dreams and visions, as his works reveal, both poetic and otherwise, and as numerous critics have remarked, including Kommerell (1977: 183–203), Smeed (1966), and Gauhe (1936). As Smeed notes, Jean Paul "ascribes transcendental validity to dream experiences" (1966: 9). For example, one finds in "Über die natürliche Magie der Einbildungskraft," 1795: "The dream is the Tempe valley and homeland of fantasy: the concerts that sound in the twilight of this Arcadia, the Elysian fields that cover it, the heavenly figures that inhabit it, do not suffer comparison with anything that the earth provides" (5: 187).[7] Similarly, in "Blicke in die Traumwelt," 1814, he writes: "The dream manages to transcend greatly . . . experiences . . . , and it delivers us heaven, hell, and earth at the same time" (16: 143). Thus it is not surprising that in many of his poetic works, Jean Paul incorporated dream sequences, *Traumdichtungen* as they are commonly called, as the most appropriate form in which to attempt to come to terms with the transcendental (Smeed, 1966: 9). Two examples among many include "Rede des todten Christus," which appears in *Siebenkäs*, 1795 (6: 247–250) and "Schlußtraum," the last episode in *Flegeljahre*, 1805 (10: 476–80). As for Jean Paul, dreams and visions for Barlach have the transcendental validity. It is the goal of the following step-by-step analysis to show that they constitute the core of *Gestohlener Mond*.

The importance of Wau as the subject of *Gestohlener Mond* commences as he senses with increasing frequency and intensity "that an impertinence of an indefinite nature all too surely resided in the rightful order of things" (443 and

446). This growing sense of spiritual awareness, which will play a significant role in determining Wau's future actions, distinguishes him from other characters in the novel, especially from his antagonist Wahl, and enables him to function as an intermediary figure. The better Wau is able to understand this very awareness, the more he will associate all people, objects and events symbolically.

Wau begins to turn inward, searching for that which he can claim as his essence; or as Schweizer phrases it: "Wau attempts . . . to discover in himself what constitutes his true self and what makes up the essence of his existence" (1959: 11). Wau endeavors to determine the difference between that which forms his true self by nature and that which he has merely acquired, that is, his superficial, naturalistic, character traits: "Thus Wau wavered back and forth at times between conviction and doubt, surprised himself in this respect at attempts to differentiate between innate qualities and acquired characteristics" (449). Wau rejects as irrelevant to the better understanding of himself those qualities by which he is judged by others, for example by Wahl; and yet, Wau is beset by serious doubts that there actually is "something" that constitutes his true self: "There arose moments of consternation to which he was not equal, when he sensed the ground sway under his foot, when he seriously doubted whether he . . . was anyone at all" (449). Wau, who senses "the ground sway under his feet," resembles the professor in Kafka's *Der Kreisel* who in a similar situation of existential despair "tottered like a top under a clumsy whip."

Vietta's interpretation of this metaphor in Kafka's parable is equally applicable to Wau's situation in *Der gestohlene Mond:* "The concrete metaphor of the self tottering 'like a top' emphasizes the abyss of an epistemological-theoretical situation where 'certainty' of knowledge cannot be achieved with regard to even the smallest detail" (Vietta/Kemper, 1975: 158). Wau's insecurity results from the awareness that what he knows about himself, in the ontological sense, is as good as nil, "sketchy and at times . . . exactly nil" (449). And yet Wau, unlike Kafka's characters, obstinately clings to the notion that he possesses "something" that is "his," even though it may ultimately defy both comprehension and description: "'I am nonetheless and in spite of everything' said [Wau] truly cross, 'because exactly where I appear to end, something turns up that I immediately recognize as myself, not exactly something impressively distinctive but, better than that, something absolute and real'" (449). This belief that one does "possess" what constitutes a true self, "ein unbewußtes Ich," even if it remains incomprehensible, is consistently adhered to by the main characters in all of Barlach's works. In this respect, Barlach characterizes himself in a letter to Julius Cohen: "Something foreign and yet related is my true self—possibly something divine that exhorts me toward the more sublime or possibly some other enigma within me" (22-28 April 1916; *Briefe I:* 480).

Many of Barlach's other protagonists discount, like Wau and unlike Wahl, the significance of their character traits, which lends further credence to the

claim that Barlach, like Einstein, Benn, Döblin and Kandinsky, rejects the major vehicles of the realist-naturalist tradition in literature: character and milieu. Boll, in *Der blaue Boll*, and the elder Sedemund in *Die echten Sedemunds*, for example, claim that the true, spiritual essence of a person differs radically from the spatiotemporally existing person that others perceive. Sedemund remarks in this regard:

> I do wish to submit, however, that this my present splendid figure is not Herr Sedemund's only one! There is yet another, as mighty as a point. This nameless point is at one with Herr Sedemund, indeed so much at one, that it is his essential self. Therefore it follows that Herr Sedemund is actually not Herr Sedemund at all, but this very point, which no hand can seize hold of, that Herr Sedemund is merely the porter of his own self, which, like a point without ears, without breath, without pain, as pure as nothingness . . . is housed quite comfortably within. Herr Porter Sedemund has no inkling of where the point is to be delivered—the so-called Herr Sedemund, whose clever son will no doubt dig up his own besmeared answer in a compost pile of foolishness. (*Dramen:* 245; Page, 1964: 142)

Boll will not even respond to people who address him by name: "Who told you who I am? I have basically very little to do with blue Boll, almost nothing" (*Dramen:* 420; Page, 1964: 192). Boll furthermore claims to have no knowledge of this Boll to whom people refer:

> VIRGIN: Good Lord, do my eyes deceive me—Herr Boll?
> BOLL: Not as far as I know. . . .
> VIRGIN: My name is Virgin—Virgin, the watchmaker.
> BOLL: A remarkably beautiful name.
> VIRGIN: As beautiful as, if not more beautiful than, yours, Herr Boll.
> BOLL: Boll? You'll have to ask elsewhere if a person by that name is known here.
> VIRGIN: If you prefer—you should know. Do forgive my mistaking you for that man. It's not exactly flattering.
> BOLL: And what sort of man is he, this Herr Boll, if I may ask?
> VIRGIN: I believe he considers himself an instance of the unsurpassable in every sense, that Herr Boll.
> BOLL: An enviable person, no doubt.
>
> (*Dramen:* 398; Page, 1964: 173)

Indeed, the mayor in *Der blaue Boll* correctly refers to the corporeal Boll most familiar to others in town as "the false Boll" and to the Boll who has undergone the spiritual metamorphosis as "the true Boll": "The lost Herr Boll, so to speak, the former Boll is the false one, whereas the present Herr Boll, the new, the new-found Boll is the true Boll" (*Dramen:* 411; Page, 1964: 185). In the course of the drama, Boll evolves as a true "intermediary figure," or, stated in conventional expressionist terminology, as the New Man, "der neue Mensch."

In *Gestohlener Mond*, Wau's tendency toward self-contemplation is contrasted with Wahl's nonreflective gregariousness: "Wahl . . . has a hand in

everything and unflaggingly exploits every occasion to engage in the unseemly, even the dissolute" (447–48). What are the specific qualities the reader is led to associate with Wahl? There is, for example, the leitmotif (a technique also employed, incidentally, by Jean Paul in *Flegeljahre*) of the "fake tan" with which Wahl is so frequently introduced: "Wahl . . . entered Wau's house after a few days . . . , not exactly bright and lively but yet freshly tanned" (659). Or similarly: "Wahl approached Wau in the room, freshly tanned, as if the deep south's salty ocean air and Homer's sun had helped with the task" (494). Wahl would like others to equate appearance with reality. Of course, both Wau and the reader can associate only artificiality with Wahl's tan. Wahl arrives with "the healthy brown of Homer's sun, which he had purchased in bottles, on his face" (636). In fact, the three elements —"healthy tan," "the sun of Homer" and "sold or purchased in bottles"—usually appear in some combination so that the reader instinctively comes to associate one element with the other two. Wahl deliberately chooses appearance, or *Schein*, over essence, or *Sein*, in direct contrast to Wau who endeavors to penetrate the guise of *Schein* as a means of gaining access to *Sein*. Wahl has come to depend on the contents of his "elegant" bottles to impart to him, if only temporarily, qualities which he quite clearly does not possess: "What was the purpose of the content of the elegant little bottles, if not to transform the old into the young, to conjure the flourishing out of the wilted? And what was the purpose of the brown tincture of radiant health? Wahl swore on his little bottles as the providers of godsends" (485).

Another quality the reader comes to associate with Wahl, and consistent with the "fake tan," are Wahl's efforts to promote his life as one of luxury through a "regal disposition" (485) and a "pompous manner of decorating his room" (614). The narrator's repeated descriptions of Wahl's megalomaniacal drive to construct a house befitting his own conception of self-importance and social status consistently reveal the ironic discrepancy between the imagined state of affairs as materialistic daydreaming and the actual.

Wahl has labored for years over plans for his mansion, variously referred to in one paragraph as "a castle," "the Wahlian splendor," and "the construction of his happiness" (485). And yet, Wahl is no closer to completing his house than he is to attaining happiness or success: "[His castle] had in the meantime neither walls erected nor foundation laid. There was not place in the entire world good enough for it, and yet Wahl also did not own so much as a square foot in the vicinity on which to build anything" (485). And yet, to give the appearance to others, and undoubtedly also to delude himself, that all is proceeding according to plan, Wahl is ready to cast a weathervane, of pure gold—"as a boastful symbol of the completely gaudy" (485)—to be mounted on the cupola (yet to be built of course) at a moment's notice. For the time being, Wahl will have to be content with this surrogate:

For the time being, however, Wahl's self-important and dazzling manner . . . , his regal disposition that caused everyone to be favorably disposed towards him, the infectious admiration that he had for his own significance, in short the appearance of being ardently courted by all kinds of luck replaced the sparkling gleam of the golden weathervane. And Wahl dedicated all of his energies to the cult of this appearance. (485)

Thus the reader is warned against accepting Wahl on the basis of the image he himself wishes to promote. The fallaciousness of appearances becomes clear to Wau in the course of the novel. He recognizes that Wahl is actually a "slave to his surroundings" (Schweizer, 1959: 24):

And Wau sat . . . on the corner of the couch, stern and intractable, so he believed, but in reality only sad, as he realized after a quick look around at the pompous decoration of the room and at the enslaved master of the velvet carpet who was so well adapted to these furnishings and who himself was almost effaced by a sort of anonymity and through an insipid splendor of appearance. "Decoration surrounded by more decoration," he thought. He continued, and yet audibly, conversing with himself: "Poor Wahl, whipped and driven by your furious superiors, by your megalomaniacal desires —always out of breath, always confused in your jungle of fruitless pomposity. (614)

In a related matter, the reader must be careful not to be too quick in accepting the literalness of a situation, character, expression, or word. Not all of Wahl's preoccupations or qualities are harmless. For example, Wahl gives the impression that his many business ventures have been highly successful, when in actuality, this is not the case:

[Wahl's] business adventures were numerous and divers. . . . [And yet,] Wau found that Wahl was involved in too many ventures at the same time and that he was like a hunting dog that tries to chase after a number of hares at the same time and as a result is unable to catch one. Now Wahl's situation was not quite so bad, but it was nonetheless strange that the Wahlian business though certainly brisk and ambitious was not profitable. Wahl got into more financial difficulties than he wanted to admit; and it was all too clear that most of his business partners were probably inferior to him and yet often triumphed over him in the end—his trusting in his own advantage because of luck and daring were the cause of many a painful surprise. (467–68)

This drive for success leads Wahl to consider other people merely as "instruments" to be used and, if necessary, abused for his own ends. Wahl perceives that Karla, for example, can become "an easily manipulable and obliging tool in his hands" (533). Similarly, Weinrebe is thought of by Wahl as no more than a "useful instrument" (546). Wahl's utilization of other people is ironic, since he himself ultimately becomes an instrument, a toy, for Bostelmann. Wahl proves easily manipulated because he is so unsuspecting, naive, unreflecting—qualities the cunning Bostelmann readily exploits: "Wahl was [Bostelmann's] man, as naive as if having just broken out of the shell,

shrewd and often cunning and at the same time unsuspecting, the perfect object for all of Bostelmann's whims, pranks and love of drunken [debauchery]" (531).

Wahl never really construes that his use of others has been with malicious intent. He simply never reflects upon the consequences his actions might have on people. The narrator, for example, comments: "As [Wahl] robbed Wau blind and financially ruined him, Wahl remained seriously concerned for Wau's well being" (555). Even more apparent in this respect is the way Wahl handles affairs with Frieda Wunderlich, whom he "unwittingly" drives to suicide. He will never be able to acknowledge that his actions played an important role in Frieda's decision to kill herself.

As a result, Wahl's sense of obligation extends only so far as the law, more specifically, the letter of the law. If he is not caught by the police or accused by the court, he admits no guilt: "Wahl . . . was completely devoid of any knowledge of the concept of obligation. He understood the power of the law to mean the implementation of the sanctions of the courts and police and authorities. In no way whatsoever did he acknowledge voluntary obedience" (470).

Indeed, Wahl is totally satisfied that he, his father and Wau cannot be implicated in Frieda's pregnancy after having manipulated her into signing a statement that declares their innocence. For Wahl, the truth of the matter lies in the slip of paper: "He possessed in black and white a judgment against [Frieda]" (586). The philosophical and religious implications of Wahl's failure to acknowledge that he must contend not only with legal (literal) accountability but also with moral (symbolic) accountability is explored in detail by Schweizer in his dissertation (1959), where he says that "the notion that he could be accountable to a metaphysical power that is imperceptible to the senses is totally foreign to [Wahl]" (20). Condemnation comes in Wau's tearing to shreds the confession Wahl has obtained from Frieda—effectively invalidating Wahl's entire manner of perception and way of life, which is based on the doctrine of materialism:

[After] Wau had skimmed over the sentences that Wahl had fashioned and had deciphered Frieda's wavering signature, he sat there for a moment without moving, his head bowed silently over the paper. Then . . . . a violent shudder shot through his body and hands and, like the crack of a whip, ripped right through the middle of the memorandum. A convulsion in his hands tore the "honestly acquired" protocol to worthless shreds which Wau then pressed into Wahl's hands. (590)

Another detail that supports the contention that Wahl and other characters in *Gestohlener Mond* perceive solely in terms of the natural-organic is Barlach's frequent comparison of them to animals. This manner of depicting a person or his actions places them in a negative context. Like animals which have no reasoning capacity, certain characters show no affinities for reflection: appearance becomes reality. What is seen, on a natural-organic level, determines further actions.

The most negative animal-person connection is found in Barlach's handling of Daß, the malicious *Betriebshelfer* whose assistance Wahl solicits to pressure Frieda and the Wunderlichs to stop their hounding of Wau. The reader is introduced to Daß in the following manner: "Daß not only possessed the head of a wild boar and the jaws of a wolf, but his creator had also obligingly endowed him with the cunning of a fox" (559–60). An even more negative portrayal of Daß emerges as his despicable role in the novel becomes evident: "Daß grunted like a pig who will devour anything—he had just ground in his jaws the juiciest portion of the last course. He scratched at his thick and scraggy beard as if he were searching for lice" (642). Daß is relegated to the realm of the brutally animalistic in both his way of thinking and his mannerisms.

The connection Barlach wishes the reader to make between Wahl's behavior and that of animals is also evident. Easily disambiguated are the comparisons of Wahl to a sly fox ("Wahl, however, was a clever fox and noticed that he was in a trap" [497]) and to a cat ("Wahl perched like a cat in front of a mousehole" [544]).[8] Barlach emphasizes that it is not reflection that forms the rationale behind Wahl's actions, but instinct based on simplistic, literal perception.

Likewise, in a passage that has already been quoted, the narrator compares Wahl's strategy of pursuing ventures to a dog's strategy when faced with the task of catching one rabbit out of a group: "[Wahl's] business adventures were numerous and divers. . . . [And yet,] Wau found that Wahl was involved in too many ventures at the same time and that he was like a hunting dog that tries to chase after a number of hares at the same time and as a result is unable to catch one" (467). Neither the dogs nor Wahl, though, seem terribly upset by their inability to zero in on the targets. Indeed, Wahl "fluttered . . . like a butterfly from one flower of disaster to the next" (468).

For Barlach, Wahl functions as the aesthetic norm. He represents the everyday man and his manner of perception, which remains firmly entrenched in the literal. Wahl never undergoes a spiritual metamorphosis and is thus unable to infuse the everyday occurrence, person or thing with meaning beyond the conventional. Wahl understands literally, not figuratively or symbolically. But since it has been shown that Barlach does not intend *Gestohlener Mond* to be viewed as a conventional exposé of character or events, Wahl must serve a function that relates to what Barlach does wish to expose. Wahl here exhibits similarities with Kafka's Josef K.—for example, the protagonist's animalistic abuse of women for his purposes, his inability to perceive beyond the circumstantial, his inability to become aware of his guilt, etc. Furthermore, Kafka condemns his character existentially to blindness.

Despite the growing awareness that he must transcend the literalness and the base materialism which predominates in, for example, Wahl's life, Wau acknowledges an affinity to Wahl: "Do I then also have a portion of Wahl in me; yes, would I not virtually be all Wahl, if I were not by chance Wau?" (473). In other words, it could just as easily have been Wahl undergoing the spiritual

metamorphosis. In a broader context, it is not clear that there is anything that separates the "saint" from the "sinner." In a letter written 20 years before his *Gestohlener Mond*, Barlach explains: "I know or suspect only this, which I knew all along: the sinners and the accursed make equally good saints as the saints themselves; there is no difference" (23 September 1915; *Briefe I:* 447). This same sentiment is echoed in *Gestohlener Mond:*

> If there are saints here . . . , and sinners elsewhere . . . , then it is nevertheless often unclear who those in question, saints here . . . the wicked there, actually are. For with the slightest progression in the course of events . . . those considered sinners put on the shoes of the saints, and the saints unexpectedly incur the burdens of guilt that no longer encumber the sinners. (519–20)

These remarks from *Gestohlener Mond*, when taken out of context, appear surprising, if one considers the degree to which the artist suffered under the regime of the Nazis. These sentiments, however, are some of the more optimistic ones in the novel. *Gestohlener Mond* is, when viewed as a whole, to a considerable degree about Wau's search to explain the presence of evil and suffering in the world, if one views the antagonistic relationship between Wau and Wahl on a nonliteral level. This issue is, incidentally, also prominent in many of Jakob Böhme's treatises, *Aurora, oder Morgenröthe im Aufgang* to name but one, which thus further supports attempts to view Barlach within the tradition of mysticism. Furthermore, the nature of evil and the presence of suffering in a world created by an omnipotent God is the specific topic of one of Wau's longer visions, the dialog between the two fallen angels, Harut and Marut. It is also the theme of Wau's "fictitious conversation" with Wahl.

Wau does not categorically deny association with Wahl or the manner of existence he epitomizes. And yet, Wau does realize he will have to struggle to keep from being dragged back down into the morass of the materialistic realm. The charcoal drawing "Bekenner und Lästerer" (1920), as was noted in chapter 3, depicts these opposing realms in a situational context. In *Der gestohlene Mond*, two episodes further help Wau, "der Bekenner," to cement his resolve against Wahl, "der Lästerer."

In the eleventh chapter of *Der gestohlene Mond*, Wau "awakens" from a dream to find at the foot of his bed a terrifying apparition, referred to as "the terror," or "der Schreck": "The terror stood at his bedside when Wau awoke to a full moon, awoke due to the viciousness of a dream. He was so awake that he made out the terror at first glance, as it stood between him and the full moon" (471). The two, "the terror" and Wau, then engage in "silent battle," "as if a matter of life and death" (471) were involved. As the apparition fades, Wau, having survived the battle "without having moved a limb," perceives that "the terror bore the features of Wahl" (472). Schweizer has pointed out the connection between this episode and the very beginning of *Gestohlener Mond:* "The duel during the night . . . announces the struggle between the two friends which

[during] the first chapter has already been described as the main plot of the novel" (19). This eleventh chapter further develops what is seminal to the reader's conception of Wau and what ultimately comes to represent reality for him: reality is what transpires in his head and not that which occurs in the spatiotemporal world. Wau's actions will accordingly be dictated by his understanding of his dreams and visions.

After the episode with "the terror," Wahl appears in a new light. Henny, Wau's wife, reinforces Wau's growing suspicion that he must beware of Wahl: "'You are both sick,' said [Henny], 'and your world is coming to an end. . . . Wahl, he is Satan, he will perish the same as all of you'" (475). Wau slowly arrives at the realization that Wahl represents that which must be overcome, transcended.

His struggles to ascertain what constitutes his essence are frequently thwarted. Perhaps, Wau thinks at times, his search is for that which can never be found. Thus, one observes that Wau's frustrations mirror Barlach's own frustrated attempts to shed light on the realm of the transcendental: "[The] absolute is incomprehensible to man. . . . [It] lies . . . beyond the power of human cognition" (27 September 1924; *Briefe I:* 730). Wahl, himself incapable of self-reflection, asks Wau: "Where does the path lead, where do you think . . . you will one day arrive?" (456) Wau responds: "How am I supposed to know? . . . That will become clear, when I have reached my destination." And yet, this manner of thinking is unacceptable and incomprehensible to Wahl: "But if you have no destination in mind, Wau, why even bother to set off, even if only with small steps?"

Although at times he seems poorly equipped to defend himself against Wahl's rationalistic arguments, Wau nonetheless claims "intuitive knowledge" (456), and he refuses to yield to Wahl's persistent efforts to unsettle him. In remarks that would appear more characteristic of a mystic than Wau, the bourgeois, he realizes that "to name, to describe, to show clearly the destination would mean to be there already" (456). Wahl, firmly entrenched in the materialistic realm of the nontranscendent, naturally proclaims such a notion "absurd" (457).

Wau's conclusion illustrates a point I made earlier, namely that language may not be able to express absolute truths. And yet, paradoxically, one may be able to uncover hitherto unexplored regions through dreams and visions. Thus although Wau may not be able to describe or possess this goal of obtaining that which constitutes his spiritual essence, he nonetheless acknowledges its presence. This realm of the transcendental which Wau encounters remains mysterious to him: "[I] have some knowledge of the meaning of life, if only an intuition, a premonition. . . . And yet, there remains something ["einen Rest"], and a great silence surrounds this something" (465). Wau first acknowledges the existence of the "Rest" and then attempts to determine its nature.

A similar distinction between those who acknowledge the transcendental forces and those who do not can be made in *Der arme Vetter* between Fräulein Isenbarn and Siebenmark. Siebenmark is unable or unwilling to look beyond the realm of the immediately perceivable and relates, in what he terms "a parable" ("ein Gleichnis"): "The roar of water on the other side of the ship's hull—to me that was always like the din of the boundless, ever obstinate irrationality through which we must arduously seek our way" (*Dramen*: 108). Fräulein Isenbarn, in contrast, does not view this "roar of water on the other side of the ship's hull," this other realm, as "irrationality," and she rephrases Siebenmark's empty "Gleichnis," for her certainly merely a superficial comparison, in the following manner: "I want to tell you how the roar of the water on the other side of the ship's hull strikes me: [I perceive it] as the pulsing and coursing of blood in the veins of the greater life about us through which we journey" (*Dramen*: 108). Fräulein Isenbarn senses the presence of "the greater life" and believes that she is in some way connected with it. Of course, Siebenmark unequivocally rejects Fräulein Isenbarn's perceptions: "You know that I can picture nothing of the sort" (*Dramen*: 108). That is, he is capable of relating to Fräulein Isenbarn's "Gleichnis" in only the most nonsymbolic way. In sum, Wau and Fräulein Isenbarn, or the intermediary figures in general, strive to transcend the limitations of the literal mode of perception that determines the view of the world accepted by Wahl and Siebenmark, or the characters of the naturalistic milieu.

## Visions and Dreams: The Symbolic State of Mind

As he becomes aware of something else, "einen Rest," and senses that "a great silence surrounds this something," Wau experiences a number of symbolic dreams and visions. They provide him with existential insights into this "Rest" that are not available through conventional modes of perception. Barlach himself claims to have experienced such moments of what might be considered mystical clarity: "In my best hours I am overcome by the illusion of deindividualization, of the union with [something] higher, or as I call it: the joy of self-overcoming that guards and maintains the total consciousness of the self" (4 February 1930; *Briefe II*: 204).

In *Gestohlener Mond*, Barlach consciously emphasizes Wau's inner life just as Jean Paul accents Walt's inner life in *Flegeljahre*. In turn, that which transpires in the spatiotemporal world in both novels is considered only in relation to the inner lives of the protagonists. In sum, in Barlach's works, intermediary figures, or New Men ("Neue Menschen") to use conventional expressionist nomenclature, acknowledge "the unattainable that is only intuited" and gain some understanding of it through explanatory vehicles, symbolic dreams and visions.

The following dreams and visions, which are the most important vehicles of

expression in *Der gestohlene Mond*, signify the presence of the symbolic mode of expression: the dream of "the shattered records," in the ninth chapter (462–63); the dream of "the terror," in the eleventh chapter (471–72); the first vision, of "the shadow," in the fourteenth chapter (482–84); the second vision, of the dialog between Harut and Marut, in the twenty-first chapter (520–22); and the third vision, of "the curse of words," in the twenty-fifth chapter (550–53). This listing is only intended to be representative. There are several other instances where Wau is struck with existential insights, during his conversations with and reflections on Henny, for example. And yet, such instances, while thematically related to the aforementioned dreams and visions, differ formally from them.

Like the floating figures in the plastic and graphic works which are found quite literally elevated above the ground, the realm inhabited by man, so too do the dreams and visions (forms of floating, in a similar respect) occur in a realm, in Wau's mind, that is removed from the reality of the spatiotemporal world.

Each dream and vision that Wau experiences, "an unprecipitated attack" (482), is preceded by an abrupt and explicit break with the world which is frequented by the other characters in *Gestohlener Mond*. The first vision, for example, is said to originate from somewhere beyond the range of normal experience, "from some unfrequented and unknown distant realms" (482). This is also said of the second vision:

> From which distant realm, from which reality had the voices come that reverberated in Wau's ears and called his soul out into space, when one day he realized that the accustomed abundance of his daily existence had been reduced to nothingness, whereas in contrast, the usual uncertainty of other conditions of his disposition had exploded in an eruption of power and pride and had assumed the shape of the most certain reality. Whence and wherefore this came over him—to discover this was denied him. (520)

And yet, the reason why he is subject to visions, and the manner in which he arrives at the realm in which existential truths are revealed, remain mysteries to Wau, as both the aforementioned passage and the following excerpt from the third vision demonstrate:

> He traversed the abyss before him as if on angel's feet, unthinking and unaware of what was happening to him. However, on touching solid ground on the far side, as if miraculously conceived, a word was born within him, which he nurtured inside himself, as a warm-blooded fetus is borne in the belly of a woman. (551)

Furthermore, Wau himself undergoes physical and mental changes as he enters or experiences dreams and visions. The aftereffects of these changes linger even after the dreams or visions have ended. For example, Wau awakens from the dream of the "shattered records" (which will soon be analyzed) "dazed" and

"slightly feverish" (462). Similarly, after the first vision, Wau finds himself "still short of breath" (482). And yet, these sensations are not to be viewed negatively, Barlach writes in a letter, since a vision, which frees one from the world of normality, is to be construed as one of life's most significant moments: "I have often proclaimed that the greatest joy is the rising-above-oneself, the momentary union with something higher" (4 February 1930; *Briefe II:* 205).

Sudden breaks between the world of normal occurrence and that of dreams and visions serve, as a poetic device, to distinguish between the two realms. The differences are explicitly stated at the beginning of the first vision:

> The occurrence which . . . overwhelmed him and . . . pushed him beyond all of his limitations, forced him out of his bourgeois sense of comfort, out of his pseudo-philosophical dalliance, angling for a fish in the mystical depths, to which he thought he had thrown the proper bait,— this occurrence then was an unprecipitated attack from some unfrequented and unknown distant realms on him, totally unprepared, unsuspecting, whether advice from those distant realms or conversely momentary ecstasy, transcendence of his self into them, into some adjacent region the knowledge of which he was either previously spared or which was withheld from him—he did not know—but he found himself, when he regained control over his bourgeois rationality, short of breath, in the corner opposite his table of the small, otherwise empty wine tavern. (482)

The existential truths revealed by each dream and vision are clearly intended to supersede the "pseudo-philosophical" insights conveyed by characters of the milieu.

Barlach always incorporated dreams and visions into his poetic works. And yet, in *Gestohlener Mond* especially they contribute meaningfully to the development of the main protagonist. Dreams and visions in Barlach's earlier works occasionally underscore elements of the grotesque or the macabre, "with the accent on the nightmarish and the horrifying" (Schmidt-Henckel, 1956: 121).[9] In *Der tote Tag*, for example, Steissbart describes dreams as "slimy worms, blind borers in the secret recesses of the soul" (*Dramen:* 13). Another example can be found when the mother, to whom the realm of dreams and visions is inaccessible (appropriately, since she epitomizes antispirituality), asks Steissbart whether her son has had dreams the previous night. He responds as follows: "It might be that such moist worms crossed over the pillows to him" (*Dramen:* 13). Even though one occasionally associates dreams or visions with the grotesque in *Toter Tag*, or in any of the poetic works, they generally serve as harbingers of "a holy reality" ("eine heilige Wirklichkeit") (*Dramen:* 20). We recall Barlach's remark in 1913: "Yes, we need images we can follow with our souls, like telescopes whose mirrors collect the rays of the infinite" (in "Güstrower Tagebuch"; *Prosa I:* 327).

And yet protagonists, or intermediary figures, are confronted with a dilemma of how such mystical revelations, "rays of the infinite," ("Strahlen der Unendlichkeit,") and "proverbs of the eternal" ("Sprichwörter der Ewigkeit")

(*Dramen:* 33) can be made intelligible to others through the medium of language. Kule, for example, faces exactly this dilemma in *Der tote Tag:*

> MOTHER: What is murmured to him who does not have the wax of sleep in his ears?
> KULE: Parables of the eternal.
> MOTHER: Do you know one that you might have overheard?
> KULE: One cannot retell them; they fade away in the ear, but they remain undiminished in the heart.
>
> (*Dramen:* 33)

Kule is able to enhance his perception of people and occurrences by utilizing an understanding, "an intuitive knowledge," "ein wortloses Wissen," as Wau might say, of the symbolic visions that befall him. Kule's physical blindness distances him from the mode of understanding which is solely based on interpretation of physical data. As Ilhi Synn observes: "Once [Kule] could see the . . . world, but his eyes had long since ceased to capture the visible phenomena. . . . His eyes, formerly atuned to record the visible, now are retuned to receive . . . visions" (1966: 47). Kule warns the son, who, until he commits suicide at the end of the drama, himself has the potential to evolve into an intermediary figure, not to rely entirely on the powers of sensual perception to form a conception of reality:

> SON: . . . After all, I see!
> KULE: And yet, perhaps you are blinder than I when it comes to many things. . . . Occasionally when I lie in bed at night and the blanket of darkness weighs upon me, a resounding light envelops me, visible to my eyes and audible to my ears. And then there gathered around my bed stand the beautiful figures of the the better future.
>
> (*Dramen:* 23–4)

All intermediary figures in Barlach's poetic works face the task of communicating their visions both to themselves and to others so that all may learn to cope better with the complexities of the world. Only when a protagonist comes to a clear understanding of his visions can he meaningfully integrate them into his world. One is reminded, in this respect, of Kandinsky's call to the artist, in *Über das Geistige in der Kunst*, to act as a prophet and harbinger of the new age of spirituality.

The son in *Der tote Tag* fails at this task of integration. He is unable to reconcile himself with the truths revealed by his dreams and kills himself before he can undergo any significant existential development. The son reverts to the ways of the mother, the materialistic or nonspiritual. Steissbart and Kule remain alone at the end of the drama to continue along what is referred to as the "messenger's path":

> KULE: Which path would be the right one for both of us?
> STEISSBART: The messenger's path, so that the world knows what we know.
>
> (*Dramen:* 95)

That is, as intermediary figures they must try to explain to others what they have come to know through their dreams and visions.

In *Die Sündflut*, Sem, like Kule, Wau, Iver, Celestine, Calan, Graf Heinrich and other Barlach protagonists, has epiphanal visions. And yet, Sem is completely unable to verbalize his revelations:

> AWAH: What did [God] look like, Sem, what did he look like?
> SEM: He looks like nothing that is. How then can I tell you, Awah? But, if you want me to, I will try to remember; only give me a little time until I can put it in words; ask me again another time. I see him often through the chinks, it's so strangely sudden, it opens, it's gone, not a trace of a joint to be found—very strange, Awah.
>
> (*Dramen:* 355; Page, 1964: 59)

Sem does not kill himself like the son in *Toter Tag*, but he does nonetheless fail to exploit his existential insights. Sem is unable to coherently communicate the meaning of the visions to even himself, and he is thus unable to maximize the potential the visions allow for change in the manner in which persons, objects and occurrences are perceived.

Visions, whose interpretation should open up new existential possibilities for the intermediary figures, come too late to be of use to them in a number of the dramas. For example, the son in *Der tote Tag* kills himself before he can integrate into his life that which he has learned from his visions. Similarly, Hans Iver in *Der arme Vetter*, Celestine in *Die gute Zeit*, and Calan in *Die Sündflut*, too, are granted their most profound visions in the moments immediately preceding their deaths. The visions that befall Wau, in contrast, appear early enough in the novel to have an impact on his conduct. Thus Wau's visions are significant exactly because they do contribute meaningfully to his existential development, more so than anything encountered or experienced in the world of the everyday, including marriage, profession or human interaction.

The dreams or visions, as has been discussed, are introduced intrusively into the discourse; that is, their relevance to the plot of *Gestohlener Mond* is not immediately evident. They appear within a context which is too weak to justify their occurrence, which signals the presence of the symbolic mode of expression, as Eco has described it. A dream or a vision is an episode purposefully endowed with vague meanings and that cannot be anchored into a preestablished code (Eco, 1984: 156). As a "guide in one's own as yet unexplored terrain" (27 December 1927; *Briefe II:* 106), it is there to reveal something about the elusive "Rest" to which Wau refers (465). Wau and the reader must decide what has been revealed. As Eco notes in the section of *Theory of Semiotics* entitled "The Aesthetic Text as Invention" (1976: 261–76): "[A reader, viewer, or listener] can recognize a phrase, an image, a melody, but something remains that [he] cannot grasp by means of commonly accepted semiotic categories. Thus the impression of 'unspeakability'" (267).

Furthermore, as each dream and vision in *Der gestohlene Mond* is unprompted, as has been seen, the reader should feel "uneasy" because he witnesses an inexplicable move on the part of the text. He senses that a dream or vision should not have been introduced in the discourse or at least should not have acquired such importance. He feels a surplus of signification without being able to explain why. As Eco relates:

> The interpreter of a text is at the same time obliged both to challenge the existing codes and to advance interpretive hypotheses that work as a more comprehensive, tentative and prospective form of codification. Faced with uncoded circumstances and complex contexts, the interpreter is obliged to recognize that the message does not rely on previous codes and yet that it must be understandable; if it is so, non-explicit conventions must exist; if not yet in existence, they have to exist (or to be posited). Their apparent absence postulates their necessity. (1976: 129)

These hypotheses which are postulated to explain the uncoded circumstances are creative abductions, as I noted in chapter 1 and as Eco discusses frequently in both *Theory of Semiotics* (1976) and *Semiotics and the Philosophy of Language* (1984). In connection with these findings, we note that for Peirce abduction is a case of synthetic inference "where we find some very curious circumstances which would be explained by the supposition that it was the case of a certain general rule, and thereupon adopt that supposition" (Peirce: 2.624). In *Gestohlener Mond*, the dreams and visions are the "curious circumstances" and one's interpretation would be that explaining hypothesis or "general rule." The following passage by Eco further helps the reader to understand how he must respond if he is to make sense of the visions and dreams that surface in *Gestohlener Mond:*

> Abduction not only allows us to interpret a message referred to an uncoded context of circumstance. It also helps us to select the appropriate code or subcode for an imprecise message. Suppose we have three cards on which are written: (i) /cane/; (ii) /e gatto/; (iii) /sugar/. We do not know if /cane/ represents the graphic transcription of the English word [*kan*] or of the Italian word [*kane*] (dog). Provided that the graphic item may freely associate either with /e gatto/ (giving "cat and dog") or /sugar/ (giving "sugar cane"), the choice of the more suitable combination can only be suggested by some surrounding context or circumstance. . . . [I]n principle, every time we hear a word we must decide to which code it has to be referred. [Thus] *abduction would seem to enter into any act of decoding.* (1976: 148)

What signals the role of a vision is the fact that it should not be there. Thus Barlach's visions are examples of the symbolic mode of expression. In this respect, they resemble James Joyce's epiphanies and T.S. Eliot's objective correlatives, also examples of the symbolic mode of expression, as Eco astutely comments:

> The textual implicature signaling the appearance of the symbolic mode depends on the presentation of a sentence, of an object . . . . , of an action that according to the acknowledged

rhetorical rules, to the most common linguistic usages, *should not* have the relevance it acquires within that context. . . .

In producing most of his epiphanies, Joyce puts them within a co-text that explicitly introduces and stresses their strangeness and their revealing intrusiveness. Other authors—see, for example, the objective correlatives in Eliot—present the irrelevant apparitions without justifying their presence. What signals their role is the fact that they *should not be there*. (1984: 158)

Furthermore, each vision is to be viewed as symbolic exactly insofar as it cannot be definitely interpreted. The content of any symbolic episode, as Eco would say, is a nebula of possible interpretations (1984: 161). The symbol, or vision, says that there is something that it could say, but this something cannot be definitely spelled out once and for all; otherwise the symbol would stop saying it. The symbol says clearly only that it is a semiotic machine devised to function according to the symbolic mode (Eco, 1984: 161). Introduced intrusively into the discourse, Wau's dream of the "shattered records," an episode purposefully endowed with vague meanings, illustrates the symbolic mode of expression:

He found himself looking into a chamber or fairly small room, and realized that it was filled with nothing but shattered records, stacked or piled like junk heaped in corners. He also knew, but from the conveyance of knowledge as it tends to occur in dreams, that all these records were once the previous stages of his life, destroyed now however and as trifles and inconsequential remains did not stand for but exactly only suggested nothing but the shattered past. It is true, there was no-one present who pronounced that the past was meaningless or was supposed to be, but the shattered condition of the records communicated this more convincingly than the eloquence of speech. (462)

And yet, Wau's conviction that "the past is meaningless" indicates that he does not experience this dream as, as the semiotician would put it, an example of the symbolic mode of expression. Although the meanings of certain words, "shattered" and "records" for example, clearly cannot be anchored in a preestablished code—as symbols they indicate, as Eco explains, "what is always beyond one's reach" (1984: 130)—Wau chooses to view them according to conventional or commonly accepted semiotic categories, that is, as icons. Since he does not recognize that the "messages" of these words do not rely on previous codes, he "misinterprets" the dream.

As what might be termed an ambiguity or "imprecise message" (cf. Eco, 1976: 148), the "records," are correctly associated with "the previous stages of his [Wau's] life," by both Wau and the reader. Barlach provides a situational context—"he also knew, but from the conveyance of knowledge, as it tends to occur in dreams"—which justifies this interpretive hypothesis. Truths revealed in dreams, as has been seen, have existential validity. And yet, as "shattered," these "records" are considered by Wau to be "destroyed and as trifles" and thus to be "meaningless." In the end, the interpretation of the entire "experience" depends on one's understanding of the word "shattered," or "zerbrochen." And yet, there is no situational context either to validate or invalidate definitively

Wau's explanatory postulation, which he has chosen out of a nebula of possible interpretations. The symbol is open; it is, however, determined to some degree by the co-text.

The reader becomes suspicious that Wau's judgment may be incorrect with the sentence that follows: "It is true, there was no-one present who pronounced that the past was meaningless or was supposed to be, but the shattered condition of the records communicated this more convincingly than the eloquence of speech." Given what is known about the juxtaposition of the heavenly and the earthly for Barlach, one is led to mistrust any claim of existential validity that owes its origins to the realm of the earthly, as would "the eloquence of speech," or "Zungenberedtheit." Barlach, in *Toter Tag*, for instance, warns that one will be misled if he believes that by merely hearing a word he has truly understood its meaning: "Do you take me to be one of those types who makes a word, sticks it in his pocket and then swaggers around as if he has grasped the thing?" (*Dramen:* 87). And yet, because Wau is convinced of the validity of his interpretation, that is, that "the previous stages of his life" are meaningless, he is content to ignore the dream. In sum, the strangeness, the intrusiveness, and the apparent irrelevance of each dream and vision that are to be taken as signals of the presence of the symbolic mode initially cause Wau either to disregard or to underestimate the importance of these revelationary vehicles.

Similarly, the significance of the first of the three visions lies on the symbolic level, as can be seen:

> There was a shadow standing there which emanated from him, thrust through the clouds, concealed the moon, obscured the sun and projected unboundedly into the universe, indeed occupied it entirely, for there remained no space beside it. And where there was world and worldly body, and space between the forms of the bodies and constellations of stars, everywhere was veiled in the shadow that emanated from him and was secure within it. And it was his shadow: this he recognized by the gait which followed his and by the lifting and moving of the arms and hands which corresponded to his, as did each gesture that he became aware of . . . , or which he made, as one is apt to do, when one compels an accompanying shadow to perform a trick upon the ground. During the non-time of his gazing, he had perceived still one thing more: the nuance of a body in the infinity of space, a shape like that of the sun in strange contortion of form, glowing, but obscured as if by mist, which stirred strangely and shuddered as if in convulsion—far, far away, well beyond the sun, which expanded and contracted and throbbed furiously like his own heart which began to beat in initial terror, so that one could have doubted, if one were unaware of one's frenzied and agonizing torment, which of both hearts could have given the other cause for such pounding, which seemed in violent struggle against paralysis. (483)

Wau, however, does not "misinterpret" this vision as he had the dream of the "shattered records." Rather, he ventures explanatory hypotheses for the symbolic images, for the "shadow" and the "shape like that of the sun" for example, that appear supported by the situational context in which they occur: "He had seen, and then the curtain between the image and the eyes which had

been open was snapped shut, and all that remained was a merciless realization of that greatness and his own insignificance, or better still: of the oneness of the whole and the part" (482). And since the shadow appears to follow his every movement, Wau believes that it is controlled by his will. And yet, despite apparently having garnered the symbolic significance of this vision, Wau does not understand how he is supposed to incorporate what he has learned into his own manner of acting in the world of the everyday. The narrator comments:

> And he himself—Wau—was he a different Wau or still the same old Wau? [The experience] was like a shot, as violent and as penetrating, but otherwise, everything seemed the same, except that Wau, as his glances collided with the walls, did not know if he had pierced the walls of time and upturned the boundaries of space, whether with those same eyes, or others with a different capacity for sight. (484)

Wau may be physically affected by the powerfulness of the vision, but he does not react spiritually to its symbolic significance: "After just a few days, the event lay behind him like a barely perceived fit of dizziness or a taunt from the uncontrolled unconscious, barely surfacing and flashing past before concealing itself again immediately behind the wall of an agreeable equanimity" (484). This recurring failure to recognize initially that the importance of all dreams and visions lies on a symbolic level of understanding temporarily places Wau on the level of the mayor and the other partygoers who, as we recall from the previous discussion, are unable to acknowledge the symbolic significance of Bostelmann's story about "the stolen moon."

In *Gestohlener Mond* the following pattern of development emerges that centers on the dreams and visions: Wau experiences a vision, the apparent symbolic significance of which he may or may not realize. Then, either because he misinterprets certain words or images, since he disambiguates a message according to conventional semiotic categories, or because he does not understand how to relate the message to his own situation, he initially disregards the episode. And yet, in contrast to other characters, Wau later becomes conscious of his interpretive "errors."

Wau alters, for example, his assessment of the dream of the "shattered records":

> The significance of the dream of the shattered records had caught him unawares. The bygone stages of life were not meaningless pieces of the past, they accompanied him like all other pieces of his own essence, continually developing with him, apportioned or innate. And even if need be he would have to let them escape from memory, they were still assimilated by and embodied in him, and he had become one with them, for better or worse. (478)

The reinterpretation of this dream prompts Wau to view his present situation in light of his past and thus to reevaluate many of his previous actions, most importantly his handling of the affair with Frieda, and relationships, with his

wife for example. This process of self-reevaluation, in turn, makes Wau conscious of what effects his actions in the present may have on the possible outcome of events in the future. At this point, Wau decides to act as a morally responsible adult by taking charge of the affair with Frieda by aggressively confronting Wahl. And because the advancement of the plot and the various digressive discussions have revolved around Frieda's condition since the beginning of the novel, such a radical change in Wau's attitude is of crucial importance to the reader's perception of Wau, the intermediary figure.

Similarly, Wau is compelled to recognize that his earlier interpretation of the "vision of the world shadow" was incorrect. A more contextually supported interpretation of the vision results during a spirited conversation between Wau and Wahl, who temporarily appears to Wau to act "as friend and closest confidant" (502) and who thus uncharacteristically contributes a number of perceptive observations, although for purely selfish reasons:

> "But," said [Wau], "He, the shadow, the large one, comes and goes and moves as I do, does what I want, and I exercise power over him according to my will."
> "No," said Wahl . . . , "you are imagining that—it is such that you only do what He wants. The will of which you are conscious is only that which is conveyed to you; you think you are the one who gives orders, whereas in reality, only He wills and commands. . . .
> "And thus I am nothing, and He is everything?"
> "Thank God, so be it. . . . For thus you, as his menial, are party to whimsical divinity—you, no longer ignored, but his footprint imbued with sublimity, you imprint of his step, you recipient of his tread,— and do not demand to be more than a believing rest—accept it in reverence." (503–4)

Wau now understands that it is not he who controls the activities of the shadow. Rather, it is the shadow, "[his] unconscious, and yet true self," as it might be termed, that commands his actions. Wau, on the basis of his new interpretation of the shadow, thus feels that he is united with a divine essence. And yet, mysteriously, even this divine essence of which Wau is a part is itself only a part of an even more all-encompassing essence, as Schweizer notes: "This is . . . not yet actual Being; for behind the actual, a light must shine in dazzling luminosity capable of casting the shadow. . . . Being therefore remains even after the vision as a . . . mystery" (1959: 56). Nonetheless, this does not alter the validity of Wau's perception that he is united with "the divine" ("die Himmlischkeit") since his heart beats in unison with that of even this "shape like that of the sun."

Once again, Wau realizes that his past actions with regard to the affair with Frieda have been based primarily on the materialistic impulses of the everyday, and that he has thus not thought or acted in the light of a higher purpose or according to any set of moral principles. Increasingly, Wau tries to determine the metaphysical consequences of all actions and thus their significance to existence

on earth. Thus, as there is symbolic meaning to words, phrases or images, so too is there metaphysical, spiritual or religious significance to actions.

In sum, all dreams and visions constitute the integral aspect of the intermediary figure Wau and foreshadow a change in his manner of perception and in his conduct, especially regarding the affair with Frieda, around which the novel revolves. And yet, before any changes can result, he must recognize that each dream and vision is an example of the symbolic mode of expression. Although the content of a symbolic episode is a harbinger of "the holy reality" or "the intuition of the unattainable," it also suggests a nebula of possible interpretations, many of which are not based on previously established codes. The intermediary figure, however, must posit an explanatory hypothesis, a creative abduction, suggested not by conventional semiotic categories—they will generally prove ineffective—but rather by the situational context in which the symbol occurs. The existential insight that results must then be applied by the intermediary figure to his own activities in the world of space and time. Only afterwards will he be able either to validate or invalidate his creative abduction, to see whether he has understood the dream or vision.

# Conclusion

There is now enough evidence to allow us to speak conclusively of a relation between the literature and the visual art that Barlach produced. Intermediary figures are used in each of the media in which Barlach was active. Stated in conventional terms, the intermediary figure is positioned, either literally or figuratively, between the average man and God and serves as a messenger, able to convey information about, or clarify to a degree, normally incomprehensible existential truths, or "die heilige Wirklichkeit."

Stated in semiotic terms, the intermediary figure signals the presence of the symbolic mode of expression, whether as a figure in the visual arts, *Das Güstrower Ehrenmal* for instance, a monument to World War I, or as a literary character, Wau for example, the central protagonist in *Der gestohlene Mond*. More specifically, formal characteristics the intermediary figure exhibits have been identified in the previous two chapters as symbols. What these symbols mean, and thus what the intermediary figure represents, depends on the creative abductions the reader or viewer posits as explanatory hypotheses. The validity of these hypotheses can be tested by a tentative tracing of a system of signification rules, that is, by explaining Barlach's "philosophy" of expression. Since the intermediary, and the messages he conveys, do not conform to a model of reality that is recognized or accepted by most viewers or readers, this makes such a task somewhat problematic. The intermediary figure appears purposefully endowed with vague meanings. In other words, he does not seem anchored in a preestablished code that would explain his function. Thus the significance of the intermediary figure appears ideolectical—holding only for the environment in which it appears, that is, for Barlach's creative oeuvre. In contrast to the intermediary figure, most other figures or characters in Barlach's works, generally identified with the naturalistic milieu, signal the presence of the iconic mode of expression. In this respect, one may establish a definite relationship between them and a previously established culturalized content.

The particular characteristics that constitute the opposing stylistic tendencies of the iconic and the symbolic prove necessarily medium-specific; that is,

they are determined either by language, in the poetic works, or by line or form, in the graphic or plastic works. This supports the claim made in chapter 1 that there cannot be equivalent formal features in works from two different media. And yet, regardless of medium, icons constitute the aesthetic norm and tend to be literal, realistic representations of persons or occurrences. Symbols, on the other hand, tend to transcend both the thematic and formal norms and thus prove better suited than icons to express Barlach's consciously reflective and highly personal existential insights. Furthermore, the *Güstrower Ehrenmal* and the manner in which Wau is presented demonstrate that Barlach purposefully strives to avoid the mere admixture of formal iconicity and formal symbolism in favor of the symbolic as the ideal. In this respect, "aesthetic attributes" exhibited by the intermediary figure become the "aesthetic substance," to borrow Walter Sokel's terminology (1959: 51–52). Thus the relation between formal attributes and purpose is the same, regardless of artistic medium.

In Barlach's literary works, the man from the naturalistic milieu is characterized by attributes that reveal the fallaciousness of judgments based on mere appearances. His actions are shown not to be the result of adherence to spiritual or metaphysical values but, on the contrary, of materialistic impulses. Unlike the intermediary figure, the characters from the milieu do not undergo spiritual metamorphoses.

The intermediary figure tends to reflect upon the nature of existence, and dreams and visions prove to be his chief vehicles of existential revelation. The knowledge he gains from them is meant to supersede the "pseudoscientific" insights expressed by the characters of the naturalistic milieu. And yet, the intermediary figure must both recognize that a dream or a vision is symbolic and come to a contextually supported understanding of its particular significance to him. A number of Barlach's literary characters have revelations but fail to integrate their findings into their lives. Wau, on the other hand, succeeds in utilizing his mystical experiences to contribute substantially to his existential development. Thus the actions of the intermediary figure, exemplified by the character Wau, are determined by his visions, and the reader's understanding of Wau, in turn, depends on analyses of these visions. Visions, as mentioned, signal the presence of the symbolic mode of expression and are thus stylized both in form and in content: they exist only in Wau's mind; that is, they take place in a realm removed from the realities of space and time, and their messages are conveyed through symbolic use of language. As a result, all mystical experiences must be interpreted before they can have an impact—they are essentially useless both to Wau and to the reader if accepted literally. Once successfully interpreted, however, dreams and visions reveal a number of important existential truths.

Normally inexpressible insights into the realm of "die Himmlischkeit" are similarly conveyed in Barlach's plastic and graphic works by the intermediary figure. Barlach's wish to express adequately such insights results in an increasing

tendency to rely on symbolic formal elements, that is, to reject iconicity, or the aesthetic norm. The floating figure, exemplified by the *Güstrower Ehrenmal*, seeks to transcend the realm of normality. His search for truth prompts a return to the self: his gaze is directed inward, arms embrace the self, lips are sealed. Abnegation of the realm of space and time on a purely physical level is urged by raising the bronze above the ground. The existence of "the intuition of the unattainable" is affirmed and its importance indicated by supporting the figure from above. The intersection of the arms of the *Güstrower Ehrenmal* at the chest forms a symbolic cross and underscores Barlach's preoccupation with the dialectic relation of thematic and formal opposites and his desire to synthesize them. In sum, the intermediary figure in all media represents this synthesis and demonstrates Barlach's belief that there is a significance to existence that transcends the average man, the iconic, the literal.

A detailed study of the intermediary figure lends credence to the unsupported claims, outlined in chapter 2, made by various interart scholars, including Bebermeyer, Günther, Schneider, Brinkmann, Böttcher and Mittenzwei, Weisstein and others that Barlach must be regarded as *doppelbegabt* and that there is furthermore a strong relation between his works of literature and his works in the visual arts. The working hypothesis stated at the end of chapter 2, which asserts that since intermediary figures frequently appear in Barlach's works in all media, there must be some relation among them, has been shown to be true, and the nature of the relation has been demonstrated. As a result, Just's remark—"Here we are neither faced with *Gesamtkunstwerke* nor with cases where a mutual illumination of the arts can be of assistance" (1975: 461)—and Chick's—"A discussion of [Barlach's] sculpture and graphic work . . . would only obscure the view of his plays and novels" (1967: 7)—have been shown to be largely unfounded. Clearly, one's understanding of the intermediary in one medium is furthered by an analysis of the intermediary as it appears in another medium; a mutual illumination of the arts, "wechselseitige Erhellung der Künste," is indeed productive. Such a comparative strategy conclusively demonstrates that, at least with respect to the intermediary figure, Barlach's works of literature bear a resemblance to his works in the visual arts.

Van Dyck notes that whereas there are a large number of Barlach studies that concentrate on either individual works or on works in one medium (1976: 5), "[there are] conspicuously few comparative and analytical discussions of Barlach's total oeuvre" (1976: 6). She furthermore asserts that a comparative study of Barlach's works in various media should prove rewarding. And yet, although I have shown van Dyck's assumptions to be correct to a large degree, it is nonetheless to be emphasized that such a study must be limited to a comparison of formal features. Only in this respect can Carls's contention that "there exist connecting lines between [Barlach's] sculptures, drawings and writings" (1969: 51) be clarified.

Consequently, my work here has gone well beyond the sort of compilation of motifs, or *Motivsammlung* one finds in a study such as Jackson's, the shortcomings of which are outlined in chapter 2. Although I too start with a recurring motif, the intermediary figure, and abide by Jackson's belief that one can trace patterns of development by proceeding with a chronological analysis of Barlach's works, I demonstrate that one recognizes a relation among the intermediary figures in the varying media primarily because of their underlying structural or formal similarities. In this regard, Jackson's basic assertion that "only when Barlach's work is viewed in its entirety can the significance of the individual parts be fully appreciated" (1950: 526–27) is shown to be correct.

When one concentrates on formal features that characterize Barlach's works, one can show that the artist strives for the same results in different media. One important implication of this finding is that a relation between works in differing media by any *Doppelbegabung* must be due to a similarity of formal features, expressive of a unified artistic vision.

# Appendix A

# Barlach, the Sculptor, in Decline

The Nazi takeover of power in Germany and the events that led up to it served drastically to undermine the creative climate that had sustained Barlach throughout the twenties. This period coincides with a noticeably less productive and less innovative phase of Barlach's career as a sculptor. Barlach did resume work on the *Fries der Lauschenden* in 1934, thanks to a contract furnished by the wealthy industrialist, Hermann F. Reemtsma (Barlach's works were already being censored by the Nazis). But the conception of this group of nine figures in wood dates to plastic sketches drawn in 1930 in response to a commission from Ludwig Katzenellenbogen (whom Tilla Durieux had married four years after the death of her first husband, Paul Cassirer, Barlach's publisher and art dealer. Barlach had completed three figures of the frieze during 1930–31 but then abandoned the project when Katzenellenbogen reneged on the contract (cf., for example, 16 March 1933; *Briefe II:* 360–61; Barlach writes to Katzenellenbogen asking for money owed him for completion of the third figure of the *Fries der Lauschenden*). The detailed drawings from 1930 are themselves actually an outgrowth of the unsuccessful *Beethoven-Denkmal* project Barlach had labored on in 1926.[1] This developmental chronology is cited as representative; a majority of the sculptures completed after 1933 hark back either to earlier detailed drawings or working models.[2] The remaining sculptures executed during the post-1933 era (cf. *Taufbecken I* and *II* and the busts of Ada Hoffmann, Willi Feine, Theodor Däubler and Leo von König), are far less innovative in every respect than works conceived before 1933.

Naomi Jackson, in her dissertation in 1950, applauds revivifications of earlier material:

> The fact that many of the late sculptures in wood turn back for inspiration to earlier drawings and plans need in no way be construed as a deadening of the creative spirit, a sign of "old age." It is rather a sign of unflagging power and zeal, utilizing the super abundance of former years to round out and fill to the brim a life devoted to creative activity. (482)

It need not be claimed that Barlach, in his later years, suffered a "weakening of the creative spirit" or the effects of "old age." But since one can find evidence of Barlach's originality in other media even after the Nazi takeover, notably in drawings and literature, his failure to execute original plastic material could not have been merely the result of a wish to round out his artistic career. Rather, Barlach's plastic oeuvre during the thirties was largely determined by historical and political, that is, external, circumstances.

As early as 1929, Barlach writes of mounting opposition to his public monuments. One reads in a letter to his brother Hans:

> I finally had to go to Kiel in order to see about the right wingers. The reception of the group [*Geistkämpfer*] is, as with that of the angel in the cathedral [*Güstrower Ehrenmal*], frosty and disapproving. Two days ago, the sword was even broken off during the night. All of the right-wing parties are letting it rip against me. All kinds of nonsense is being trumpeted loudly and with obvious pleasure. What is worse here is the rabble-rousing propaganda against me on the part of the nationalistic clubs, specifically *Stahlhelm*. My plans for a memorial in Malchin have been made into such an incident by them . . . that it is claimed that I signed the communist petition against the armoured cruisers. Every dog that bites . . . risks a stone's throw, but these gentlemen operate anonymously, out the fox-hole of irresponsibility. (22 January 1929; *Briefe II:* 147)

As has already been mentioned, Barlach did manage to realize a number of public monument commissions, including the *Güstrower Ehrenmal* (1927), *Kieler Geistkämpfer* (1928), *Magdeburger Ehrenmal* (1929) and the *Hamburger Relief* (1932), in spite of the controversy that surrounded their designs. And during these years of turmoil, Barlach did continue to receive private commissions.

Pressure exerted by right-wing organizations such as the *Stahlhelm* did, however, effectively block passage of proposals submitted by Barlach in both Malchin (1928–29) and Stralsund (1932–33). The Stralsund affair was particularly disappointing for Barlach. He had expected a bitter struggle after the city had requested he submit a monument proposal, but had nonetheless hoped for success: "[I] have been invited to submit plans for a memorial in Stralsund; the clients are local veterans groups. I predict no small measure of aggravation and frustration—but the thought of having a work in Stralsund is all too tempting" (1 October 1932; *Briefe II:* 324).

Two months later, having experienced difficulties with the selection committee, personal letters yield evidence both of Barlach's persistent optimism and of his increasing despair:

> My "work" has suffered the past several months in waiting for a decision about plans which I drew up for a Pomeranian city [Stralsund], mind you: at their invitation and at their request. Otherwise, I would have never ventured into Pomerania; and already this undertaking, arranged in such a manner, appears to me cheeky and pointless. (4 January 1933; *Briefe II:* 803)

You can imagine what sort of negotiations are involved with veterans groups when it comes to a memorial! But who would not give one little finger or both for the sake of a commission in Stralsund! The rest of my fingers are indispensable, because after all, I do have to work. (Christmas 1932; *Briefe II:* 341)

After more than six months of negotiations, Barlach concedes defeat by "voluntarily" withdrawing his monument proposal: "Six months I waited for a commission in Stralsund until I myself, not without strong prompting, withdrew the plans so as to spare myself even greater hardship" (28 March 1933; *Briefe II:* 365–66).

The demise of the Stralsund project marks the beginning of the end for Barlach, the sculptor. There is a direct correlation between the lack of monument commissions and lack of private commissions. As early as July 1933, Barlach appears almost without means of support. He writes to his good friend, the publisher Reinhard Piper: "Commissions? No one, with the exception of one solitary private citizen, who could only pay a pitifully small amount, risks a venture with me" (16 July 1933; *Briefe II:* 385). And then begins the era of persecution. In 1933, by decision of the "Church Council of the Magdeburg parish," the *Magdeburger Ehrenmal* is removed to the Nationalgalerie in Berlin, where it is put "in storage."[3] In 1935, *Das Wiedersehen* (1926, in wood) is removed from the Landesmuseum in Schwerin (the smaller bronze version [1926] was shown at the *Entartete Kunst* exhibition in Munich in July of 1937). In 1936, the book *Ernst Barlach. Zeichnungen* (Fechter, 1935),[4] published by Rheinhard Piper, is confiscated by the Bavarian secret police (a copy of this, also, was displayed at the *Entartete Kunst* exhibition), prompting Barlach to write letters of protest to Joseph Goebbels (25 May 1936; *Briefe II:* 636–48) and to the Gestapo (4 June 1936; *Briefe II:* 640–43), to which there were no replies.[5] Also occurring in 1936, in November: Barlach's works (and Lehmbruck's and Kollwitz's) were removed from the Jubiläumsausstellung der Preußischen Akademie der Künste, entitled "Berlin Sculptors from Schlüter to Present Day" (*Schult I*, 258). In 1937, monuments by Barlach were taken down in two more cities: in Kiel, on April 20th, and in Güstrow, on August 24th. Barlach's relief in Hamburg was removed in 1938. During the Nazi era, according to one statistic, 381 works by Barlach were either removed or confiscated (Rave, 1949: 85).[6]

One certainly does observe the influence of external circumstances on the makeup of Barlach's plastic oeuvre during the thirties, contrary to the misconception propagated by Jackson. Had Barlach not suffered the agonies of fascist persecution, such plans as those drawn up for the proposed monument in Stralsund might have been accepted and Barlach might have continued to pursue actively the formally innovative ideas that characterize his works of the late twenties and early thirties.

# Appendix B

# Scholarly Neglect of the Posthumous Publications

Regardless of the literary merits of the posthumously-appearing fragments, historical circumstances have clearly worked to the advantage of the dramas published during Barlach's lifetime. The Paul Cassirer Verlag issued the dramas and the limited-edition-format portfolios of illustrations that Barlach executed to accompany them, with the exception of *Der Graf von Ratzeburg* (where incidentally, no illustrations are found). Cassirer also published Barlach's autobiographical *Ein selbsterzähltes Leben* (1928), numerous lithographs (for example, those appearing in *Kriegszeit* [1914–16] and *Bildermann* [1916]—both Cassirer ventures) and woodcuts (to Rheinhold von Walter's poem "Der Kopf" [1919], *Die Wandlungen Gottes* [1922], Goethe's *Walpurgisnacht* [1923], Schiller's *An die Freude* [1927], etc.). Paul Cassirer, who headed the publishing conglomerate bearing his name, also served as Barlach's art dealer. Karl Scheffler (1869–1951), an influential art critic of Barlach's generation, who himself had written on Barlach as early as 1901, describes the nature of the relationship between Cassirer and Barlach:[1]

> Paul Cassirer worked hard [to promote] Barlach, his entire production, that of the sculptor and also that of the dramatic poet. Paul Cassirer was a good judge of character, when he wanted to be one, and in this case, he wanted to be one. He knew to handle [Barlach's] fear of people carefully, and [Barlach] tolerated the promotion, because he was, as a result, free of all worries and could work undisturbed. . . . He was happy that all business matters were taken care of for him. (Scheffler, 1946: 132–33)[2]

Barlach had been brought to Cassirer's attention in 1906 by the artist August Gaul. By 1907, Cassirer had offered Barlach a contract which guaranteed a stipend in exchange for the artist's noncommissioned works, or "freie Arbeiten" (Cassirer and Gaul had a similar arrangement). This contract was honored by the firm Cassirer had headed even after his suicide in 1926. As Barlach relates, however, he was "always at liberty to accept commissions" (15 January 1926; *Briefe II:* 49); that is: "I can accept outside commissions without consulting with Cassirer and [without having to be concerned with his] sales commission" (20

November 1928; *Briefe II:* 138). Generally speaking, however, Barlach's main source of income from 1907 to 1927 appears to have been derived from Cassirer's stipends. The effect this business arrangement had on the distribution of Barlach's sculpture, or in this case the lack thereof, is seldom examined. Leo Kestenberg, "advisor to Paul Cassirer and temporary director of his publishing firm" (Jansen, 1972: 529), and also well known to and highly regarded by Barlach,[3] saw in Cassirer a second René Cardillac, a reference to the jeweller in E.T.A. Hoffmann's novella *Das Fräulein von Scuđri* who could not bear to part with his creations: "For many years, Cassirer—like a second Cardillac—could not part with Barlach's works. He had marked up the prices so high that they were hardly affordable" (in Jansen, 1972: 246).

This is, however, not to imply that Cassirer did not exhibit the art works he received from Barlach. It could be argued that the prominent display of Barlach works in major exhibitions "arranged" by Paul Cassirer served to draw them to the attention of art critics. Indeed, Paul Cassirer played an important role in furthering the careers of many aspiring artists: his was a strong voice in the *Sezession* (as early as 1907, Barlach, too, had two works entered in one of the group's exhibitions) and his own gallery furnished the opportunity for many artists to promote their works.[4] It is unfortunate that the correspondence between Barlach and Cassirer is unavailable: "The correspondence with Paul Cassirer has yet to surface; the archive of the publishing firm and art dealership . . . is at present presumed lost" (Jansen, 1972: 36). The relationship between Cassirer and Barlach was undoubtedly a determining factor in the public's perception of Barlach as sculptor and graphic artist until well into the mid-twenties. But by the time of Cassirer's suicide in 1926 at the latest, circumstances had changed. The monument commissions for Güstrow, Kiel, Magdeburg and Hamburg, where they were executed, and Malchin and Stralsund, where proposals were solicited of Barlach but never implemented, and the number of lucrative private commissions indicate that Barlach, by the mid-to-late-twenties, had gained a considerable public following that extended beyond any sphere of influence over which Cassirer could ever have presided.

While Cassirer's actions vis-à-vis Barlach's sculpture could, in certain respects, be negatively assessed, his role as Barlach's publisher can only be positively perceived.[5] His fostering of Barlach's literary endeavors and, equally important, their accompanying "illustrations" is well documented in various letters written by Barlach himself. Thus, from a production and dissemination standpoint, in every medium, we owe much to the efforts of Paul Cassirer.

The attention devoted by literary historians to *Der tote Tag* (1912), *Der arme Vetter* (1918), *Die echten Sedemunds* (1920), *Der Findling* (1922), *Die Sündflut* (1924), *Der blaue Boll* (1926) and *Die gute Zeit* (1929) can be attributed not only to Paul Cassirer's generosity as a publisher, but also to a variety of other circumstances. These dramas were frequently performed during the twenties and

early thirties when Barlach was at the apex of his career as a sculptor: there were even performances as late as 1935, long after Barlach had been blacklisted by the Nazis. Furthermore, these dramas were staged in many large cities known for their theater (Berlin, Munich, Hamburg, Düsseldorf, Stuttgart and Leipzig) by capable acting companies. The stagings were orchestrated by well-known directors, such as Jürgen Fehling (Berlin), Kurt Eggers-Kestner (Altona), Leopold Jeßner (Berlin), Gustav Lindemann (Düsseldorf) and Edzard Schaper (Stuttgart: "At that time [1926], assistant director" [Graucob, 1969: 113)), whose reputations, to an extent, justified the plays selected for performance. Chick, however, correctly notes: "The destinies of Barlach's dramas on the stage fall into no distinct pattern, nor can the frequency or infrequency of their inclusion in the repertoires of German theaters be easily explained" (1967: 125). The publication and the performances of the aforementioned Barlach dramas, regardless of the success or failure of their stagings, generated critical discussions in newspapers and journals which were in turn read by a great number of people. Dietrich Fleischhauer's dissertation, *Barlach auf der Bühne. Eine Inszenierungsgeschichte* (1956) details the staging histories of the Barlach dramas. Chick provides critical analyses of their theatrical fortunes and concludes that directorial misinterpretation of Barlach's dramatic intention, and Jeßner is singled out for particular criticism, did the worst damage to the play's popularity. There is, however, no Barlach bibliography to which one can refer for a comprehensive listing of the staggering number of Barlach book reviews or performance reviews published in newspapers and periodicals during the twenties and early-to-mid thirties.

Elmar Jansen does endeavor to bring to light a largely neglected body of primary material related to Barlach's works. In just two chapters of his book (1972), for example, "The Dramatist—Book Editions—Premiere Performances 1917–29" (109–66) and "The Berlin Productions in the Eyes of the Critics (1921–1930)" (167–212), 48 reviews, articles and commentaries are reproduced, albeit with a certain amount of editing.[6] Jansen opts for a cross-sectional approach to each topic, selecting material from a variety of critical directions. Thus one's conception of how Barlach and his dramatic works were regarded during the artist's lifetime is greatly expanded. Jansen's book contains a wealth of material; but the most useful tools are lacking: chronological or alphabetical indexes.

The continuity of production and dissemination (thanks to Cassirer) of the dramas appearing during Barlach's lifetime and the vast number of book and performance reviews (as indicated by, e.g., Jansen) contrasts with the very different production and dissemination of the posthumously-appearing fragments and the effects they have had on both the general public and on literary critics.

*Der Graf von Ratzeburg* first appeared in 1951 as a collector's edition (Flemming, 1958: 226) edited by Friedrich Schult and published by the Grillen-Presse. Schult, a longtime acquaintance of Barlach's (dating back to

1914 [Jansen, 1972: 540]), headed the Barlach estate, or *Barlach-Nachlaß*, in Güstrow from 1945 to 1976 and edited the oeuvre catalogs, with assistance from the Deutsche Akademie der Künste in Berlin. The first edition of *Der Graf von Ratzeburg* was limited to 180 copies, which thus made it unavailable to the general public.[7] It was furthermore rarely discussed in the periodicals of the time, in stark contrast to the reception enjoyed by the earlier dramas. Barlach scholars accorded importance to *Graf von Ratzeburg*, but it was not until the edition of Barlach's collected works published by Piper in 1956–59 that the unfinished drama gained a more widespread audience.[8]

Barlach's novel-fragments, *Seespeck* and *Der gestohlene Mond*, were first published separately by Fischer Verlag in 1948. Both were edited by Friedrich Dross and based "on Ernst Barlach's hand-written manuscript" as the title page to *Gestohlener Mond* indicates. Neither publication was without its weaknesses, as subsequent editions make clear (*Prosa I* [1958] and *Prosa II* [1959] from the collected works edition published by Piper).

*Seespeck* was written by Barlach between 1912 and 1915. It displays serious formal flaws and logical defects and can hardly be considered a polished product. Barlach's habit of reworking material several times before final publication does not apply to *Seespeck*": "In the case of *Seespeck*," as Daniel Charles O'Neil notes, "the process of revision was not even begun" (1966: 89). Isolated sections are, however, extremely well written: Chick, for example, observes that the episode involving Seespeck, Hannis and Burr is a superb instance of Barlach's use of grotesque humor (1967: 60–67).

Whereas each of the dramas which appeared during Barlach's lifetime follows a clean copy, or *Reinschrift*, prepared by Barlach, *Der Graf von Ratzeburg* as published today apparently follows a preliminary draft.[9] The earliest plans for *Graf von Ratzeburg* were conceived in 1925. The manuscript upon which the published text is based contains the following comments by Barlach on the inside cover of the first book:

> St[arted], beg[inning] of January 1927
> E Barlach
> Güstrow Schwerinerstr. 22
> completed May 15, 1927
> revised, read, let lie, etc., Christmas 1934
> January again at it March 1935
> Wish to complete and to expand with already written scenes. Nov[ember] 1936
> Have been however since April 10 on "Gestohlener Mond"
>
> (Schult: 1951: 93)

A conviction that Barlach did at some point prepare a *Reinschrift* is supported by the following evidence noted by Schult in the 1951 collector's edition:

There has been, in the mean time, no trace of either a clean copy on folio of the sort Barlach usually submitted for printing or the "already written scenes," so frequently mentioned. . . . These scenes must have been either revisions or cleaner forms of scenes already present in the rough draft or new scenes with which Barlach later expanded the piece. Thus the only scene released by the artist as truly finished is the one reprinted in the *Zeitschrift für Musikpflege*, of which the . . . Barlach-estate does not possess a clean copy. (94)

Klaus Lazarowicz, who wrote the "Nachwort" to *Dramen*, supports the opinion that a clean copy was prepared but no longer exists (1956: 618). Chick too accepts this view (1967: 84). Thus the 1951 edition of *Graf von Ratzeburg*, subsequently republished in *Dramen* in 1956, cannot be considered a final version. The view that we have only a preliminary copy would then account for many of the textual flaws: "The text known to us today exhibits a number of discrepancies, vagaries, gaps and inconsistencies" (Graucob, 1969: 117). Despite its unfinished form, many a Barlach expert—Graucob, Lazarowicz or Lietz, for example—considers *Graf von Ratzeburg* to be one of Barlach's main works.

While *Der Graf von Ratzeburg*'s significance to one's conception of Barlach the dramatist cannot be discounted, I would have to agree with a contention voiced by many other scholars that the drama, as a fragment which exists only in preliminary-draft form, is "too loosely constructed [and is] overladen with symbolic characters and deeply felt but poorly articulated ideas" (Chick, 1967: 84). Furthermore, it is important to note that Barlach abandoned *Graf von Ratzeburg* to work on *Der gestohlene Mond*—perhaps an indication that the poet himself was not totally satisfied with the progress of the drama.

Barlach worked on *Der gestohlene Mond* from April 10, 1936 until about November 19, 1937, according to dates and events he noted, almost diarylike, along the margins of the surviving manuscript.[10] One can only speculate why Barlach ceased working on his novel, as he did continue to write letters during 1938. Apparently, failing health deprived him of the motivation necessary for any concentrated artistic efforts. Barlach had stayed in the Harz region for nearly two months for reasons of health (late December of 1937 through mid-February of 1938). By September of 1938, he had entered a clinic in Rostock, where he remained until his death on October 24 of the same year. For the year 1938, one finds that Barlach executed only 14 uninspired drawings and two crude plastic sketches, all done in May and June, detailing plans for a proposed baptismal font.

Chick ranks *Der gestohlene Mond* in its importance for the novel as a literary form alongside Kafka's *Schloß* and Musil's *Mann ohne Eigenschaften*—experimental novels and also fragments. He also writes that only *Gestohlener Mond* truly displays Barlach's verbal virtuosity: "Barlach carries his stylistic principle of being significant in a casual way to new extremes" (1967: 99). And yet, Chick does not pursue this observation.

Three dissertations written in the 1950s are devoted to various aspects of *Gestohlener Mond:* Horn, 1952; Schmidt-Henkel, 1956; and Schweizer, 1959. Schweizer's dissertation, subsequently republished as a monograph (1959), remains one of the most thorough and insightful analyses of any of Barlach's works. Most established scholars, however, writing on either expressionism or literature from the twenties and thirties, largely overlook the unfinished novel, as they do the *Graf von Ratzeburg*.

A variety of circumstances worked in favor of those dramas published during Barlach's lifetime. There was time to prepare clean copies; Barlach knew that Paul Cassirer was an enthusiastic publisher. The dramas were performed during the twenties and early thirties when Barlach's works in all media enjoyed considerable popularity. The wealth of articles in newspapers and periodicals helped to further cement the public's conception of Barlach, *der Dichter*, based on these dramas. *Der Graf von Ratzeburg* and *Der gestohlene Mond*, on the other hand, have always been virtually forced into obscurity: their initial publication (and performances, in the case of *Graf von Ratzeburg*) did little to promote their popularity. In contrast to the reception by journalists and critics of the dramas published during Barlach's lifetime, there has been considerably less mention of the posthumously-appearing fragments. Only a limited number of devoted Barlach scholars have sought to promote the importance of these two works. Established literary scholars even today approach Barlach via his earlier dramas. I hope to reverse this trend.

# Alphabetical List of Figures

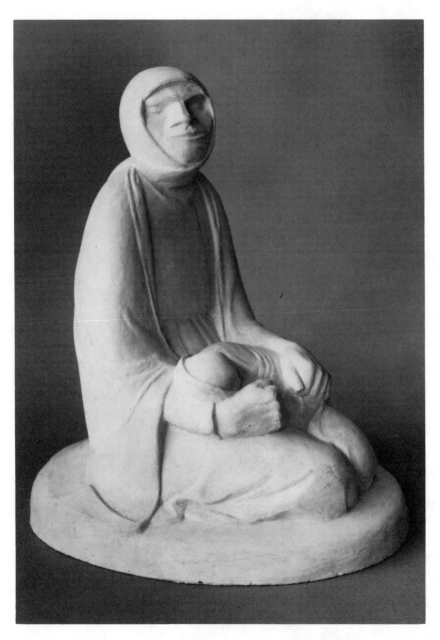

Figure 1.  *Blinde Bettlerin mit Kind,* 1907 *(Schult I: 73)*
Plaster.
*(Photograph by Hans Cordes)*

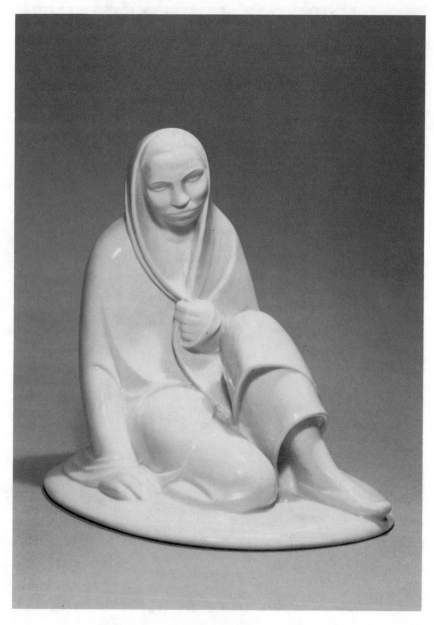

Figure 2.   *Sitzendes Mädchen*, 1908 (*Schult I:* 83)
Porcelain.
*(Photograph by Heinz-Peter Cordes)*

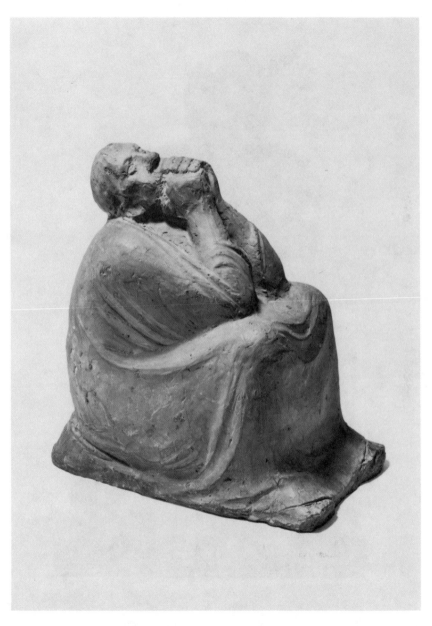

Figure 3.    *Sterndeuter II*, 1909 (*Schult I:* 99)
Terra cotta.
*(Photograph by Heinz-Peter Cordes)*

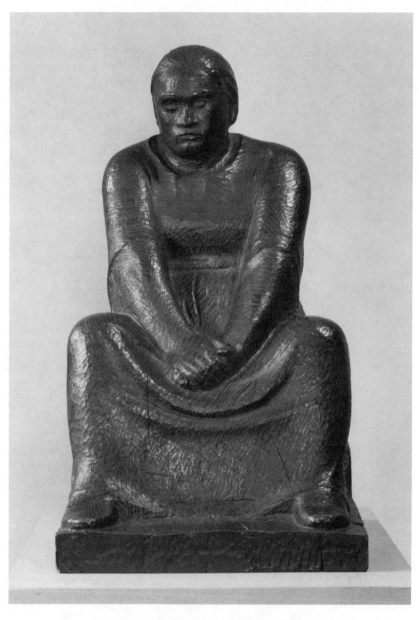

Figure 4.   *Sorgende Frau*, 1910 (*Schult I:* 103)
Wood (oak).
*(Photograph by Heinz-Peter Cordes)*

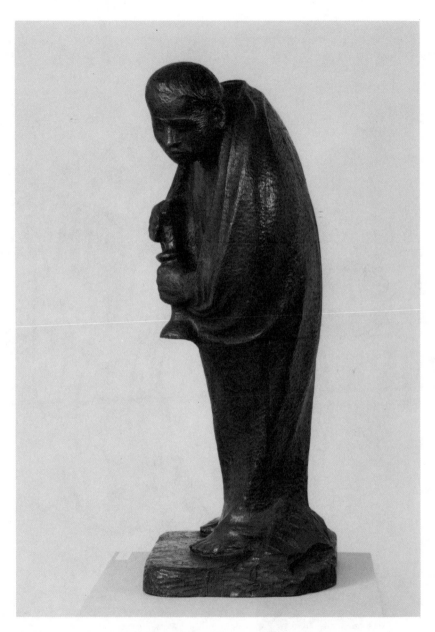

Figure 5.   *Der Einsame*, 1911 (*Schult I:* 117)
Wood (oak).
(*Photograph by Heinz-Peter Cordes*)

Figure 6. "Der Traum," 1912 (*Schult III*: 946)
Charcoal.
(*Photograph by Heinz-Peter Cordes*)

Figure 7.   "Schwebender," 1912 (*Schult III:* 976)
Charcoal.
*(Photograph by Heinz-Peter Cordes)*

Figure 8.   "Schwebender," 1912 (*Schult III:* 979)
Charcoal.
*(Photograph by Heinz-Peter Cordes)*

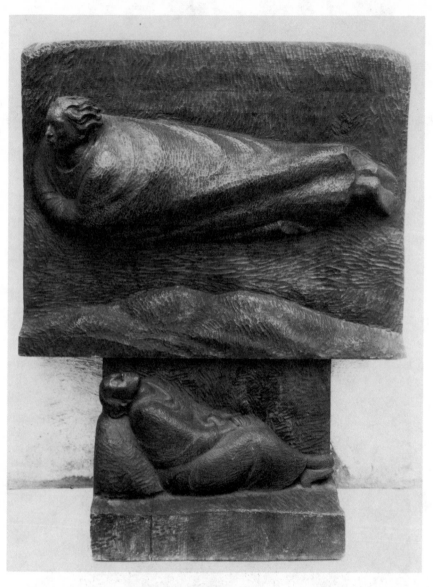

Figure 9.   *Die Vision*, 1912 (*Schult I:* 123)
High relief in wood (oak).
*(Staatliche Museen Preußischer Kulturbesitz,*
*Nationalgalerie, Berlin; photograph by Jörg P. Anders)*

Figure 10. "Verdammte im Feuersturm," 1912 (*Schult III:* 1005)
Charcoal.
*(From* Schult III: *128)*

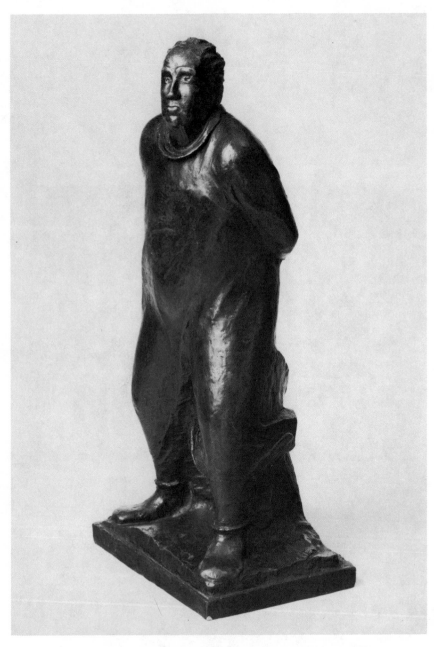

Figure 11.  *Der Spaziergänger*, 1912 (*Schult I:* 135)
Bronze, ca. 1930, from plaster working model.
*(Photograph by Heinz-Peter Cordes)*

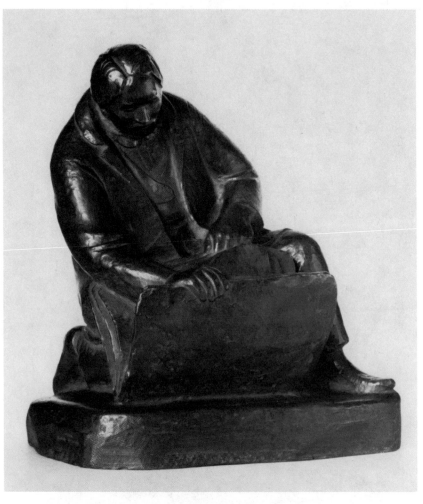

Figure 12.  *Der Sammler,* 1913 (*Schult I:* 156)
Bronze, ca. 1930, from plaster working model.
*(Photograph by Hans Cordes)*

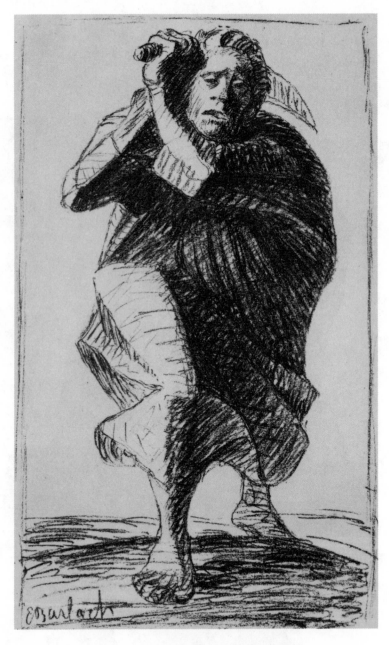

Figure 13. *Der heilige Krieg*, 1914 (*Schult II: 65*)
Lithograph. See also *Der Rächer*.
*(Photograph by Heinz-Peter Cordes)*

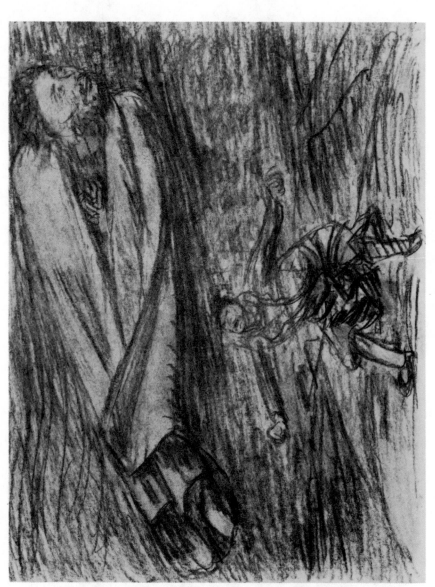

Figure 14. "Armer Vetter und hoher Herr," 1917 (*Schult III*: 1204)
Charcoal.
(*Photograph by Hans Cordes*)

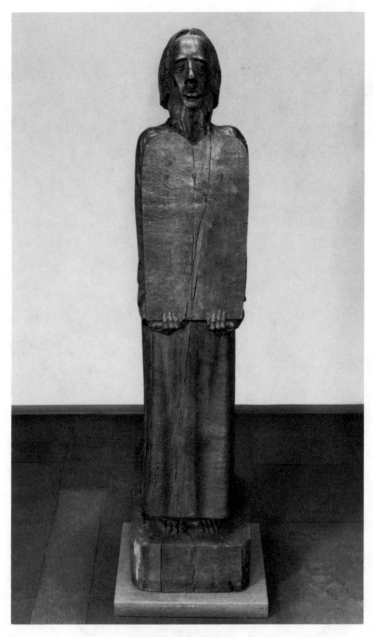

Figure 15.   *Moses*, 1918 (*Schult I:* 210)
Wood (oak).
*(Photograph by Heinz-Peter Cordes)*

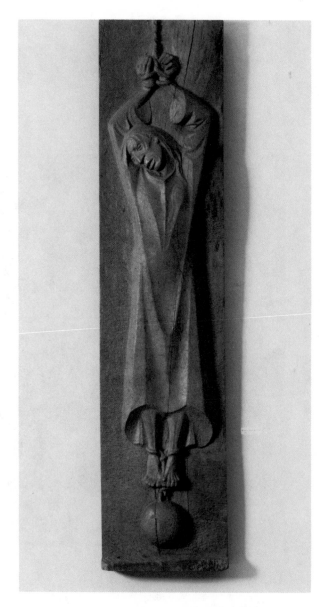

Figure 16.   *Die gemarterte Menschheit*, 1919
            (*Schult I:* 211)
            Wood (oak).
            (*Photograph by Heinz-Peter Cordes)*

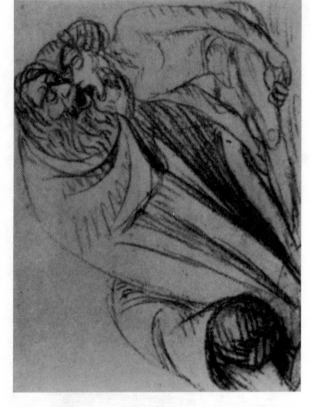

Figure 17. "Erschaffung Adams," 1920 (*Schult III*: 1416)
Charcoal (lost in 1945).
(*From* Schult III: *176*)

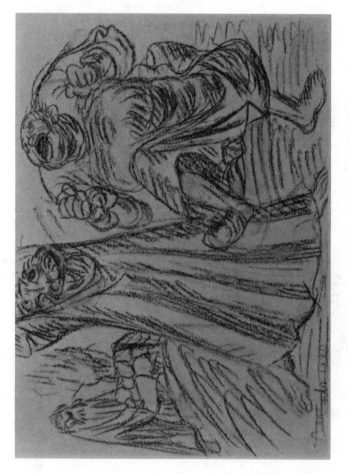

Figure 18. "Bekenner und Lästerer," 1920 (*Schult III:* 1417)
Charcoal.
*(From Gross, 1967; picture 3)*

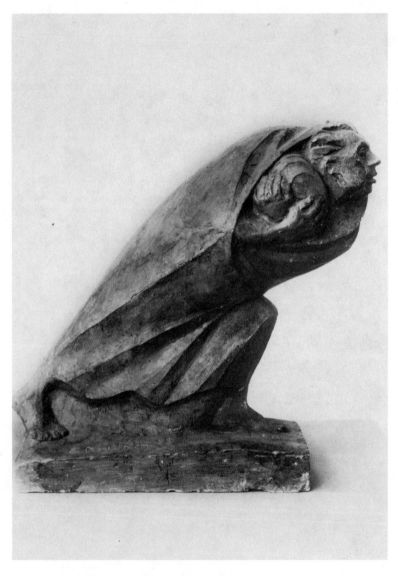

Figure 19.  *Der Flüchtling*, 1920 (*Schult I: 226*)
Clay.
*(Rembrandt Verlag, Berlin; photograph by B. Kegebein)*

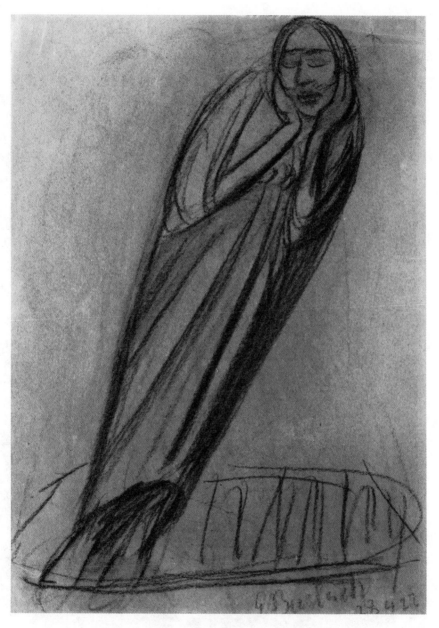

Figure 20.   "Aufschwebende," 1922 (*Schult III:* 1633)
Charcoal.
*(Photograph by Heinz-Peter Cordes)*

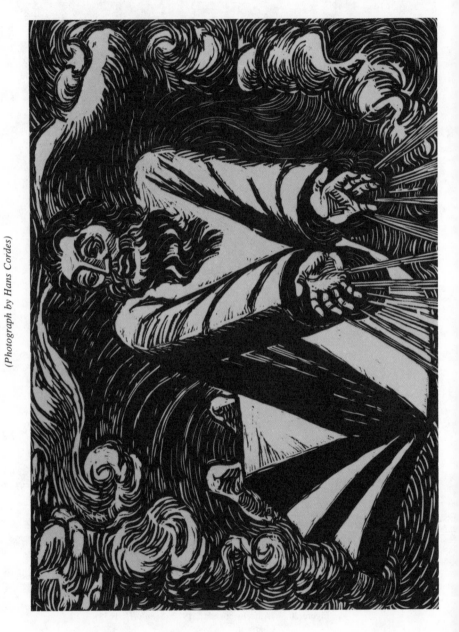

Figure 21. *Der erste Tag*, 1922 *(Schult II: 164)*
Woodcut.
*(Photograph by Hans Cordes)*

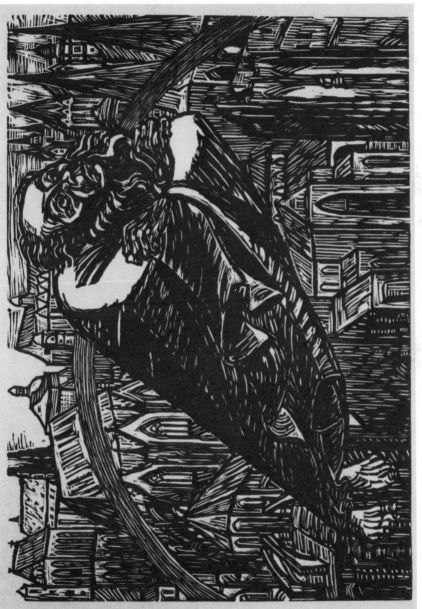

Figure 22. *Die Dome*, 1922 (*Schult II:* 165)
Woodcut.
*(Photograph by Heinz-Peter Cordes)*

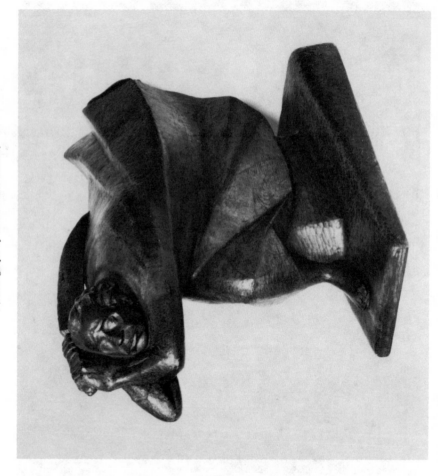

Figure 23. *Der Rächer*, 1922 *(Schult I: 271)* Wood (linden). See also *Der heilige Krieg*. *(Photograph by Heinz-Peter Cordes)*

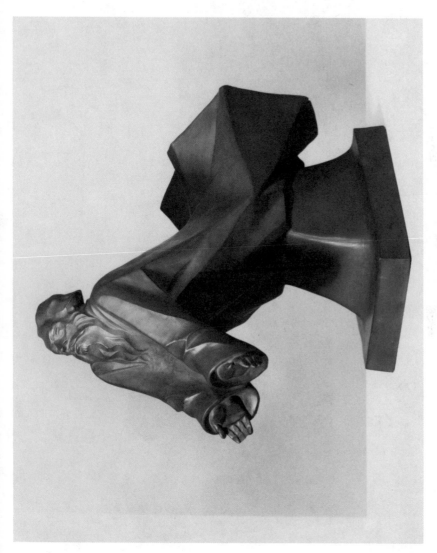

Figure 24.  *Schwebender Gottvater*, 1922 *(Schult I: 276)*
Meißen; Böttger-Stoneware.
*(Photograph by Heinz-Peter Cordes)*

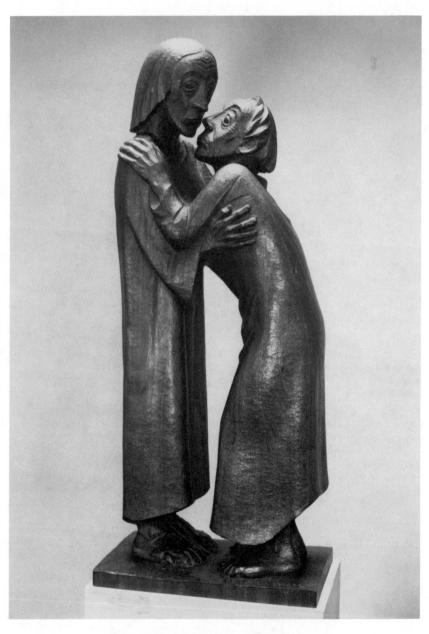

Figure 25. *Das Wiedersehen*, 1926 (*Schult I:* 307)
Wood (Sapeli mahogany).
*(Photograph by Heinz-Peter Cordes)*

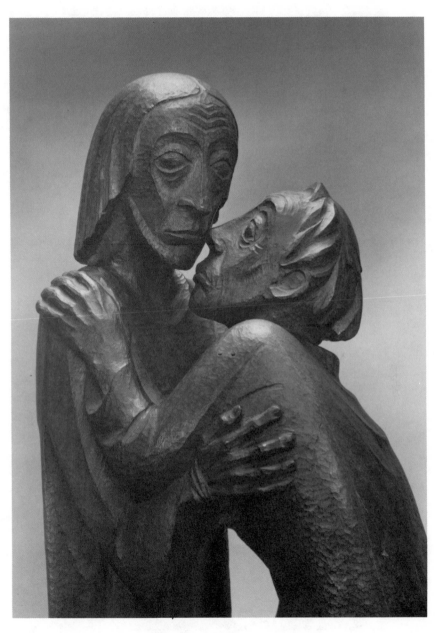

Figure 26. *Das Wiedersehen*, 1926, Detail
*(Photograph by Heinz-Peter Cordes)*

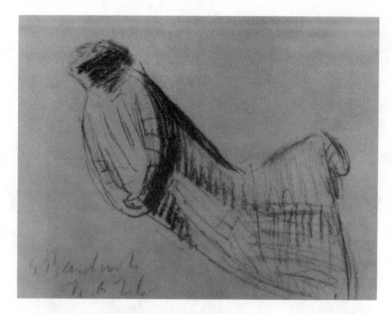

Figure 27. "Entwurf zum *Güstrower Ehrenmal*," 1926 (*Schult III:* 1848) Charcoal.
*(From Jansen, 1981, 2:97; photograph: Akademie der Künste der DDR/Deutsche Fotothek, Dresden)*

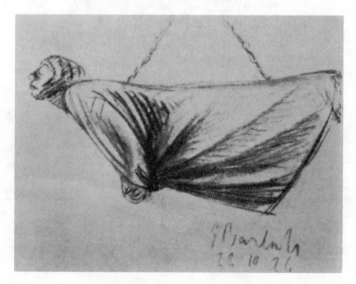

Figure 28. "Entwurf zum *Güstrower Ehrenmal*," 1926 (*Schult III:* 1851) Charcoal.
*(From* Schult III: *228)*

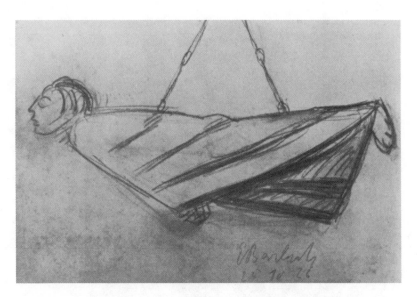

Figure 29. "Entwurf zum *Güstrower Ehrenmal*," 1926 (*Schult III:* 1852)
Charcoal.
*(From Groves, 1972: picture 99; photograph: Barlach Estate, Güstrow)*

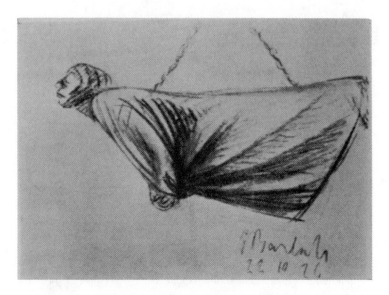

Figure 30. "Entwurf zum *Güstrower Ehrenmal*," 1926 (*Schult III:* 1853)
Charcoal.
*(Photograph by Heinz-Peter Cordes)*

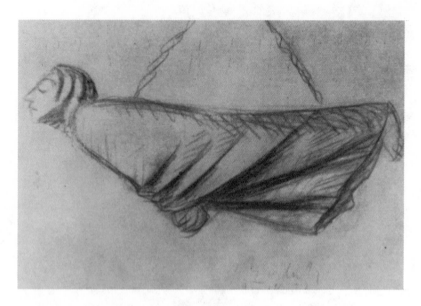

Figure 31.   "Entwurf zum *Güstrower Ehrenmal*," 1926 (*Schult III:* 1855)
Charcoal.
*(From Jansen, 1981, 2:98; photograph: Akademie der Künste der DDR
[Christian Kraushnaar])*

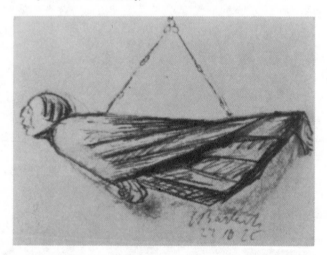

Figure 32.   "Entwurf zum *Güstrower Ehrenmal*," 1926 (*Schult III:* 1856)
Charcoal.
*(From* Schult III: *229)*

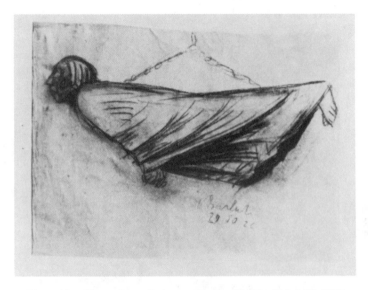

Figure 33. "Entwurf zum *Güstrower Ehrenmal*," 1926 (*Schult III:* 1857)
Charcoal.
*(From* Ernst Barlach Haus Stiftung Hermann F. Reemtsma:
Plastiken, Kandzeichnungen, Autographen, *1977:84;*
*photograph Ingeborg Thormann)*

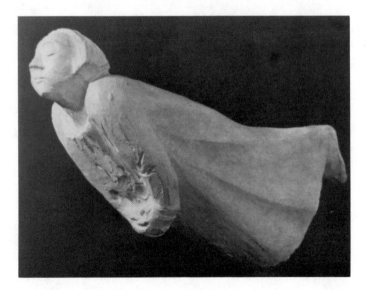

Figure 34. *Das Güstrower Ehrenmal* (Vorentwurf), 1927 (*Schult I:* 332)
Relief (plaster).
*(From* Schult I: *186)*

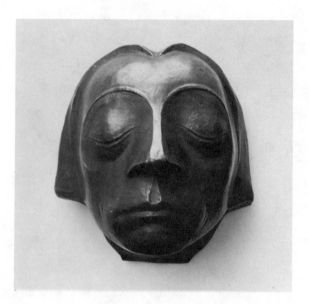

Figure 35.  *Kopf des Güstrower Ehrenmals*, 1927 (*Schult I:* 336)
Bronze.
*(Öffentliche Kunstsammlung Basel, Kunstmuseum)*

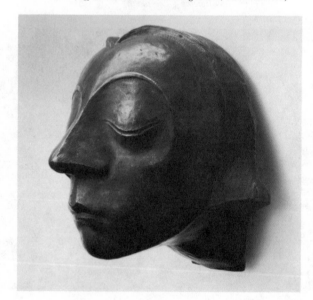

Figure 36.  *Kopf des Güstrower Ehrenmals*, 1927 (*Schult I:* 336)
Bronze.
*(Öffentliche Kunstsammlung Basel, Kunstmuseum)*

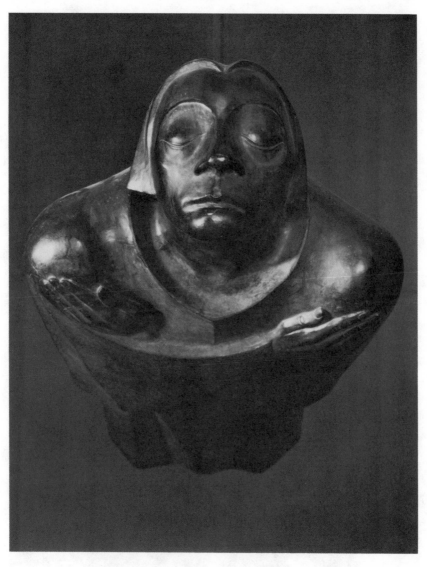

Figure 37.   *Das Güstrower Ehrenmal*, 1927 (*Schult I:* 336)
Bronze (post-World War II).
*(Photograph by Heinz-Peter Cordes)*

Figure 38.  *Das Güstrower Ehrenmal*, 1927 (*Schult I: 336*)
Bronze (post-World War II).
*(By permission: Deutscher Kunstverlag, Munich and Berlin; photograph by Elisabeth Sorge)*

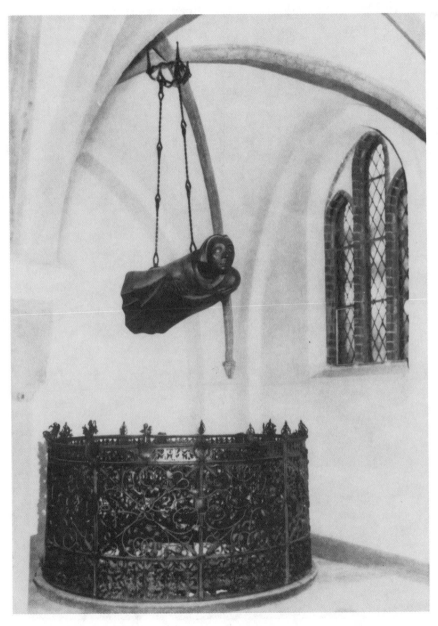

Figure 39.  *Das Güstrower Ehrenmal* (in Güstrow), 1927 (*Schult I:* 336)
Bronze.
*(From Fühmann, 1970: 150; photograph by Gisela Patsch)*

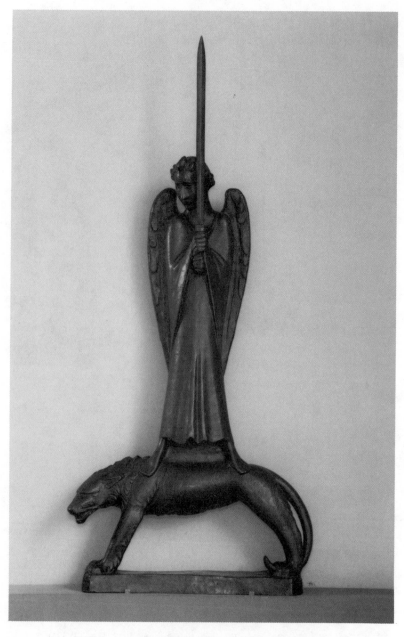

Figure 40.  *Der Geistkämpfer Kiel,* 1928 (*Schult I:* 339)
Bronze from 1:4 scale plaster working model.
*(Photograph by Heinz-Peter Cordes)*

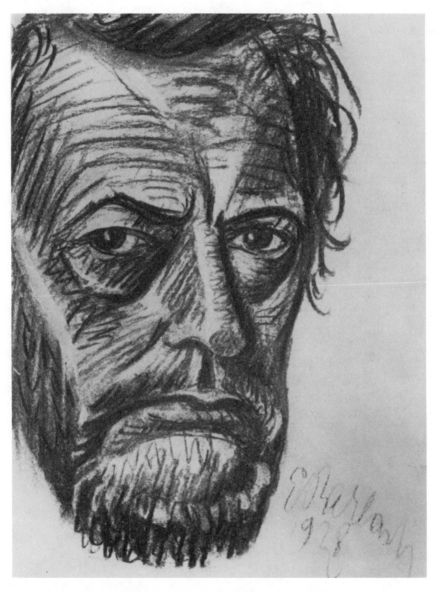

Figure 41. "Selbstbildnis," 1928 (*Schult III:* 1949)
Charcoal.
*(Bildarchiv Foto Marburg)*

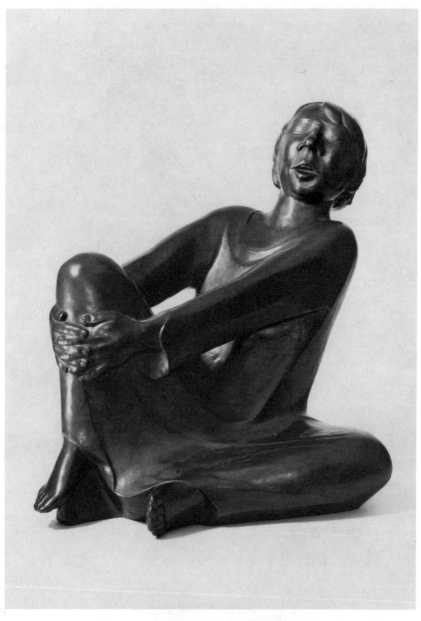

Figure 42.   *Der singende Mann*, 1928 (*Schult I:* 343)
Bronze from plaster model.
*(Photograph by Heinz-Peter Cordes)*

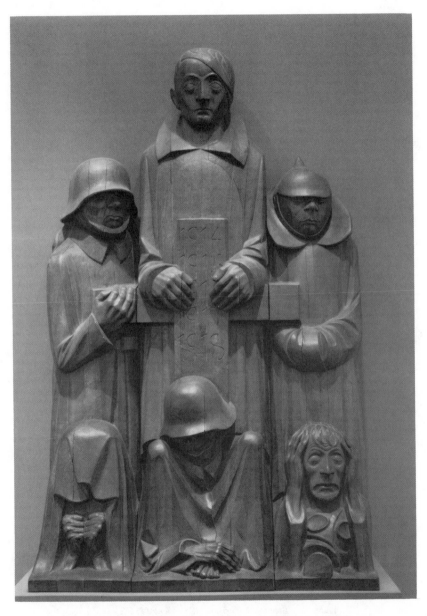

Figure 43. *Das Magdeburger Ehrenmal*, 1929 (*Schult I:* 349)
Wood (oak).
*(Photograph by Heinz-Peter Cordes)*

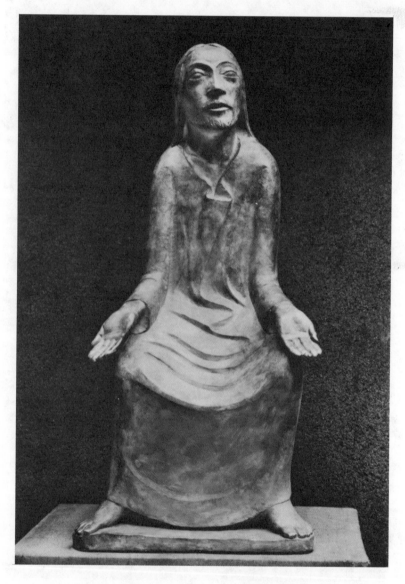

Figure 44.  *Lehrender Christus*, 1931 (*Schult I:* 372)
Plaster.
*(Bildarchiv Foto Marburg; Archiv-Nr. 89886)*

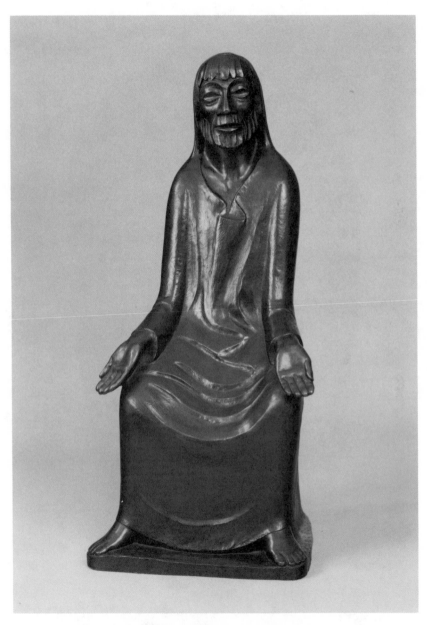

Figure 45.   *Lehrender Christus,* 1931 *(Schult I:* 373)
Bronze casting (post-World War II).
*(Photograph by Hans Cordes)*

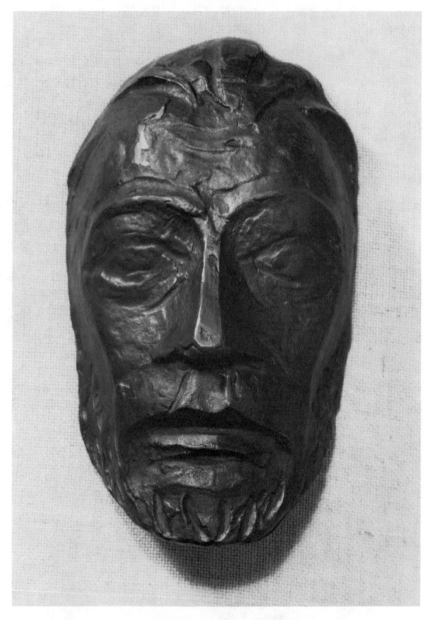

Figure 46.    *Christusmaske I*, 1931 *(Schult I:* 375)
Bronze from plaster model.
*Photograph by Heinz-Peter Cordes)*

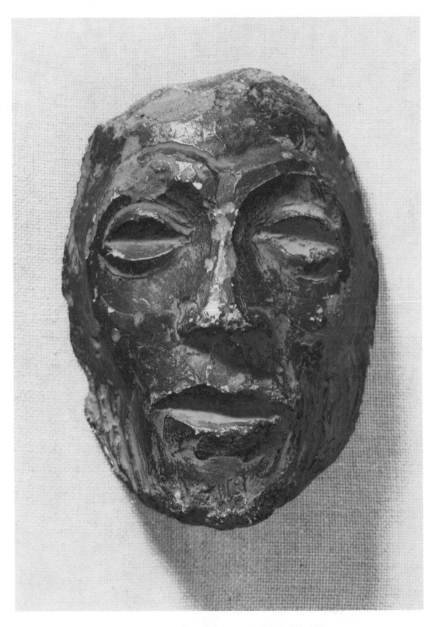

Figure 47.   *Christusmaske V*, 1931 (*Schult I:* 381)
Bronze from stucco model.
*(Photograph by Heinz-Peter Cordes)*

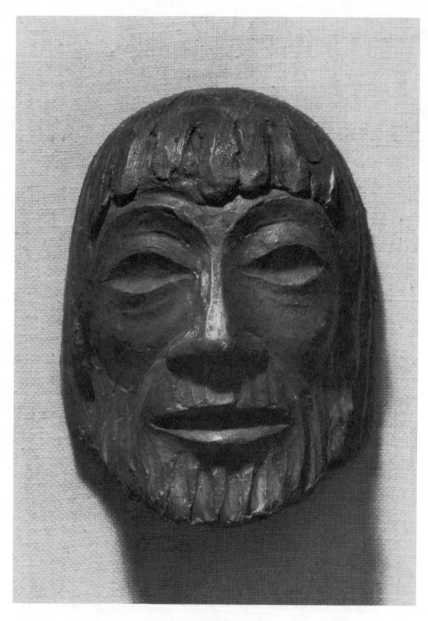

Figure 48.   *Christusmaske VI*, 1931 (*Schult I:* 383)
Bronze from stucco model.
*(Photograph by Heinz-Peter Cordes)*

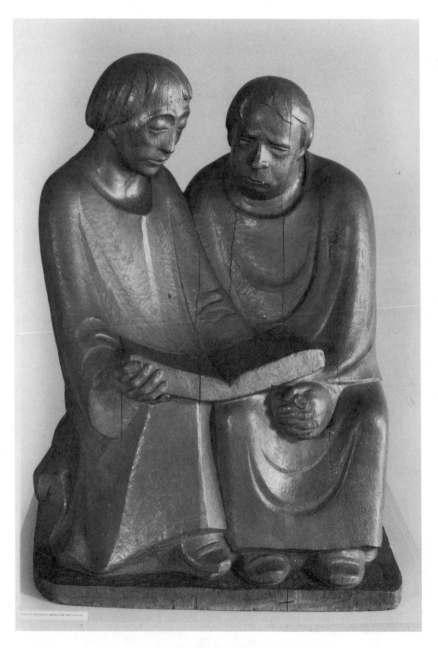

Figure 49. *Lesende Mönche III*, 1932 (*Schult I: 423*)
Wood (oak).
*(Photograph by Heinz-Peter Cordes)*

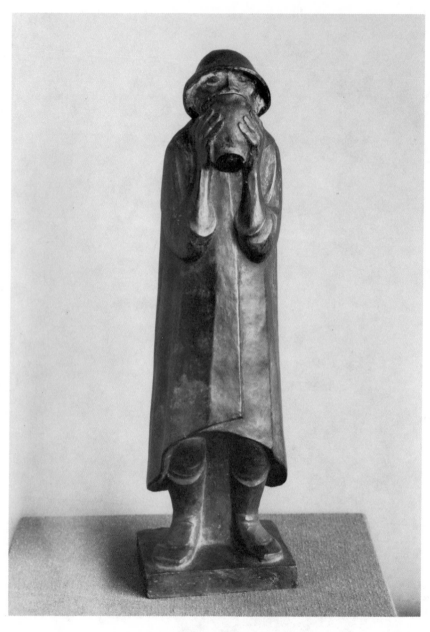

Figure 50.   *Der Trinker*, 1933 (*Schult I:* 437)
Bronze from plaster model.
*(Photograph by Heinz-Peter Cordes)*

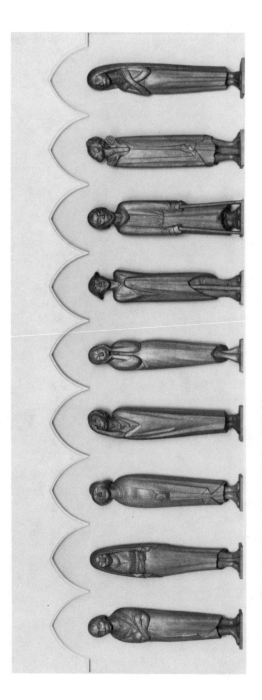

Figure 51.   *Fries der Lauschenden*, 1930–35
Wood (oak). Left to right: *Der Empfindsame* (1935, I: 462); *Die Träumende* (1931, I: 371); *Die
Pilgerin* (1934, I: 454); *Der Begnadete* (1935, I: 457); *Die Tänzerin* (1931, I: 370); *Der
Wanderer* (1930, I: 351); *Der Blinde* (1935, I: 460); *Der Gläubige* (1934, I: 452); *Die
Erwartende* (1934, I: 456)
*(Photograph by Heinz-Peter Cordes)*

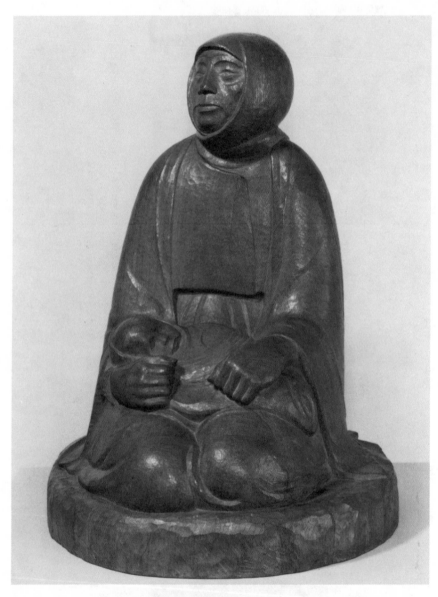

Figure 52.   *Mutter und Kind*, 1935 *(Schult I: 463)*
Wood (teak).
*(Photograph by Heinz-Peter Cordes)*

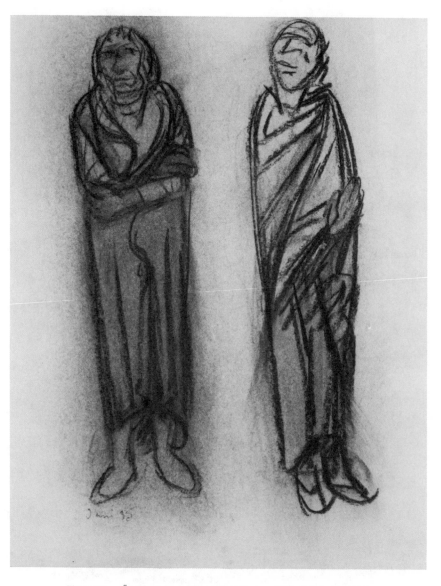

Figure 53.    *Übungen der leichten Hand* Series, 1935 (*Schult III:* 2102)
Charcoal. Left to right: "Stehender, Die Arme vor dem
Leib verschrankt" and "Abwehrender."
*(Photograph by Heinz-Peter Cordes)*

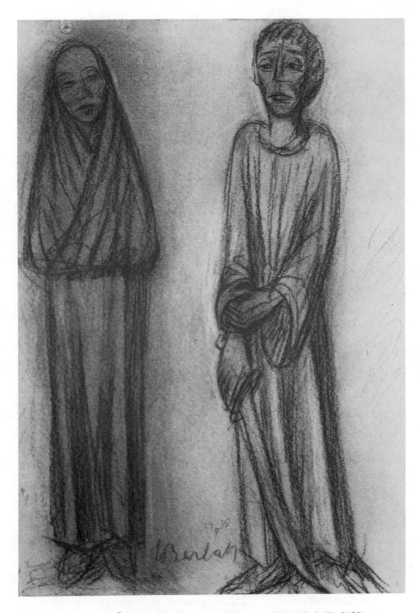

Figure 54.   *Übungen der leichten Hand* Series, 1935 (*Schult III:* 2120)
Charcoal. Left to right: "Das schlimme Jahre 1937" and
"Jungling mit Schwert."
*(Photograph by Heinz-Peter Cordes)*

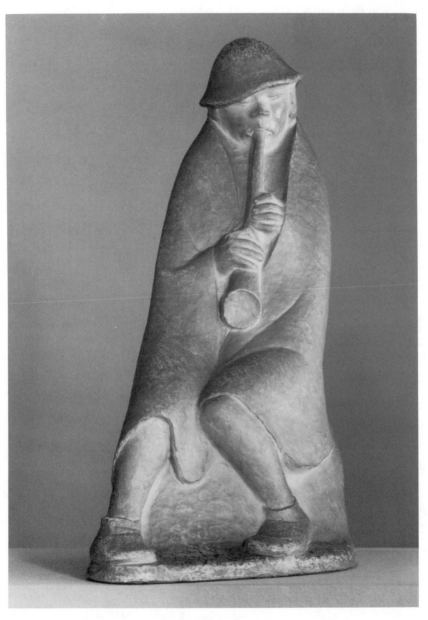

Figure 55.   *Der Flötenbläser,* 1936 (*Schult I:* 468)
Plaster.
*(Photograph by Heinz-Peter Cordes)*

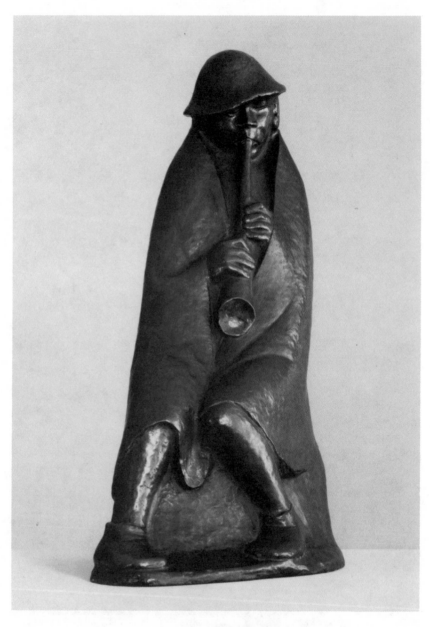

Figure 56.  *Der Flötenbläser*, 1936 (*Schult I:* 469)
Bronze from plaster model.
*(Photograph by Heinz-Peter Cordes)*

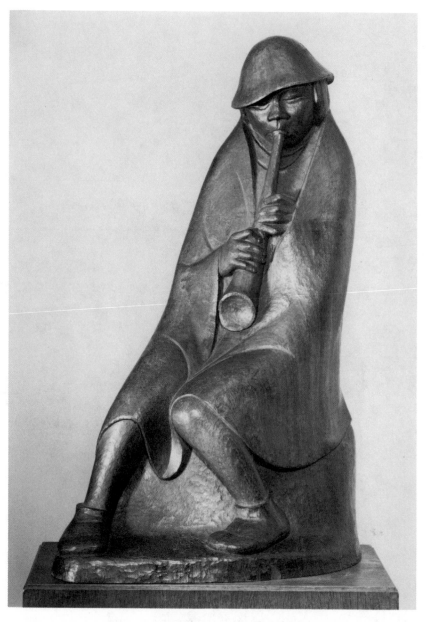

Figure 57.   *Der Flötenbläser*, 1936 (*Schult I: 471*)
Wood (teak).
*(Photograph by Heinz-Peter Cordes)*

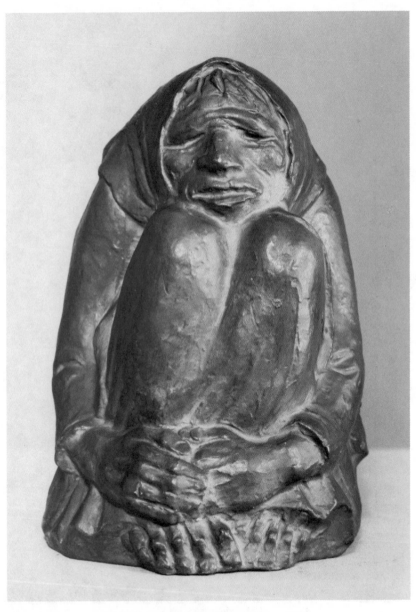

Figure 58.    *Frierende Alte*, 1937 (*Schult I:* 479)
            Plaster.
            (*Photograph by Heinz-Peter Cordes*)

# Notes

## Chapter 1

1. Of the 96 "writers who painted and drew" born between 1500 and 1875 catalogued by Böttcher and Mittenzwei, only 6 are not mentioned by Günther (Beer, Merck, Forster, von Ense, Kügelgen and Edel). It is a tribute to Günther that he, despite the sweeping nature of his book, manages such an exhaustive listing of those in the field that Böttcher and Mittenzwei map out so carefully in their preface.

   The 1960 edition of *Künstlerische Doppelbegabungen* is, however, more than merely dated; some of the more prominent artists whose multiple talents were evident well before 1960 who should have been identified by Günther include Oskar Kokoschka, Hans Arp, Oskar Maria Graf and Günther Grass. These men are included in Böttcher and Mittenzwei's *Dichter als Maler*.

   Böttcher and Mittenzwei admit that their selection of poets who were also painters is meant to be representative, not all-inclusive (1980: 27). Several "poet-painters" entered in Günther's *Künstlerische Doppelbegabungen* (1960) are not discussed in *Dichter als Maler*, including Hermann Burte, Else Ernst, Herbert von Hoerner, Franziska Gräfin zu Reventlow and Georg Trakl. Böttcher and Mittenzwei reject Burte because he was a Nazi (1980: 27). Their reasons for not including the other artists are not stated; but Böttcher and Mittenzwei, in their preface, do relate why other multiple talents (many of whom are not mentioned by Günther either) were not considered: because they were, for example, "painters who wrote" (1980: 26) or because no reproductions of works or originals could be located (1980: 27), etc. Not rejected, however, are a number of so-called multiple talents clearly more important for their leftist political positions than for their literary or artistic talents, for example Erich Weinert and Alfred Kurella. The reader is, however, not misled by the East German critics Böttcher and Mittenzwei to think otherwise.

   Despite its inadequacies, *Künstlerische Doppelbegabung* (1960) still provides the most complete listing of German-speaking artists active but not necessarily particularly adept in more than one art form for the period 1500–1945. When Günther's work is supplemented by *Dichter als Maler*, a fairly complete overview can be derived for the period 1300–1960. Unfortunately, a truly comprehensive picture of contemporary German-speaking artists with *Doppelbegabungen* is unavailable at this time.

2. There are of course exceptions. For example, two penetrating, book-length studies do investigate the relation among Oskar Kokoschka's works in varying media: Henry I. Schvey's *Oskar Kokoschka: The Painter as Playwright* (1982) and Gerhard Johann Lischka's *Oskar Kokoschka: Maler und Dichter. Eine literar-ästhetische Untersuchung zu seiner Doppelbegabung* (1972).

3.  The following passage from *Laokoon oder Über die Grenzen der Malerei und Poesie*, original-
    ly published in 1766, supports the contention that Lessing felt that the visual arts were essential-
    ly spatial whereas literature was temporal:

    > I reason thus: if it is true that in its imitations painting uses completely different means or
    > signs than does poetry, namely figures and colors in space rather than articulated sounds in
    > time, and if these signs must indisputably bear a suitable relation to the thing signified, then
    > signs existing in space can express only objects whose wholes or parts coexist, while signs
    > that follow one another can express only objects whose wholes or parts are consecutive.
    >
    > Objects or parts of objects which exist in space are called bodies. Accordingly, bodies
    > with their visible properties are the true subjects of painting.
    >
    > Objects or parts of objects which follow one another are called actions. Accordingly,
    > actions are the true subjects of poetry.
    >
    > However, bodies do not exist in space only, but also in time. They persist in time, and in
    > each moment of their duration they may assume a different appearance or stand in a different
    > combination. Each of these momentary appearances and combinations is the result of a
    > preceding one and can be the cause of a subsequent one, which means that it can be, as it
    > were, the center of an action. Consequently, painting too can imitate actions, but only by
    > suggestion through bodies.
    >
    > On the other hand, actions cannot exist independently, but must be joined to certain beings
    > or things. Insofar as these beings or things are bodies, or are treated as such, poetry also
    > depicts bodies, but only by suggestion through actions.
    >
    > Painting can use only a single moment of an action in its coexisting compositions and must
    > therefore choose the one which is most suggestive and from which the preceding and
    > succeeding actions are most easily comprehensible.
    >
    > Similarly, poetry in its progressive imitations can use only one single property of a body.
    > It must therefore choose that one which awakens the most vivid image of the body, looked at
    > from the point of view under which poetry can best use it. (1964: 114–15; (1962, 1984:
    > 78–79)

4.  This presents an obvious problem, identified by Edward Allen McCormick, among others: "We
    are told . . . in the ["Preface"] that [Lessing] understands under the heading of painting
    ["Malerei"] all the visual arts. It does not occur to him . . . that just as painting and poetry are
    different from each other and hence subject to different laws, so do sculpture and painting
    differ" (1984: xxvii).

5.      Indeed, this spurious criticism [criticism after Simonides] has to some degree misled even
    the masters of the arts. In poetry it has engendered a mania for description and in painting a
    mania for allegory, by attempting to make the former a speaking picture, without actually
    knowing what it could and ought to paint, and the latter a silent poem, without having
    considered to what degree it is able to express general ideas without denying its true function
    and degenerating into a purely arbitrary means of expression. (1964: 5; 1962, 1984: 5)

6.  In 1982, Weisstein revises his listing of the "various types of interrelations that are of interest to
    the literary scholar" (1982: 259). Included among this new listing is *Doppelbegabung*: "A
    rather special case is that constituted by the multiple talent" (1982: 261). And yet, Weisstein
    has not significantly altered his critical position regarding the issue, as can be seen in the
    following passage:

    > In raising the issue of multiple talent —a heading under which one might also treat the work
    > of writers . . . who served as art critics and whose art criticism . . . had a bearing on their
    > literary activities—we have left the safe realm of tangible objects and structural relations and

entered the precarious domain of psychology. Methodologically, psychological approaches . . . are best left to those better equipped to deal with the mind . . . , unless, that is, there is concrete evidence of mental processes . . . to be found in the completed work or the preparatory stages. (1982: 261–62)

Therefore, my comments on the 1981 article remain as a valid criticism of Weisstein's 1982 position. While accurately pinpointing many areas where meaningful interart studies are possible and detailing other areas where methodological misconceptions occur, Weisstein's assessment of the phenomenon of multiple talent in artists proves quite conventional.

7. In formal logic, abductions are syllogisms where the major premise is certain but where the minor premise is only probable. The word "syllogism" is defined, in the *The Random House Dictionary of the English Language: the Unabridged Edition* (1967), as follows:

   *syllogism*: an argument the conclusion of which is supported by two premises, of which one (major premise) contains the term (major term) that is the predicate of the conclusion, and the other (minor premise) contains the term (minor term) that is the subject of the conclusion; common to both premises is a term (middle term) that is excluded from the conclusion. A typical form is: All A is B; All B is C; Therefore, all A is C.

8. Consult Eco, 1984: 41–42 for a discussion of what is meant by "overcoded abduction" and "undercoded abduction."

## Chapter 2

1. For an excellent selection of reviews of the Berlin productions of Barlach's dramas, the reader is referred to Jansen, 1972: 167–212. As a brief excursus, let us focus on extant bibliographies of secondary literature on Barlach. Recent scholars note that there is no comprehensive Barlach bibliography. Kaiser, in 1972, simply states: "There is no Barlach-bibliography" (8). Elmar Jansen, also in 1972, observes that most critics continue to rely on the bibliography Schult compiled for the first volume of the oeuvre catalog in 1960 (referred to in this dissertation as *Schult I*): "Most recent studies rely on the thorough and yet not by any means complete bibliography in [*Schult I*]: 278–94" (509). I would hasten to agree with Jansen's contention, although he does neglect to mention that there are also many additional cites in the commentaries that accompany each sculpture entry in *Schult I*. It is puzzling, however, that Jansen makes neither reference to nor use of appendix D in Naomi Jackson's dissertation from 1950. This source was evidently available to him, as he mentions it on page 524 of his book. In appendix D Jackson lists a substantial number of newspaper and periodical articles that appeared between 1900 and 1950 in which Barlach is discussed. A cursory glance at this appendix, however, reveals it to contain inaccuracies. On page 596, to note but one example, the author of a contribution is erroneously listed as E. Claesser; the correct entry should be A[rthur] Eloesser. I do not wish to discount the value of Jackson's appendix, but it may only be used, realistically, as a stepping-stone to further bibliographic research. A comparison of Jackson's listing with material cited by Jansen and Schult reveals less overlap than would be expected, with such extensive listings involved. Thus, when looking to recover articles written on Barlach that appeared between 1900 and 1950, it is most advisable to consult Jackson, Jansen and Schult concurrently. Such a method of cross-comparison is inordinately tedious. And it is made even more so since these scholars have developed highly idiosyncratic bibliographic methods. Jackson arranges journals more or less alphabetically (she is inconsistent when dealing with *der*, *die* and *das*) and then lists articles appearing in them chronologically. Since Schult's bibliography is selective, many cites must be scrounged from the text itself. Jansen does not see fit to include

a bibliography at all: all cites are located in footnotes and biographical/bibliographical sketches he provides on the persons whose contributions appear in the monograph.

One can consult Schult and Jansen to obtain a thorough but by no means exhaustive listing of secondary literature appearing between the years 1950 and 1960. For material related to Barlach that was published between 1960 and 1972, one is essentially limited to cross-checking selective bibliographies provided by Schmidt-Sommer (1967) and Kaiser (1972) and cites located throughout Jansen (1972) and to the laborious task of consulting national bibliographies or similar reference tools.

Rosina-Helga Schöne van Dyck's dissertation, written in 1976, indicates that the bibliographic situation regarding "Barlach secondary literature" has not improved: "Indicative of the unmanageability of secondary literature is that there is still no bibliography that can be considered even close to comprehensive" (5). Van Dyck does mention a bibliography compiled in the German Democratic Republic by Karl-Heinz Kröplin (1972) which is conspicuous because of its total lack of comprehensiveness. A comparison of Kröplin's bibliography with those provided by Jackson, Schult and Jansen reveals it to be virtually worthless, a conclusion also arrived at by van Dyck but via other means (1976: 6). Unfortunately, however, van Dyck's own bibliography does little to improve upon the one found in Kaiser (1972), as the most recent Barlach-related material she lists was published in 1973. Thus, after 1972, there are no selective bibliographies attempting to account for current scholarship.

In 1985, I brought the matter of a comprehensive bibliography of material related to Barlach to the attention of the Ernst-Barlach-Gesellschaft and received the following message from Horst O. Müller who, along with his wife and Dr. Ekkehard Nümann, is responsible for the *Mitteilungen der Gesellschaft:*

> In response to your suggestion regarding a Barlach-bibliography, I would like to relate that, to my knowledge, three projects are already underway all of which remain uncompleted. Mind you, we in the Ernst Barlach Museum in Ratzeburg are in the beginning stages of establishing an archive, but these projects are not yet available to us. Nonetheless, you are correct in any case that we should pursue further this plan [for a Barlach-bibliography]. (Müller, 1985)

The archive newly established at the Ernst Barlach Museum and the bibliographic tools available today make an exhaustive Barlach bibliography a feasible project indeed.

2. The following examples demonstrate the length to which Kleberger goes to embellish factual information with tidbits of fantasy: the reader learns that Barlach's mother was "a pretty girl" ("ein hübsches Mädchen" [15]) and that Barlach was born in the town of Wedel in the beautiful old house at the corner of the market, "under the watchful eyes of Roland so to speak" ("in dem schönen alten Eckhaus am Markt, sozusagen unter den Augen Rolands" [16]). Kleberger should refer to documents that provide evidence that Barlach's mother was "hübsch" or that Barlach's house of birth was "schön" or "alt." I further object to such journalese as "unter den Augen Rolands," if the only point to be made is that there is a statue of Roland in Wedel. Although such embellishments may seem trivial, they are indicative of Kleberger's tendency to stray at times from the truth. Since her book is poorly documented, it is often difficult for the reader to separate fact from fiction.

## Chapter 3

1. Hans Franck is one of only a few critics who would disagree. He regards Barlach's monuments to World War I, done during the mid-to-late-twenties, to be artistic failures (1961: 215–16). I will demonstrate why such a position is untenable.

2.  Friedrich Schult provides a comprehensive listing of exhibitions that featured Barlach's works during the artist's lifetime (*Schult I:* 27–28).

3.  Jansen explains Schwarzkopff's important role vis-à-vis the Güstrow *Ehrenmal:* "In 1925 [he had] the first decisive conversations with Barlach. Such continued conversations eventually led to the artist's assenting, in 1927, to create a memorial for Güstrow. Pastor Schwarzkopff . . . contributed greatly to the fact that Barlach presented the floating angel to the congregation of the cathedral" (1972: 541).

4.  Friedrich Schult, "Der Güstrower Dom," *Mecklenburgische Tageszeitung,* 3 November 1928, quoted in *Briefe II:* 150.

5.  For the sake of brevity, only the drawing numbers as they appear in *Schult III* will be listed here: #545, 668, 675, 794–96, 797, 798, 799–800, 801, 875, 878–79, 881, 930, 945–46, 947, 962–63, 972, 975, 976–77, 978, 979, 1004–05, 1076, 1077, 1079, 1080, 1164–65, 1171, 1203–04, 1228–29, 1329, 1403, 1404, 1413–14, 1424, 1448, 1559, 1608, 1610–11, 1625, 1631, 1632, 1633, 1646, 1647, 1648, 1689, 1722–23, 1762–63, 1767, 1768–69, 1770, 1800, 1844, 1848–57, 2000, 2055, 2101, 2124–25 and 2127.

6.  The following list contains references to works, all numbers of which are from *Schult I:*

| | | |
|---|---|---|
| *Die Vision* | (1912) | #120, 122–23 |
| *Der Rächer* | (1914) | #166–67 |
| | (1922) | #271–72 |
| *Auferstehung* | (1917) | #192 |
| *Der Übergang* | (1917) | #193–95 |
| *Der Flüchtling* | (1920) | #226–28 |
| *Grabmal Luise Barlach* | (1921) | #258–59 |
| *Kieler Ehrenmal (Schmerzenmutter)* | (1921) | #261 |
| *Schwebender Gottvater* | (1922) | #276 |
| *Güstrower Ehrenmal* | (1927) | #332–36 |
| *Grabmal Reuss* (Engelrelief) | (1931) | #397–98 |
| *Grabmal Pauly* | (1933) | #426–29 |
| *Grabmal Däubler* | (1935) | #466–67 |

7.  This is particularly clear in the following drawings:

| | | |
|---|---|---|
| #545 | (1907/08) | "Vier figürliche Studien auf einem Blatt |
| #675 | (1909) | "Hirtenverkündigung" |
| #878–79 | (1912) | each, "Eingebung" |
| #962–63 | (1912) | each, "Engelgeleit" |
| #994 | (1912) | "Schlaf im Tod" |
| #1076 | (1914) | "Lügt, Stürme, lügt" |
| #1080 | (1914) | "Erst Sieg, dann Frieden" |
| #1164–65 | (1916) | each, "Der Müde" |
| #1166 | (1916) | "Brüder" |
| #1171 | (1916) | "Schmerzenmutter" |
| #1203–04 | (1917) | "Armer Vetter und hoher Herr" |
| #1228–29 | (1917) | "Auferstehung" |
| #1403 | (1920) | "Der erste Tag" |
| #1404 | (1920) | "Die Dome" |
| #1448 | (1921) | "Schmerzenmutter" |

| #1722–23 | (1923/24) | "Grenzen der Menschheit" |
| #1767 | (1924/25) | "Die Jakobleiter" |
| #1770 | (1924/25) | "Unser Schuld sei vernichtet" |
| #1848–57 | (1926) | all: "Entwürfe zum *Güstrower Ehrenmal*" |

8.   Virch makes some astute observations regarding the use of the angel both as an allegory that can be interpreted along the lines of Christian mythology and as a symbol particular to Barlach's own philosophy of expression:

> With the figure of the angel in *Geistkämpfer*, Barlach employed an objective and collective christian symbol whose meaning is well established and universally intelligible. This may be misleading, however, because Barlach is not at all concerned with an illustration of christian teaching. . . . His angel is not a christian symbol but rather an embodiment in the Rilkean sense of the superhuman, of the "more powerful existence." Related and parallel to Barlach's angel in the history of ideas . . . , Rilke's angels and demons too become . . . private symbols for the powers of life, symbols no longer bound to christian religiosity. (Virch, 1953: 17–18)

The *Güstrower Ehrenmal* is an angellike figure. And yet, it cannot be interpreted exclusively as a Christian symbol or allegory. Rather, it is a personal symbol, the interpretation of which is determined by the interaction of formal elements.

9.   Virch refers to each of the drawings, not necessarily to the lithograph, as "Zwei Schwebende."

10.   Representative drawings will be discussed in the text. A more complete listing is furnished below for informational purposes:

| #976–77 | (1912) | each, "Schwebender" |
| #979 | (1912) | "Schwebender" |
| #1005 | (1912) | "Verdammte im Feuersturm" |
| #1077 | (1914) | "Der Rächer" |
| #1171 | (1916) | "Schmerzenmutter" |
| #1203–04 | (1917) | "Armer Vetter und hoher Herr" |
| #1228–29 | (1917) | "Auferstehung" |
| #1403 | (1920) | "Der erste Tag" |
| #1404 | (1920) | "Die Dome" |
| #1416 | (1920) | "Erschaffung Adams" |
| #1417 | (1920) | "Bekenner und Lästerer" |
| #1424 | (1920) | "Gestreckt liegende weibliche Gestalt" |
| #1446 | (1920/21) | "Der Flüchtling" |
| #1722–23 | (1923/24) | "Grenzen der Menschheit" |
| #1848–57 | (1926) | all: "Entwürfe zum *Güstrower Ehrenmal*" |

11.   Virch does consider *Singender Mann* (1928) to be an exception (cf. his note 104).

12.   For similar remarks concerning this relation, consult Bruhns, 1978: 25; Schneckenburger, 1975: 92; Gross, 1967: 113; Stubbe, 1959: 12, 16, 24; and Beyer, 1921: 487.

13.   Here one finds a listing of exhibitions and exhibition catalogs where drawing #1853 has been displayed.

14.   Paul Fechter remarks in a similar and yet more unwieldy fashion: "The rigid linearity of the body from the feet to the shoulders is tenseness; the face on the other hand is being, timelessness, form of a finality which has subdued and tamed the temporal motion [projected by the other features]" (Fechter, 1957: 162).

15. Rainer Rumold discusses the symbolism of blindness as it appears in the works of various expressionists and modernists, including Gottfried Benn, Carl Einstein and Paul Celan (1982: 152). For these writers and others, including T.S. Eliot, Georg Trakl and Ernst Barlach, blindness signals, in addition to the rejection of objective and concrete reality (Rumold, 1982: 152), the advent of a new manner of perception. As Rumold notes: "Along with the world of objects, the world of the categorical concepts of language should also be simultaneously rejected and transcended ["aufgehoben"] in order to accord complete creative freedom to intuition and imagination" (152–53). The dialectic sense of the word "aufheben," as Rumold relates it to the modernist understanding of blindness, is also exemplified in the following dialog between Kule and the son in *Der tote Tag*.

> SON: You see nothing?
> KULE: Nothing.
> SON: Not even the sun? . . .
> KULE: No better than I see you. . . .
> SON: You do not see the sun?
> KULE: I see no sun, no world no heaven, nothing!
> SON: But still you speak of seeing, your tongue is familiar with it, you can say "see"; thus you must nonetheless know what it is. You see absolutely nothing?
> KULE: No, I do see black night. . . .
> SON: But during the night one dreams, and you said you saw black night; thus dreams must be in there—do you see them? I saw this past night, before it came, the horse in a dream . . . ! It was as if my eyes were open, as if the sun were shining. . . .
> KULE: You see, thus I see as in a dream and see more beautifully and more penetratingly than with wakeful eyes.
> SON: And what do you see?
> KULE: The future. . . . Do you know how I lost the energy to see?
> SON: Why should I know? After all, I see!
> KULE: And yet, perhaps you are blinder than I when it comes to many things. Look, my eyes were two spiders who waited in the sockets and caught in their webs the images of the world that strayed their way, captured them and savoured their sweetness and pleasantness. And yet, the more images they captured, the more they found that were bitterly succulent and horribly rich. At last the eyes could no longer stand the bitterness and they wove the entrance to their sockets shut, sat inside, deciding rather to starve, and then they died. ["Sieh, meine Augen, das waren zwei Spinnen, die saßen im Netz ihrer Höhlen und fingen die Bilder der Welt, die hineinfielen, fingen sie und genossen ihre Süße und Lust. Aber je mehr kamen, um so mehr wurden ihrer, die waren saftig von Bitterkeit und fett von Gräßlichkeit, und endlich ertrugen die Augen nicht mehr solche Bitterkeiten, da haben sie den Eingang zugewoben, saßen drinnen, hungerten lieber und starben."] How could I express in words that which blinded my eyes . . . ? But let me continue. Occasionally when I lie in bed at night and the blanket of darkness weighs upon me, a resounding light envelops me, visible to my eyes and audible to my ears. And then there gathered around my bed stand the beautiful figures of the better future, still unmoving but of magnificent beauty, still sleeping. Whoever could awaken them would create a better looking world. Whoever could do this would be a hero. (*Dramen:* 21–24)

There is both a negation of corporeal reality and an incorporation of it, in the sense of *aufheben*, an untranslatable German word, in Kule's manner of seeing. Kule's imagination and intuition provide him with glimpses of a more profound reality, with "pictures of the future," "Bilder der Zukunft." And yet, the problem with these "Bilder" is that they defy concrete definition.

16. This represents a practical application of Eco's theoretical remarks that appear on page 161 of *Semiotics and the Philosophy of Language* (1984).

**Chapter 4**

1.  To a degree, treatment of this issue by Böhme and Eckhart was influenced by knowledge of the various works of the early Christian writer Dionysius, sometimes referred to as Pseudo-Dionysius, as Rutledge comments:

> He claims to be the Aeropagite mentioned in Acts xvii, 22, who became a disciple of St. Paul after listening to his discourse of the Unknown God. He wrote in Greek, was probably a Syrian, and his works were certainly known by the early sixth century. Scholars are generally agreed that, on internal evidence, these works could not be of the first century. In antiquity he was identified with both the first Bishop of Athens and with the Denys, Bishop of Paris, who suffered martyrdom in the third century. There can be no doubt that the belief that he was indeed the disciple of St. Paul added greatly to his prestige in the past. . . . His true identity is still unknown. (1964: 9)

Dionysius's influence on theologians, mystics and poets of the Middle Ages was "immense," to quote E.F. Osborne (1967: 510). Dom Denys Rutledge agrees with Osborne's assessment of Dionysius's influence: "In the Middle Ages [Dionysius's] authority surpassed that of any other Father of the Church" (1964: 9). In one of his treatises, *On Divine Names*, Dionysius asserts that "the science and contemplation of Itself [God] in Its [His] essential Nature is beyond the reach of all created things, as superessential above all" (1897: 3). Or, in other words:

> For, as things intelligible cannot be comprehended and contemplated by things of sense, and things uncompounded and unformed by things compounded and formed; and the intangible and unshaped formlessness of things without body, by those formed according to the shapes of bodies; in accordance with the self-same analogy of the truth, the superessential Illimitability is placed above things essential, and the Unity above mind above the Minds; and the One above conception is inconceivable to all conceptions; and the Good above word is unutterable by word—Unit making one every unit, and superessential essence and mind inconceivable, and Word unutterable, speechlessness and inconception, and namelessness—being after the manner of no existing being, and Cause of being to all, but Itself not being, as beyond every essence, [so too will God remain beyond the reach of man]. (1897: 2–3)

Meister Eckhart also contends that God defies definition by man, for example, in one of his sermons that was composed in Latin, entitled *Homo quidam fecit cenam magnam*. Furthermore, in this sermon Eckhart cites Dionysius in a context that substantiates the claim that there is a link between the ideas of the two thinkers:

> Now St. Luke says: "A man made a great supper." This man had no name, this man had no equal, this man is God. God has no name. A pagan master says that no tongue can say an adequate word of God, because of the sublimity and purity of his being. If we speak of a tree, we make statements about it through the things that are above the tree, such as the sun that acts on the tree. Therefore we cannot speak of God in a true sense, because there is nothing above God, and God has no cause. Secondly, we make statements about things by means of similarity. Therefore one cannot really speak of God because nothing is equal to him. Thirdly, we make statements about things according to their operations: if one wants to speak about the art of a master, one speaks of the image he has created: the image reveals the master's art. All the creatures are too inferior to reveal God, all of them are nought compared with God. This is why no creature is capable of uttering one single word about God through the things he has created. Hence Dionysius says: All those who want to make statements about God are wrong, for they fail to say anything about him. Those who want to say nothing about him are right, for no word can express God; but he expresses himself in himself. (In Ancelet-Hustache, 1957: 115)

In another of his Latin sermons, *Renovamini spiritu mentis vestrae*, Meister Eckhart similarly expresses the view that attempts to define God through conventional means of expression will necessarily prove futile:

> God is without name, for no one can say or understand anything of Him. . . . Hence if I say: "God is good," this is not true. I am good, but God is not good. . . . If I say further: "God is wise," this is not true, I am wiser than He. If I say also: "God is a being," this is not true; He is a being above being and a superessential negation. A master says: If I had a God whom I could know, I would not think Him to be God. . . . You must love Him as He is: neither God, nor spirit, nor person, nor image; rather the One without mixture, pure and luminous. (In Ancelot-Hustache, 1957: 55)

If one continues this line of inquiry, one finds that Jakob Böhme too writes that God will remain absolutely inexpressible—at the very beginning of his first work, *Aurora, oder Morgenröthe im Aufgang*, for example: "Flesh and blood cannot comprehend the essence of God" (1,1). Similarly, in the next chapter, one reads: "The profundity of God can be gauged by no creature" (2, 17).

2. As Peter Erb astutely remarks:

> All things are created in and by the Word and are reflected in man's word. All things have power ["Kraft"] . . . which is paralleled by the *Kraft* above all, the Word of God. Because of the close relationship between macrocosm and microcosm, man's words are therefore to be carefully spoken. A man speaks and has creative power in his word. Speaker, word and power are one and yet three. They reflect the Trinity. Empty words are destructive. In their existence they create either in the Word or aside from it. If they are spoken outside of the Word, they make idols; in their power to create they blaspheme. Only the prophet, the man directly inspired by God, is free of this danger.(1978: 22–23)

3. Dionysius, in *On Divine Names*, explains that God is absolutely unknowable. And yet, in another treatise, *Mystic Theology*, Dionysius describes how one may come to a truer understanding of God through a mystical union of the soul with God, experienced in the form of dreams or visions. Dionysius, for example, implores Timothy (whose historical identity has never been firmly established) to abandon his efforts to define God through conventional means and to surrender himself to a life of prayer, in the hope that he will someday be blessed with this mystical direct communion of the soul with God. The beginning passages of *Mystic Theology* deserve quotation at length, as they clearly detail the nature of these mystic dreams and visions that a number of the later mystics less clearly explain:

> Triad supernal, both super-God and super-good . . . , direct us aright to the super-unknown and super-brilliant and highest summit of the mystic Oracles, where the simple and absolute and changeless mysteries of theology lie hidden within the super-luminous gloom of the silence, revealing hidden things, which in its deepest darkness shines above the most super-brilliant, and in the altogether impalpable and invisible, fills to overflowing the eyeless minds with glories of surpassing beauty. This then be my prayer; but thou, O dear Timothy . . . , leave behind both sensible perceptions and intellectual efforts, and all objects of sense and intelligence . . . , and be raised aloft unknowingly to the union, as far as attainable, with Him Who is above every essence and knowledge. For by the resistless and absolute ecstasy in all purity . . . , thou wilt be carried on high, to the superessential ray of the Divine darkness, when thou hast cast away all, and become free from all. . . .
>
> [T]he good Cause of all is both of much utterance, and at the same time of briefest utterance, and without utterance. . . . It is superessentially exalted above all, and manifested

without veil and in truth, to those alone who pass through both all things consecrated and pure, and ascend above every ascent of all holy summits . . . , and enter into the gloom, where really is, as the Oracles say, He Who is beyond all. . . . [T]he most Divine and Highest of the things seen and contemplated are a sort of suggestive expression of the things subject to Him Who is above all, through which His wholly inconceivable Presence is shown, reaching to the highest spiritual summits of His most holy places; and then he is freed from them who are both seen and seeing, and enters into the gloom of the *Agnosia;* a gloom veritably mystic, within which he closes all perceptions of knowledge and enters into the altogether impalpable and unseen, being wholly of Him Who is beyond all, and of none, neither himself nor other; and by inactivity of all knowledge, united in his better part to the altogether Unknown, and by knowing nothing, knowing above mind.

We pray to enter within the super-bright gloom, and through not seeing and not knowing, to see and to know that the not to see nor to know is itself the above sight and knowledge. For this is veritably to see and to know and to celebrate super-essentially the Superessential, through the abstraction of all existing things. (1897: 130–33)

Parker, incidentally, relates that *Agnosia* for Dionysius is "neither ignorance nor knowledge intensified; but a supra-knowledge of Him, Who is above all things known" (1897: xi). The devout theologians, not the "uninitiated," become for Dionysius the intermediaries between God and the ordinary man. Their task is to communicate their experiences to the uninitiated through the use of symbolic language or images.

For Meister Eckhart, not only the devout theologian but also the mystic may be subject to these revelations, to this *unio mystica.* As Jeanne Ancelot-Hustache explains: "The soul that is advanced in the spiritual life, the mystic, 'senses' and 'tastes' the union of God and the soul through grace; the terms of ordinary language have to make do as well as may be to define the indefinable. God gives himself to the soul beyond all intellectual categories" (1957: 60).

Jakob Böhme contends that even the briefest mystical vision affords one a truer knowledge of the Divine than years of learning at the universities. Böhme thus elevates the type of knowledge gained in visions above that which is available through conventional intellectual means:

I have never understood how I should seek or find [the divine *Mysterio*]. . . . I have only sought Jesus Christ. . . .

In such my sincere seeking and desire [for Jesus Christ], the gates of heaven have been opened to me, and in the course of a quarter hour, I saw and knew more than if I had attended the universities for years. I was greatly amazed and did not know how it happened to me. . . .

I then saw and understood the essence of all essence ["Wesen aller Wesen"] . . . the birth of the trinity, and the origins of this world. (*Epistolae Theosophicae, oder Theosophische Send-Briefe* 12, 6–8)

4.  The importance Wau attaches to both the real and intangible qualities associated with his overcoat is reminiscent of Akaki Akakievich's relation to "the overcoat" in Gogol's short story *The Overcoat* (1842).

5.  As a result, Kandinsky claims, there are very few in society who are occupied with matters of the "spirit":

The awakening soul is still deeply under the influence of this nightmare. Only a weak light glimmers, like a tiny point in an enormous circle of blackness. This weak light is no more than an intimation that the soul scarcely has the courage to perceive, doubtful whether this light might not itself be a dream, and the circle of blackness, reality. (1912: 4–5; 1982: 128)

Kandinsky considers "the spiritual life" responsible for all the positive historical developments of mankind, and views the spiritual life in terms of a metaphor—that of a triangle which progresses slowly forwards and upwards:

> The spiritual life can be accurately represented by a diagram of a large acute triangle divided into unequal parts, with the most acute and smallest division at the top. The farther down one goes, the larger, broader, more extensive, and deeper become the divisions of the triangle.
>
> The whole triangle moves slowly, barely perceptibly, forward and upward, so that where the highest point is "today"; the next division is "tomorrow," i.e., what is today comprehensible only to the topmost segment of the triangle and to the rest of the triangle is gibberish, beomes tomorrow the sensible and emotional content of the life of the second segment. (1912: 11; 1982: 133)

Thus, Kandinsky claims that contemporary society, with its accent on materialistic doctrine, impedes the movement of the triangle and must therefore be superseded by a new age of spirituality. Significantly, art, for Kandinsky, can play an important role in heralding this new age and in furthering its development. For him, certain artists at all levels of the spiritual triangle are to be viewed as prophets: "In every division of the triangle, one can find artists. Every one of them who is able to see beyond the frontiers of his own segment is the prophet of his environment, and helps the forward movement of the obstinate cartload of humanity" (1912: 12; 1982: 134). Furthermore, Kandinsky writes that this prophetic art educates man in matters of the spirit because it divines transcendental truths:

> The . . . type of art . . . capable of further development . . . has an awakening prophetic power, which can have a widespread and profound effect. The spiritual life, to which art also belongs and in which it is one of the most powerful agents, is a complex but definite movement forward and upward—a progress, moreover, that can be translated into simple terms. This progress is the progress of knowledge. (1912: 9; 1982: 131)

And yet, since the current age is one that is dominated by the principle of nonspirituality, the true artist is often scorned and the message his art works convey is ignored:

> The origins of the necessity that drives man onward and upward "by the sweat of his brow," through suffering, evil, and torture, are veiled in darkness. Even after one has progressed to the next stopping point and removed many a troublesome stone from one's path, an evil, invisible hand casts new obstacles in the way, which sometimes appear completely to block the path ahead and render it unrecognizable.
>
> And then, without fail, there appears among us a man like the rest of us in every way, but who conceals within himself the secret, inborn power of "vision."
>
> He sees and points. Sometimes he would gladly be rid of this higher gift, which is often a heavy cross for him to bear. But he cannot. Through mockery and hatred, he continues to drag the heavy cartload of struggling humanity, getting stuck amidst the stones, ever onward and upward. (1912: 9–10; 1982: 131)

In contrast to those works of art which are grounded in spirituality, those which owe their origins to materialism, that is, naturalistic or realistic works of art, do not advance the spiritual triangle. In "Über Bühnenkomposition," a contribution which also appeared in *Der Blaue Reiter*, Kandinsky explains: "The nineteenth century distinguished itself as a time far removed from inner creation. Concentration upon material phenomena and upon the material aspect of phenomena logically brought about the decline of creative power upon the internal plane, which apparently led to the ultimate degree of abasement" (1979: 193–94; 1982: 259). Kandinsky further notes that in contemporary society and also in the nineteenth century, an all-pervasive "materialistic philosophy" (1912: 5; 1982: 128) has given rise to a "purposeless, materialistic

art" (1912: 8; 1982: 130), "a castrated art" (1912: 9; 1982: 131), which is not based on the principle of inner necessity but rather is "external and thus has no future" (1912: 5; 1982: 128). Consequently, the true artist should seek to bring into his works only "the inner essence of things, which of itself brought about a rejection of the external, the accidental" (1912: 4; 1982: 128). Consistent with these views is Kandinsky's subsequent rejection of nineteenth-century drama, which he characterizes as follows:

> Nineteenth century drama is in general the more or less refined and profound narration of happenings of a more or less personal character. It is usually the description of external life, where the spiritual life of man is involved only insofar as it has to do with his external life. The cosmic element is completely lacking.
>
> External happenings, and the external unity of the action comprise the form of drama today. (1979: 194–95; 1982: 260)

6.  Viewing the question from the standpoint of the internal, the whole matter becomes fundamentally different.

    1.  Suddenly, the external appearance of each element vanishes. And its inner value takes on its full sound.
    2.  It becomes clear that, if one is using the inner sound, the external action can be not only incidental, but also, because it obscures our view, dangerous.
    3.  The worth of the external unity appears . . . as unnecessarily limiting, weakening the inner effect.
    4.  There arises of its own accord one's feeling for the necessity of the inner unity, which is supported and even constituted by the external lack of unity.
    5.  The possibility is revealed for each of the elements to retain its own external life, which externally contradicts the external life of another element.

    Further, if we go beyond these abstract discoveries to practical creation, we see that it is possible

    re 1.  to take only the inner sound of an element as one's means;
    re 2.  to eliminate the inner sound of an element as one's means;
    re 3.  by means of which the external connection between the parts collapses of its own accord;

    likewise,

    re 4.  the external unity, and
    re 5.  the inner unity place in our hand an innumerable series of means, which could not previously have existed.

    Here, the only source thus becomes that of internal necessity (1979: 202–6; 1982: 263).

7.  One finds under "Tempe" in *Meyers Konversations-Lexikon: Eine Encyklopedia des allgemeinen Wissens* (1874–78: 15:26):

    > *Tempe*: . . . the valley whose praise the ancient poets so often sang, between 100 and 2000 paces wide and about 10 kilometers . . . long, between the Olympus and Ossa mountains through which the Peneus River [reaches the Aegean Sea from the central plain] of Thessaly. . . . In the pass itself stood a highly sacred altar to Apollo, not far from the ocean an altar to Poseidon to whom the narrow valley's origins are attributed. The vale is strategically important as the chief pass into central Greece [from Macedonia].

8.  The phrase "to disambiguate" is used by Umberto Eco throughout *Semiotics and the Philosophy of Language* (1984). It appears that "to exact" might be a suitable substitute. For example, when one disambiguates a message, one exacts a message.

9.  The reader is referred to Chick (1967: 51–67 and 112–15) for a general discussion of Barlach's use of the grotesque in his literary works.

## Appendix A

1. In April 1926, the municipal authorities of Berlin had invited the sculptors E[rnst] B[arlach], Belling, Breuer, Kolbe, Lederer, Manzel, Placzek and Scharff to submit plans by October 15, 1926 for a Beethoven-memorial which the city, along with the Reich and with the state of Prussia, wanted to erect in front of the *Volksbühne* at *Bülowplatze* in honor of the 100th anniversary of Beethoven's death, March 26, 1927 (Number 572 of the *Drucksachen der Stadtverordnetenversammlung*). The competition ended without result (Alfred Dreifuß, Märkisches Museum). (*Briefe II*, Anmerkung 675, 1. : 812)

2. *Lachende Alte* (1937) and *Frierende Alte* (1937), "as images, first appeared . . . during 1908" (*Schult I:* 250, 251); *Der Zweifler* (1937), working model, 1931; *Der Buchleser* (1936), "thematically preceded . . . 1916" (*Schult III:* 246); *Der Flötenbläser* (1936), from a detailed drawing done 1919/1920; *Grabmal Däubler, Schwebender* (1935), a copy of *Die Vision, Schwebender* (1912); *Mutter und Kind* (1935), variation of *Blinde Bettlerin mit Kind* (1907); *Vergnügtes Einbein* (1934),from a drawing done in 1927; *Die Flamme* (1934), from a drawing 1929; *Der Trinker* (1933), from drawings 1910/1911 and 1927; and *Hockende Alte* (1933), conceived in 1908.

3. For detailed histories of many of Barlach's sculptures during the Nazi era, refer to individual entries in *Schult I*.

4. The 1948 "reissue" actually contains a new introduction and a different selection of drawings than the original edition. The 1948 version lists a copyright year of 1935, misleading the reader to assume that the two editions are the same.

5. Foreword to the 1948 edition of Fechter:

   This book . . . first appeared in November, 1935 in [a run of] close to 5,000 copies. On March 24, 1936, [the book] . . . was confiscated under the decree issued by the president of the *Reich* for the protection of the German people: "the content poses a threat to public security and order." All of the copies in book stores, and the 3,400 copies still remaining in the warehouse were gathered up by the police. A complaint lodged by the publishing firm was answered eight weeks later with notice that the confiscation was ordered by the Prussian secret police in Berlin, in accordance with the wishes of the *Reichsminister* for artistic design ["künstlerische Formgebung"]. He had ruled that "the artistically bolshevist content of the text was an expression of a destructive artistic view not suitable to our time and represented a threat to national-socialist cultural politics." An appeal by the publishing firm for permission to market the book in foreign countries was denied with the warning that this would amount to "damaging the perception of German art in foreign countries." All copies confiscated by the police were destroyed.

6. Rave has apparently obtained this figure from original Nazi-era documents "taken from the files of the ministry for *Reichs* propaganda" (1949: 85).

## Appendix B

1. "E. Barlach," *Dekorative Kunst* 9 (1901/02), 78–80.

2. Scheffler wrote these remarks during 1933 and 1934, according to the title page of *Die fetten und die mageren Jahre* (1946).

3. In *Briefe II*, "Verzeichnis der Briefempfänger," one finds:

> [Barlach] held K[estenberg] in such high esteem that he contributed the fourth Sinai-scene from the *Graf von Ratzeburg* to the special volume of *Die Musikpflege* in honor of Kestenberg's 50th birthday with the heading: "For Leo Kestenberg. From an unfinished drama." This is the only portion we possess in final form, since the clean copy of this drama has been lost. (88)

> Barlach also sculpted a bust of Kestenberg in 1928 (*Schult I* #344, 345).

4. For more detailed analyses of Cassirer's importance to the German art scene during the first two decades of this century, consult Paret (1980), von Löhneysen (1972) and Scheffler (1946).

5. The reader is referred to Scheffler's article in *Kunst und Künstler* (1925/26: 286–89) and the many ambivalent accounts of Cassirer and the way he conducted business recounted in Paret (1980).

6. The important new productions, *Neuinszenierungen*, of *Der blaue Boll* in 1934 and *Die echten Sedemunds* in 1935 by Kurt Eggers-Kestner in Altona fall outside the scope of these chapters. Surprisingly, Eggers-Kestner is mentioned only briefly in Jansen's book (1972: 556–57).

7. *Graf von Ratzeburg* was however briefly staged twice in 1951, in Nürnberg and in Darmstadt (Graucob, 1969: 144–45; and Bremer, 1954: 226–33).

8. As of 1968, the Piper publication containing *Graf von Ratzeburg* (*Dramen*) was only in its second printing—7,000–9,000 copies. This printing was still being marketed in 1985.

9. Cf. "Arbeitsweise, Handschriftenverhältnisse" in *Dramen*: 617–19.

10. They are reproduced in the "Anmerkungen," edited by Friedrich Dross, that accompany *Gestohlener Mond* in *Prosa II* (713–22).

# Bibliography

Adorno, Theodor W. "Die Kunst und die Künste." *Anmerkungen zur Zeit* 12 (1967). Rpt. in *Ohne Leitbild: Parva Aesthetica*. Edition Suhrkamp 201. Frankfurt am Main: Suhrkamp, 1967: 158–82.

Ancelet-Hustache, Jeanne. *Master Eckhart and the Rhineland Mystics*. Trans. by Hilda Graef. Harper Men of Wisdom 4. New York: Harper Torchbooks, 1957.

Barlach, Karl. *Mein Vetter Ernst Barlach*. Bremen: Heye, 1960.

B[eaucamp], E[duard]. "Verfälschung." *Frankfurter Allgemeine Zeitung*, 26 April 1984: Rpt. Ernst-Barlach-Gesellschaft-Hamburg: 37–8.

Beaucamp, Eduard, and Hans Barlach. "Seltsame Originale: Darf man das Werk Ernst Barlachs 'weiterentwickeln'?" [2 separate, untitled, articles listed under one common heading]. *Frankfurter Allgemeine Zeitung*, 22 May 1984. Rpt. Ernst-Barlach-Gesellschaft-Hamburg: 38–42.

Bebermeyer, Gustav. "Literatur und bildende Kunst." *Reallexikon der deutschen Literaturgeschichte*. 4 vols. Berlin: Walter de Gruyter, 1955-n.d. 2: 82–103.

Bebermeyer, G[ustav]. "Kunst und Literatur (in ihren Wechselbeziehungen)." *Reallexikon der deutschen Literaturgeschichte*. 4 vols. Berlin: Walter de Gruyter, 1925–31. 2: 158–69.

Berger, Ursel. "Der verfälschte Barlach." *Frankfurter Allgemeine Zeitung*, 13 June 1984. Rpt. Ernst-Barlach-Gesellschaft-Hamburg: 42–44.

Beyer, Oskar. "Der Plastiker Ernst Barlach." *Feuer* [Saarbrucken] 3 (1921): 478–91.

Bohl, Willard. *The Aesthetics of Visual Poetry: 1914–1928*. Cambridge: Cambridge University Press, 1986.

Böhme, Jakob. *Aurora, oder Morgenröthe im Aufgang. Sämtliche Schriften: Faksimile-Neudruck der Ausgabe von 1730 in elf Bänden*. Ed. Will-Erick Peuckert. Stuttgart: Fr. Frommann, 1955–60. 1: [n.g.].

———. *Libri Apologetici, oder Schutz-Schriften Wider Balthasar Tilken. Sämtliche Schriften: Faksimile-Neudruck der Ausgabe von 1730 in elf Bänden*. Ed. Will-Erick Peuckert. Stuttgart: Fr. Frommann, 1955–60. 5: [n.g.].

———. *De electione gratiae, oder Von der Gnadenwahl. Sämtliche Schriften: Faksimile-Neudruck der Ausgabe von 1730 in elf Bänden*. Ed. Will-Erick Peuckert. Stuttgart: Fr. Frommann, 1955–60. 6: [n.g.].

———. *Epistolae Theosophicae, oder Theosophische Send-Briefe. Sämtliche Schriften: Faksimile-Neudruck der Ausgabe von 1730 in elf Bänden*. Ed. Will-Erick Peuckert. Stuttgart. Fr. Frommann, 1955–60. 9: [n.g.].

Böttcher, Kurt, and Mittenzwei, Johannes. *Dichter als Maler*. Stuttgart: Kohlhammer, 1980.

Bremer, Klaus. "Barlach und die Bühne." *Akzente* 1 (1954): 226–33.

Brinkmann, Richard. *Expressionismus: Internationale Forschung zu einem internationalen Phänomen*. Stuttgart: J. B. Metzler. Special publication of the German Quarterly for the History of Literature and the History of Ideas [*Deutscher Vierteljahresschrift für Literaturwissenschaft und Geistesgeschichte*], 1980.

———. *Expressionismus: Forschungsprobleme 1952–1960*. Stuttgart: J. B. Metzler. Special publication of the German Quarterly for the History of Literature and the History of Ideas [*Deutscher Vierteljahresschrift für Literaturwissenschaft und Geistesgeschichte*], 1961.

Bruhns, Maike. *Ernst Barlach: Beiheft zur Lichtbildreihe H80 a/b*. Hamburg: Staatliche Landesbildstelle Hamburg, 1978.

Carls, Carl Dietrich. *Ernst Barlach*. New, expanded, rev. ed. New York: Praeger, 1969.

———. *Ernst Barlach: das plastische, graphische und dichterische Werk*. 5th ed. Flensburg: Christian Wolff, 1950.

———. *Ernst Barlach: das plastische, graphische und dichterische Werk*. Berlin: Rembrandt, 1931.

Chick, Edson M. *Ernst Barlach*. TWAS 26. New York: Twayne, 1967.

"Cratylus." Trans. by Benjamin Jowett. *The Collected Dialogues of Plato: Including the Letters*. Eds. Edith Hamilton and Huntington Cairns. Bolingen Series 71. Princeton University Press: Princeton, N.J., 1961, 421–74.

Dionysius the Areopagite. *Mystical Theology. The Works: now first translated in English from the original Greek*. Trans. by John Parker. London: James Parker, 1897: 130–37.

———. *On Divine Names. The Works: now first translated in English from the original Greek*. Trans. by John Parker. London: James Parker, 1897: 1–127.

Döblin, Alfred. Untitled article. *Prager Tagblatt*, 2 June 1923. Rpt. in Jansen, 1972: 290–94.

Dyck, Rosina-Helga Schöne van. "Ernst Barlach: Die Zeichnungen zu seinen Dramen *Die Sündflut, Der blaue Boll* und *Die gute Zeit*." Diss., University of Munich, 1976.

Eco, Umberto. "Producing Signs." *On Signs*. Ed. Marshall Blonsky. Baltimore: Johns Hopkins University Press, 1985: 176–83.

———. *Semiotics and the Philosophy of Language*. Advances in Semiotics. Ed. Thomas A. Sebeok. Bloomington: Indiana University Press, 1984.

———. *The Role of the Reader: Explorations in the Semiotics of Texts*. Advances in Semiotics. Ed. Thomas A. Sebeok. Bloomington: Indiana University Press, 1979.

———. *A Theory of Semiotics*. Advances in Semiotics. Ed. Thomas A. Sebeok. Bloomington: Indiana University Press, 1976.

Erb, Peter. Introduction to *The Way to Christ*, by Jacob Böhme. Trans. and intro. by Peter Erb. Preface by Winfried Zeller. New York: Paulist, 1978.

Ernst-Barlach-Gesellschaft-Hamburg., ed. *Ernst-Barlach-Gesellschaft e.V.: Mitteilungen der Gesellschaft 1985*. Hamburg: Ernst-Barlach-Gesellschaft-Hamburg, 1984.

Ernst Barlach Haus Stiftung Hermann F. Reemtsma. *Plastiken, Handzeichnungen, Autographen* [museumm catalog]. Hamburg: Ernst Barlach Haus Stiftung Hermann F. Reemtsma, 1977.

Fann, K. T. *Peirce's Theory of Abduction*. The Hague: Martinus Nijhoff, 1970.

Faust, Wolfgang Max. *Bilder werden Worte: Zum Verhältnis von bildender Kunst und Literatur im 20. Jahrhundert oder Vom Anfang der Kunst im Ende der Künste*. Literature as Art [Literatur als Kunst]. Munich: Carl Hanser, 1977.

Fechter, Paul. *Ernst Barlach*. Gütersloh: C. Bertelsmann, 1957.

———. Einführung. *Zeichnungen*. 6th through 8th thousand [2nd, rev. ed.]. Ed. and comp. by Ernst Barlach [and Rheinhard Piper]. Munich: R. Piper, 1948.

———. Einführung. *Zeichnungen*. 1st through 3rd [5th] thousand. Ed. and comp. by Ernst Barlach [and Rheinhard Piper]. Munich: R. Piper, [1935].

Fleischhauer, Dietrich. "Barlach auf der Bühne: Eine Inszenierungsgeschichte." Diss., University of Cologne, 1956.

Flemming, Willi. *Ernst Barlach: Wesen und Werk*. Series [Sammlung] Dalp 88. Bern: Francke, 1958.

Foucault, Michel. *This is Not a Pipe: with Illustrations and Letters by René Magritte*. Trans. and ed. by James Harkness. Berkeley: University of California, 1983.

Franck, Hans. *Ernst Barlach: Leben und Werk*. Stuttgart: Kreuz, 1961.

Fühmann, Franz. *Ernst Barlach: Das schlimme Jahr*. 4th ed., Wiesbaden: [n.p.], 1964.

————, ed. *Das Wirkliche und Wahrhaftige: Briefe, Grafik, Dokumente*. Photos, Gisela Pätsch. Rostock [East Germany]: Hinstorff, 1970.

Gauhe, Ursula. *Jean Pauls Traumdichtung*. Bonn: Scheuer, 1936.

Glöde, Günter. *Barlach: Gestalt und Gleichnis*. [East] Berlin: Evangelical Publication Center [Evangelische Verlagsanstalt], [n.d.]. Hamburg: Furche, 1966.

Gogol, Nikolai. *The Overcoat and Other Stories*. Trans. by Constance Garnett. New York: A.A. Knopf, 1923.

Goodman, Nelson. *Languages of Art: An Approach to a Theory of Symbols*. Indianapolis: Bobbs-Merrill, 1976.

Graucob, Karl. *Ernst Barlachs Dramen*. Kiel: Walter G. Mühlau, 1969.

Gross, Helmut. "Zur Seinserfahrung bei Ernst Barlach: Eine ontologische Untersuchung von Barlachs dichterischem und bildnerischem Werk." Diss., University of Würzburg, 1965. Freiburg: Herder, 1967.

Groves, Naomi [Jackson]. *Ernst Barlach: Leben und Werk*. Königstein im Taunus: Karl Robert Langewiesche Nachfolger Hans Köster, 1972.

Günther, Herbert. *Künstlerische Doppelbegabungen*. Munich: Ernst Heimeran, [1960].

————. *Künstlerische Doppelbegabungen: Mit 125 meist erstveröffentlichten Abbildungen nach Werken deutschsprachiger Künstler vom 16. bis ins 20. Jahrhundert*. Munich: Ernst Heimeran, 1938.

Hamann, Richard. *Der Impressionismus im Leben und Kunst*. Cologne: M. Dumont-Schauberg, 1907.

Heffernan, James A.W. "Resemblance, Signification, and Metaphor in the Visual Arts." *Journal of Aesthetics and Art Criticism* 44.2 (1985): 167–80.

Hermand, Jost. *Literaturwissenschaft und Kunstwissenschaft: Methodische Wechselbeziehungen seit 1900*. Stuttgart: J. B. Metzler, 1965.

Hofmannsthal, Hugo von. *Ein Brief. Gesammelte Werke in Einzelausgaben*. Ed. Herbert Steiner. 15 vols. Frankfurt am Main: S. Fischer, 1945–59. 6: 7–20.

————. *The Letter of Lord Chandos. Selected Prose*. Trans. by Mary Huttinger and Tania and James Stern. Intro. by Hermann Broch. Bollingen 33. [New York]: Pantheon, [1952].

Horn, Friederike. "Die Dichtung Ernst Barlachs und ihr ethischer Gehalt." Diss., University of Vienna, 1952.

Innis, Robert E. *Semiotics: An Introductory Anthology*. Bloomington: Indiana University Press, 1985.

Jackson, Naomi. *Ernst Barlach: The Development of a Versatile Genius*. Diss., Radcliffe College, 1950.

Jansen, Elmar. *Ernst Barlach*. [East] Berlin: Henschelverlag Kunst und Gesellschaft, 1984.

————, ed. *Ernst Barlach: Werke und Werkentwürfe aus fünf Jahrzehnten*. 3 vols. A publication by the Academy of Fine Arts of the GDR in conjunction with the National Museums in Berlin, capital of the GDR [Veröffentlichung der Akademie der Künste der DDR in Zusammenarbeit mit den Staatlichen Museen zu Berlin Hauptstadt der DDR]. Exhibition in the Altes Museum April-June 1981. [East] Berlin: Akademie der Künste der DDR, [1981].

————, ed. and comp. *Ernst Barlach: Werk und Wirkung. Berichte. Gespräche. Erinnerungen*. Frankfurt am Main: Athenäum, 1972.

Jean Paul. *Sämtliche Werke: Historisch-kritische Ausgabe; Erste Abteilung: Zu Lebzeiten des Dichters erschienene Werke*. 19 vols. Eds. Die preußische Akademie der Wissenschaften, die Akademie zur wissenschaftlichen Erforschung und zur Pflege des Deutschtums, die Jean-Paul-Gesellschaft. Weimar: Hermann Böhlaus Nachfolger, 1927–63.

Just, Klaus Günther. "Ernst Barlach." *Deutsche Dichter der Moderne: Ihr Leben und Werk*. 3rd ed. Ed. Benno von Wiese. Berlin: Erich Schmidt, 1975: 456–75.

Kafka, Franz. *Sämtliche Erzählungen*. Ed. Paul Raabe. Frankfurt am Main: S. Fischer, 1970.
——— . "The Top." Trans. by Tania and James Stern. *The Complete Stories*. Ed. Nahum N. Glatzer. New York: Schocken, 1971: 444.

Kaiser, Herbert. *Der Dramatiker Ernst Barlach: Analysen und Gesamtdeutung*. Munich: Wilhelm Fink, 1972.

Kandinsky, [Wassily]. *Complete Writings on Art*. Eds. Kenneth C. Lindsay and Peter Vergo. 2 vols. The Documents of Twentieth Century Art. Ed. Robert Motherwell and Jack D. Flann. Boston: G.K. Hall, 1982.

——— . *Über das Geistige in der Kunst: insbesondere in der Malerei*. 3rd ed. Munich: R. Piper, 1912.

Kandinsky, Wassily and Marc, Franz. *Der Blaue Reiter*. Documentary new edition [Dokumentarische Neuausgabe]. Ed. Klaus Lankheit. Munich: R. Piper, 1975.

Kleberger, Ilse. *Der Wanderer im Wind—Ernst Barlach*. Berlin: Erika Klopp, 1984.

[Körtzinger, Hugo], ed. *Freundesworte: Ernst Barlach zum Gedächtnis*. Hamburg: privately printed, 1939.

Kokoschka, Oskar. *Mörder, Hoffnung der Frauen*. Berlin: Sturm, 1907.

Kommerell, Max. *Jean Paul*. 5th ed. Frankfurt am Main: Vittorio Klostermann, 1977.

Krahmer, Catherine. *Ernst Barlach: mit Selbstzeugnissen und Bilddokumente*. Rowohlt's monographs [rowohlts monographien] 335. Reinbeck/Hamburg: Rowohlt, 1984.

Kröplin, Karl-Heinz. *Ernst-Barlach-Bibliographie*. [East-]Berlin: Deutsche Staatsbibliothek DDR, 1972.

Kunne-Ibsch, Elrud. *Die Stellung Nietzsches in der Entwicklung der modernen Literaturwissenschaft*. Studies in German Literature [Studien der deutschen Literatur] 33. Tübingen: M. Niemeyer, 1972.

Lazarowicz, Klaus. Nachwort. *Die Dramen*, by Ernst Barlach. Ed. Friedrich Dross. In *Das dichterische Werk: In drei Bänden*. Munich: R. Piper, 1958: 575–620.

Lessing, Gotthold Ephraim. *Laocoön: An Essay on the Limits of Painting and Poetry*. Trans., intro., notes by Edward Allen McCormick. [Indianapolis]: Bobbs-Merrill, 1962. Baltimore and London: Johns Hopkins University Press, 1984.

——— . *Laokoon oder Über die Grenzen der Malerei und Poesie*. Stuttgart: Philipp Reclam, 1964.

Lietz, Gerhard. "Das Symbolische in der Dichtung Barlachs." Diss., University of Marburg, 1937.

Lischka, Gerhard Johann. *Oskar Kokoschka: Maler und Dichter. Eine literar-ästhetische Untersuchung zu seiner Doppelbegabung*. European University Publications Series 18 [Europäische-Hochschulschriften Reihe 18]: Comparative Literature 4 [Vergleichende Literaturwissenschaften 4]. Bern: Herbert Lang. Frankfurt: Peter Lang, 1972.

Lohmann-Siems, Isa. "Zum Problem des Materials Ernst Barlach." *Ernst Barlach: Plastik, Zeichnungen, Druckgraphik. Kunsthalle Köln: 19. Dezember bis 5. Februar 1975* [exhibition catalog]. 2nd ed. Ed. Manfred Schneckenburger. Cologne: Kunsthalle, 1975: 23–32.

——— , ed. *Ernst Barlach Haus Stiftung Hermann F. Reemtsma: Plastiken, Handzeichnungen, Autographen* [museum catalog]. Hamburg: Ernst Barlach Haus Stiftung Hermann F. Reemtsma, 1977.

Löhneysen, Wolfgang Freiherr von. "Paul Cassirer—Beschreibung eines Phänomens." *Imprimatur; ein Jahrbuch für Bücherfreunde* [Frankfurt: Gesellschaft der Bibliophilen], ns 7 (1972): 153–80.

Lübeß, H. "Ernst Barlach nationalsozialistisch gesehen." *Niederdeutscher Beobachter*, 6 January 1934: sec. 1. In Jansen, 1972: 419–21.

McClain, Jeoraldean. "Time in the Visual Arts: Lessing and Modern Criticism." *Journal of Aesthetics and Art Criticism* 44.1 (1985): 41–58.

McCormick, Edward Allen. Translator's Introduction. *Laocoön: An Essay on the Limits of Painting and Poetry*, by Gotthold Ephraim Lessing. Trans. Edward Allen McCormick. [Indianapolis:] Bobbs-Merrill, 1962. Baltimore: Johns Hopkins University Press, 1984: ix–xxviii.

Merriman, James D. "The Parallel of the Arts: Some Misgivings and a Faint Affirmation." *Journal of Aesthetics and Art Criticism* 31. 2 (1972): 153–64; 31. 3 (1973): 310–21.

Mitchell, Breon. "Introduction." *Yearbook of Comparative and General Literature* 27 (1978): 5–6.

Müller, Horst O. Letter to the author. 23 March 1985.

Nietzsche, Friedrich. "Über Wahrheit und Lüge im außervoralischen Sinne." *Werke in drei Bänden.* Ed. Karl Schlechta. 3 vols. Munich: Carl Hanser, 1954–56. 3: 309–22.

––––––. "On Truth and Falsity in their Ultramoral Sense." Trans. by M.A. Mugge. *The Complete Works: First Complete and Authorized English Translation in Eighteen Volumes.* Ed. Oscar Levy. 18 vols. New York: MacMillan, 1911. 2: 171–92.

O'Neil, Daniel Charles. "Form and Content in the Novels of Ernst Barlach: A Critical Study of *Seespeck* and *Der gestohlene Mond* with Special Attention to Distinctive Visual Elements." Diss., Cornell University, 1966.

Osborn, E.F. "Pseudo-Dionysius." *Encyclopedia of Philosophy.* Ed. Paul Edwards. 8 vols. New York: Crowell Collier and MacMillan, 1967. 6: 510–11.

Page, Alex, trans. *Three Plays by Ernst Barlach.* Minneapolis: University of Minnesota Press, 1964.

Paret, Peter. *The Berlin Secession: Modernism and its Enemies in Imperial Germany.* Cambridge, Mass.: Harvard University Press, 1980.

Parker, John. "Preface." *On Divine Names. The Works: now first translated into English from the original Greek,* by Dionisius the Areopagite. Trans. by John Parker. London: James Parker, 1897.

Peirce, Charles Sanders. *Collected Papers.* 8 vols. Eds. Charles Hartshorne and Paul Weiss, vols. 1–6; Arthur Burks, vols. 7–8. Cambridge, Mass.: Harvard University Press, 1935–1958.

Piper, Ernst. *Ernst Barlach und die nationalsozialistische Kunstpolitik: eine dokumentarische Darstellung zur "entarteten Kunst."* Munich: R. Piper, 1983.

Praz, Mario. *Mnemosyne: The Parallel between Literature and the Visual Arts.* Bollingen Series 16. 1970. Princeton: Princeton Paperback, 1974.

Rave, Paul Ortwin. *Kunstdiktatur im Dritten Reich.* Hamburg: Mann, 1949.

Riegl, Alois. *Stilfragen.* n.p. 1893.

Rilke, Rainer Maria. *Die Aufzeichnungen des Malte Laurids Brigge.* Leipzig: Insel, 1910.

Rumold, Rainer. *Gottfried Benn und der Expressionismus: Provokation des Lesers; absolute Dichtung.* Monographs Literary History 52 [Monographien Literaturwissenschaft 52]. Königstein/Ts.: Scriptor, 1982.

Rutledge, Dom Denys. *Cosmic Theology: The Ecclesiastical Hierarchy of Pseudo-Denys: An Introduction.* London: Routledge and Kegan Paul, 1964.

Rüttenauer, Benno. *Maler-Poeten.* Strassburg: n.p., 1899.

Sartre, Jean Paul. *La nausée, roman.* Paris: Gallimard, [1938].

Scheffler, Karl. *Die fetten und die mageren Jahre.* Munich: Paul List, 1946.

––––––. "E. Barlach." *Dekorative Kunst, Illustrierte Zeitschrift für angewandte Kunst* [Munich] 9 (1901/02): 78–80.

Schmidt-Henkel, Gerhard. "Ernst Barlachs posthume Prosafragmente *Seespeck* und *Der gestohlene Mond:* Ein Beitrag zur Erkenntnis der existentiellen Autobiographie in Romanform." Diss., Free University of Berlin [FU], 1956.

Schmidt-Sommer, Irmgard. "Sprachform und Weltbild in den Dramen von Ernst Barlach." Diss., University of Tübingen, 1967.

Schneckenburger, Manfred., ed. *Ernst Barlach: Plastik, Zeichnungen, Druckgraphik. Kunsthalle Köln: 19. Dezember bis 5. Februar 1975* [exhibition catalog]. 2nd ed. Cologne: Kunsthalle, 1975.

Schneider, Karl Ludwig. "Expressionismus in Dichtung und Malerei." *Gratulatio: Festschrift für Christian-Wegner zum 70. Geburtstag am 9. September 1963.* Eds. Maria Honeit and Matthias Wegner. Hamburg: Christian Wegner, 1963: 226–43.

Schult, Friedrich. Bericht. *Der gestohlene Mond,* by Ernst Barlach. Ed. Friedrich Schult. Hamburg: Grillenpresse, 1951: 93–4.

————. *Barlach im Gespräch.* Wiesbaden: Insel, 1948.

————. "Der Güstrower Dom." *Mecklenburgische Tageszeitung,* 3 November 1928. Rpt. in *Briefe II:* 150.

Schvey, Henry I. *Oskar Kokoschka: The Painter as Playwright.* Detroit: Wayne State University Press, 1982.

Schweizer, Heinz. "Ernst Barlachs Roman *Der gestohlene Mond.*" Diss., University of Basel, 1959. Basel Studies in German Language and Literature 22 [Baseler Studien zur deutschen Sprache und Literatur 22]. Bern: Francke, 1959.

Seiler, Harald. "Ernst Barlachs Bildwerke." *Zugang zu Ernst Barlach: Einführung in sein künstlerisches und dichterisches Schaffen.* [Ed. Gerhard Hillman]. Evangelical Forum 1 [Evangelisches Forum 1]. Ed. Evangelical Academy Tutzing [Evangelische Akademie Tutzing]. Göttingen: Vandenhoeck and Ruprecht, 1961: 23–29.

Seznec, Jean. "Art and Literature: A Plea for Humility." *New Literary History* 3. 3 (1972): 569–74.

Smeed, J.W. *Jean Paul's Dreams.* London: Oxford University Press, 1966.

Sokel, Walter. *The Writer in Extremis: Expressionism in Twentieth-century German Literature.* Stanford: Stanford University Press, 1959.

Steiner, Wendy. *The Colors of Rhetoric: Problems in the Relation between Modern Literature and Painting.* Chicago and London: University of Chicago Press, 1982.

Stubbe, Wolf. "Einführung." *Ernst Barlach: Plastik.* Ed. and comp. by Wolf Stubbe, photos by Friedrich Hewicker. Munich: R. Piper, 1959: 7–33.

————, ed. *Ernst Barlach: Zeichnungen.* Photos by Friedrich Hewicker. Munich: R. Piper, 1961.

Synn, Ilhi. "The Ironic Rebel in the Early Dramatic Works of Ernst Barlach." Diss., Princeton University, 1966.

Valk, Geza Müller. "Ort der Handlung in den Dramen Ernst Barlachs: Untersuchung zum Nicht-Verbalen im Drama." Diss., Cornell University, 1972.

Vietta, Silvio, and Kemper, Hans-Georg. *Expressionismus.* German Literature of the Twentieth Century: Literary Criticism Workbooks 3 [Deutsche Literatur im 20. Jahrhundert: Literaturwissenschaftliche Arbeitsbücher 3]. Munich: Wilhelm Fink [-UTB 362], 1975.

Virch, Claus. "Die Handzeichnungen Ernst Barlachs und ihre stilistische Entwicklung." Diss., University of Kiel, 1951.

Waetzoldt, Wilhelm. *Deutsche Wortkunst und deutsche Bildkunst.* German Evenings in the Central Institute for Education and Instruction 2 [Deutsche Abende im Zentralinstitut für Erziehung und Unterricht 2]. Berlin: Ernst Siegfried Mittler, 1916.

Wais, Kurt. "The Symbiosis of the Arts." Trans. by Gregg A. Richardson. Intro. by Ulrich Weisstein. *Yearbook for Comparative and General Literature* 31 (1982): 76–95.

————. *Symbiose der Künste: Forschungsgrundlagen zur Wechselberührung zwischen Dichtung, Bild- und Tonkunst.* Essays and Lectures of the Wurttemberg Society of the Sciences—Division of the History of Ideas 1 [Schriften und Vorträge der Württembergischen Gesellschaft der Wissenschaften—Geisteswissenschaftliche Abteilung 1]. Stuttgart: W. Kohlhammer, 1936.

Walter, Rheinhold von. *Ernst Barlach: eine Einführung in sein plastisches und graphisches Werk.* Berlin: Furche, 1929.

Walzel, Oskar. *Wechselseitige Erhellung der Künste: Ein Beitrag zur Würdigung kunstgeschichtlicher Begriffe.* Philosophical Lectures published by the Kant-society 15 [Philosophische Vorträge veröffentlicht von der Kantgesellschaft 15]. Berlin: Reuther and Reichard, 1917.

Weininger, Otto. *Sex and Character.* London: William Heinemann; New York: G.P. Putnam's Sons, 1906. New York: AMS, 1975.

————. *Geschlecht und Charakter: eine prinzipielle Untersuchung.* 13th ed. Vienna: W. Braunmüller, 1911.

Weisstein, Ulrich. "Literature and the Other Arts." *Interrelations of Literature.* Eds. Jean-Pierre Barricelli and Joseph Gibaldi. New York: MLA, 1982: 251–77.

_____ . "Comparing Literature and Art: Current Trends and Prospects in Critical Theory and Methodology." *Literature and the Other Arts*. Eds. Zoran Konstantinovic, Steven P. Scher and Ulrich Weisstein. Proceedings of the 9th Congress of the International Comparative Literature Association 3. Special Publication 51 of the Innsbruck Contributions to Cultural Studies [Innsbrucker Beiträge zur Kulturwissenschaft Sonderheft 51]. Innsbruck: Institut für Sprachwissenschaft der Universität Innsbruck, 1981: 19–30.

_____ . "Verbal Paintings, Fugal Poems, Literary Collages and the Metamorphic Comparatist." *Yearbook of Comparative and General Literature* 27 (1978): 7–18.

_____ . "Comparing the Arts." *Yearbook of Comparative and General Literature* 25 (1976): 5–6.

Wellek, René and Warren, Austin. *Theory of Literature*. 3rd ed. New York: Harcourt, 1962.

New York: Columbia University Press, 1942: 29–63.

_____ and Warren, Austin. *Theory of Literature*. 3rd ed. New York: Harcourt, 1962.

Werner, Alfred. *Ernst Barlach*. New York: McGraw-Hill, 1966.

Worringer, Wilhelm. *Formprobleme der Gotik*. Munich: R. Piper, 1911.

# Index